Photographers and Research

This ground-breaking book situates research at the heart of photographic practice, asking the key question: What does research mean for photographers? Illuminating the nature and scope of research and its practical application to photography, the book explores how research provides a critical framework to help develop awareness, extend subject knowledge, and inform the development of photographic work. The authors consider research as integral to the creative process and, through interviews with leading photographers, explore how photographers have embedded research strategies into their creative practice.

Shirley Read is an independent curator based in London. She currently curates exhibitions for the Idea Store Canary Wharf during the Photomonth International Photography Festival. She has been interviewing photographers about their lives and work for the Oral History of British Photography (part of the National Sound Archive at the British Library) for twenty years. She teaches at every level of photographic practice and her book *Exhibiting Photography* (Focal Press 2008 and 2014) has been published in Chinese and English.

Mike Simmons is a photographic artist, author and Leader of the taught Master's Program in Photography at De Montfort University. His research interests are centred on the development of innovative approaches to exploring issues of social concern, through the application of creative photography. He has contributed to numerous exhibitions, conferences and symposia in the UK, Europe, Australia and the USA.

Photographers and Research

The Role of Research in Contemporary Photographic Practice

*Shirley Read and
Mike Simmons*

Routledge
Taylor & Francis Group

NEW YORK AND LONDON

First published 2017
by Routledge
711 Third Avenue, New York, NY, 10017

and by Routledge
2 Park Square, Milton Park, Abingdon, Oxon OX14 4RN

Routledge is an imprint of the Taylor & Francis Group, an informa business

Library of Congress Cataloging in Publication Data
A catalog record for this book has been requested

ISBN: 978-1-138-84431-5 (hbk)
ISBN: 978-1-138-84432-2 (pbk)
ISBN: 978-1-315-73046-2 (ebk)

Typeset in Times New Roman and Helvetica
by Florence Production Ltd, Stoodleigh, Devon, UK

Contents

Photographers and Research in Higher Education

Essays

Foreword

Wittgenstein said 'A man will be imprisoned in a room with a door that's unlocked and opens inwards; as long as it does not occur to him to pull rather than push.' Research is the pull that allows me to get out of the room and into the street, into what's actually happening in the world. There are as many ways to research as there are artists. From words read in the silence of the British Library to words read on placards while taking part in a demo, it's research.

Researching reality for me involves ripping photographs out of their context to bring the perpetrators of war and poverty slap bang into the same space as their victims. I want to act as an early warning system, be the canary down the mine. Imagining through images the end result of the direction in which we are heading and picturing people struggling to find another way. I look through thousands of photos, from picture archives, magazines, the internet, newspapers to scraps picked up on the street. I am a picture scrap merchant.

Through the use of photomontage I try and connect single clicks of the camera shutter to create a visual language that can be understood globally. Two clicks of the camera shutter can be brought together to create a third meaning that exposes cause and effect. Breaking down elements in photographs, cutting them up and reconstituting them allows a critical narrative of opposing forces to be presented visually. This encourages the viewer to think critically about the consequences of our actions on an asphyxiating planet.

That is my research method and the resulting image is a conglomeration of fragments. It's therefore easier to say what my research isn't rather than what it is—one thing it isn't is an acceptance of the bombardment of corporate images we are in danger of drowning in everyday. One thing it is, is an attempt to stem that ceaseless flow.

To temporarily dam that bombardment with my researched image fragments, sometimes, in my studio, I'm waving not drowning. It's at those moments when I'm able to pull Wittgenstein's door open just enough to throw light on the hidden critical connections locked away in the un-researched flow of the everyday.

Peter Kennard, Senior Research Reader in Photography,
Art and the Public Domain at the Royal College of Art, London

Introduction

This is a book about current photographic practice. The initial premise for the book evolved gradually from a series of occasional conversations between the two authors about the nature of the creative process for contemporary photographers, and the role that research plays in the development of ideas and the creation of work. Later it became a more deliberate attempt to unpick some of the thoughts and themes that emerged from those discussions, to extend them and formalise our exchange of views in a book that would be useful to students and practising photographers alike.

Although our individual understanding of research came from two quite distinct perspectives, one as a photographer turned academic and one curatorial, it became clear early on that the ways we understood the term research in relation to photography often overlapped and resonated with recurring themes, shared understandings, experiences and opinions.

At this stage our first question to ourselves was the very obvious one: 'What does research mean for photographers?' So our starting point for the book was to find a way to ask this of as many photographers as we could, and to do this we decided that the core of the book would be a set of interviews with photographers.

At the same time we thought that the book would also benefit from a number of essays as counterpoint to the interviews. The purpose of these would be to provide a broader context for thinking about research than the first person, experiential accounts and to address, in more depth, particular issues that the interviews might only touch on. Our starting point for the essays was the research we knew Patricia Townsend to be doing in looking at the processes of making work.

In deciding to interview practitioners we set out to find out what photographers actually do when they research and how they integrate research into their work. We wanted to see to what degree individual practices differ and what parallels could be drawn across those practices. We wanted to identify ways in which research is understood by a diverse range of photographic practitioners; to see the forms it takes; to look at the question of whether there is a basic level of research that needs to be conducted before a project can begin. We also wanted to

look at the roles of intuition and chance and to allow for other ideas to emerge from our enquiry.

As a way of shaping the project we defined our aims in order to develop a set of questions which we asked every interviewee:

1. How do you define the term research? Do you have a personal interpretation of research?
2. How would you describe the kinds of research that you do, and how does your research inform your practice?
3. How would you describe the impact it has on work in progress? In what ways does the research you do enhance, transform or otherwise impact on your work? Does research influence or inform the formulation of your ideas? Does research help to identify and foster a critical approach? Can you give examples of the ways in which research has enabled you to identify and solve problems that have emerged in your work?
4. Has research developed your practice over time and, if so, how?
5. Do you record the creative journey for each project in some way? And do you evaluate the research input as part of this?
6. How would you describe the impact research has on the ways in which you consider the siting of your work in the public domain and your approach to audiences?
7. Do you have any additional observations regarding research that you would like to add?

However, we left it to the interviewees to decide whether or not they would answer all the questions and in what depth since we soon discovered that some issues had more resonance than others for each practitioner. Above all we wanted to avoid a proscriptive approach or the suggestion that there is only one way to undertake, evaluate and apply the outcomes of research.

We selected as wide a range of photographers as we could—chosen across practices, approaches, gender, race, and stage of career. However, it soon became clear that it would be impossible to achieve a completely comprehensive coverage of current practice that would include, for instance, a range of editorial and advertising practices without making a very much larger and encyclopaedic book rather than the intimate look into personal practice that we wanted this book to be.

In the end we also limited ourselves to interviewing mostly mid- and late-career photographers on the basis that they would have more experience to draw on and share. But we also felt it was important to look at the way students at different levels of higher education might understand research and how they would evaluate its usefulness to their developing practice, and so we interviewed two students who had just completed a BA and an MA and one who is working towards the completion of a photographic practice-based PhD.

What became clear quite quickly, though not unexpectedly, was that although there were some similarities and common approaches to research, each of our interviewees had, over time, shaped and adapted their experiences and methods to suit their particular needs or circumstances, which they applied across most of their projects.

So, for example, we talked to photographers like Simon Norfolk who researches every aspect of his subject, including how he might take the final images, before he starts the work, in contrast to Susan Derges and Hannah Collins for whom the research is itself the work and cannot be unpicked from the final outcome. It became difficult to avoid seeing this as a gender issue initially, although we also interviewed other women photographers, including Deborah Bright and Mandy Barker, who don't follow the same path. We then recognised that our survey exists to describe possible research routes, to ask questions and open up ideas about research but that it could not in itself come up with a definitive analysis or roadmap which anyone can follow. This is because the options and variables within the research process for photographers are broad and because practice is so particular and dependent on the habits, needs and preferences of the individual as well as the purpose and audience for the work. To make this visible we also asked our interviewees to provide a portfolio of images, because we wanted to situate our discussions within a practical context and to *see* how research threaded through their work.

The term research represents a course of action that can lead to outcomes that are not fixed or predictable. Research materials can be drawn from many sources including specialist archives of all kinds; the established conventions, theories and practices laid down in the literature of photographic and art history, science, technology and the many philosophies that have become central to discussion on photography. Research can emerge through everyday encounters and can be triggered by self-inquiry and the personal nature of experience. And, of course, the starting point for many photography projects is to look at what and how other photographers or artists have covered the same subject. Anything is possible and anything may feed the research process.

In selecting the subject matter for the series of essays in the book we started with Patricia Townsend's research into the negotiation between the 'inner' and 'outer' worlds of the artist. In a way we saw this sort of juggling between what she describes as 'the hunch' and what is already known as the pivot on which all the interviews turn. During the interview process we discovered that each interviewee has, over time, found a way of working which marks a different resolution of the process she is describing and which fits with their own particular mindset, practice and approach to working.

We then expanded on some of the subjects touched on in the interviews. So, for example, Conohar Scott looks in some detail at working collaboratively both with a small group and with organisations with the same, or similar, concerns. Shirley Read reflects on the interests of photographers who focus on a single, broad research theme which they then develop over time. Janina Struk looks at how the two different elements of her photographic practice intertwine and impact on each other and on her thinking about her work. Mike Simmons presents an approach to the organising and recording of photographic projects through written documentation. Sian Bonnell opens up the question of the audience's influence on practice, which is also considered in many of the interviews, by describing how unexpected audience response caused her a major rethink about her work. Camilla Brown considers how exhibition as a chosen outcome for the work can be a subject for the photographer to research in terms

of practical aspects such as planning, space, design installation and the development of a collaborative relationship with a curator.

It is part of the human condition to look beyond the horizon in an effort to understand the world we live in more completely, and photography has been pivotal to that process since its inception. Photography has come a long way since the early pioneers grappled with the science of the new medium, but in many ways it still remains grounded in the desire to explore the boundaries of what we know or understand. Across the span of art history photography is a relative newcomer. Yet in the short period since its invention it has given the world some of the most memorable and challenging images of our times. Photographs have been the means used to question our actions, expose our motives and plumb the very depths of the human soul. Photography has succeeded in presenting both the ordinary and the extraordinary in equal measure; fact and fiction, memory and the imagination all fall within its scope. What makes photography relevant lies in its paradoxical nature and the ability to both describe and express.

We see this book as a research project in itself, bringing together examples of photographic practice for you to consider and absorb into your own ideas, processes and projects.

Shirley Read
Mike Simmons
London and Leicester 2016

Edmund Clark

Edmund Clark is a photographer working on issues
raised by the war on terror.

From the series *Guantanamo: If the Light Goes Out*.
Camp 4, arrow to Mecca and ring for ankle shackles
© Edmund Clark

For ME RESEARCH WORKS on many different levels and functions in many ways. It can be reading something specific about the background of a subject, an event or an issue. It can be talking to people who have been involved with that situation. It can be absorbing information, almost subconsciously, from the news or the radio. It can be anything from thinking about what kind of camera I am going to use to how I access a site or who I have to know to get access to a site. It's everything.

My unconscious plays a part, there's always something going on at the back of my mind about the questions I'm involved with, how they might be visualised and for whom. I've been reading a lot of Kafka recently and that's directly related to the subjects I've been working on about processes of control. Looking for other cultural references, expressions and forms that relate to the ideas and subjects I'm dealing with is definitely a part of what I do.

The films I go to see are all related to my work. In looking at media narratives about things like extraordinary rendition, control orders and the way people who have been in Guantanamo Bay are perceived and represented the role of popular culture in helping to facilitate a changing common perception of standards of legality and morality is really interesting and important. Films like *Zero Dark Thirty* and TV series like *24* and *Homeland* are in some ways an expression of changing perceptions of standards of behaviour by our government

agencies. But they also raise the question of whether they constitute justification or tacit agreement for some of the measures that these agencies have carried out. So understanding all that is definitely part of a wide research context.

The nature of the work I do in looking at the war on terror, the use of control and incarceration in that war and the expression of those controls through legal forms, whether it be memos justifying enhanced interrogation techniques by the American government or the formulation of control orders by the British government, means I have to really understand the legal implications. So, on *Control Order House* I worked incredibly closely with the lawyers at Gareth Peirce's practice, Birnberg Peirce.[1] They read every word I wrote. I had to know that what I was saying was watertight because I'd be an easy target if it wasn't. And also I was producing material that could, in theory, be used as evidence in the case of the man I was working with, who was a terrorism suspect. In a sense what I was producing was also research in itself. I do think lawyers have both positive and negative attitudes to photography and are incredibly aware of what media exposure can bring to their work in terms of both public debate and possible damage.

There are certain starting points, such as access, with my projects. I think there's a basic amount of research you have to do in order to know whether something is going to be practicable or what you have to do to find a way around the

obstructions to accessing, representing or visualising something.

My work is actually about trying to visualise experiences that are unseen and the involvement of agencies in that—which is not something that photographers get to see. Yet I can use images in a way that will re-represent these subjects and through that try to engage people to think about them in a new way.

There are projects I've given up on because I thought they couldn't be done. I was trying to do some work in Saudi Arabia, in a rehabilitation centre for ex-Jihadis and people who had been sent back from Guantanamo Bay. There's a centre there where they use a mixture of western therapy techniques blended with what I think is basic intimidation and reward—if you do what you are supposed to do and you're reformed you get a job, a car, a house and, I believe, a wife as well in some cases. I spent about a year trying to get access but eventually realised that, no matter what people said, it wasn't going to happen.

For me, contextual research is more important than practical. I rarely have full control over the practical elements of my

From
*Guantanamo:
If the Light
Goes Out.*
Camp 1,
exercise cage
© Edmund Clark

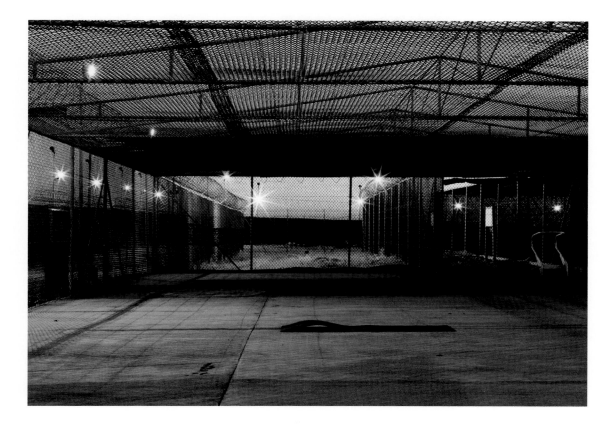

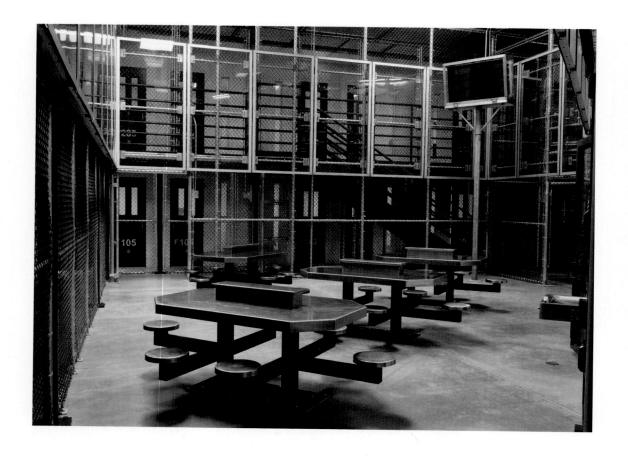

work because I am so dependent on getting access, dealing with censorship and with people allowing me to photograph or not photograph things or deleting my pictures or simply not being able to photograph something important. So my practical choices tend to be quite straightforward and a lot of what I do is shaped by the agencies I've got to deal with. I've just done a series of trips to sites around Europe, for example, including the former CIA black site in Bucharest.[2] When photographing a Romanian government building, which I know they don't want

photographed, I'm unlikely to take a large format camera on a big tripod because I know I will get stopped. So in that kind of situation I will use a camera I know I can work with quickly but will still give me the quality I want.

So, practical research is shaped by the situation but that comes after I've developed my ideas about the project conceptually and considered how the form may allow me to explore other ideas about representation. These come out of the contextual research I do in reading and

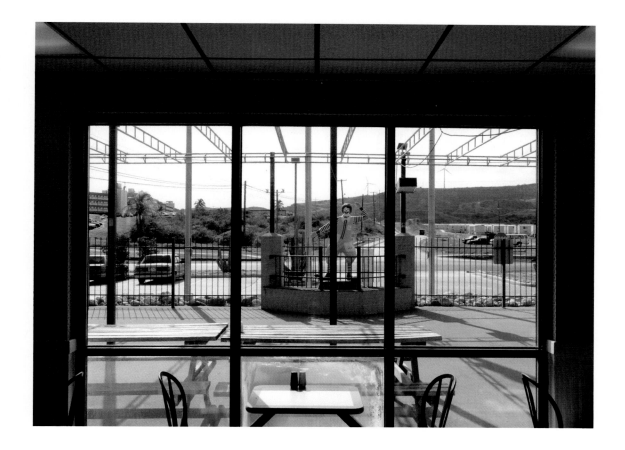

looking for documentation. I use a lot of documents in my work. How the bureaucracy of control looks is really interesting. The documents are the interface between power and the individual so how they look, how they've been presented or how they may have been redacted says so much.

My research process is a constant process of absorption. I do a lot of primary research looking at documents produced by these situations and by the subjects and individuals involved and secondary research looking at how academics, journalists and lawyers have written about them. A lot of my research is down to personal contacts. Talking to people who have been the subject of extraordinary rendition or have been held in Guantanamo Bay or living with a man who is a terrorist suspect is a key part of what I do. There may be no people in my pictures but I have directly related to the individuals who are involved. I don't interview people like a journalist would; I just spend time with them and let those relationships develop. So that aspect of personal

From Guantanamo: If the Light Goes Out. US Naval Base, McDonalds © Edmund Clark

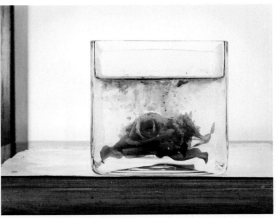

From *Guantanamo: If the Light Goes Out*. *(left)* Ex-detainee's home *(right)* Ex-detainee's home, rose suspended in solution © Edmund Clark

contact, which I would define as being part of my research, is incredibly important.

The decision to re-read Kafka came out of an essay in book of literary critique, *On Art and War and Terror* by Professor Alex Danchev.[3] I'd read Kafka a long time ago and with a different understanding. I've also looked at WG Sebald who uses photography, documents, direct memory and experience combined with a more fictional narrative. There's a relationship between the way Sebald writes and uses images and documents and putting together photographs and documents about extraordinary rendition. Extraordinary rendition is all about

obfuscation, cover-up and denial being in plain sight and this geo-political, moral event, which was the extra-legal abduction, detention and torture of people by the west. So, looking at the way a novelist like Sebald is using a range of different forms is really interesting in terms of how I think about how I am going to formulate my work.

My research is both random and comprehensive because it's just implicit to the way I'm thinking. But, when I analyse what I'm doing, there's actually something quite logical going on and, having worked as a researcher, I can recognise that I am accessing different forms of material from different sources. What's so interesting

about this, and perhaps why it's so particularly relevant to photography, is that tension between the creative act and the informed decision. The form of my creative act is deeply informed by the research I have done. For a previous project I had, for instance, researched sixteenth-century Dutch Vanitas painting in which everyday objects were imbued with symbolism representing the ephemeral nature of temporal life. Because I had looked at that type of iconography, I could then see the rose and its petrification in a vase in the UK home of an ex-detainee as an image of confinement and abuse.

The obvious definition of the creative act for a photographer is when they're looking through the viewfinder deciding what to put in the frame and when to push the shutter button. You can be working it out formally but you also kind of just know when the balance is there, when something is going to make an image that works. But the decision is related to all that research I've done before. Because you are having to work quickly you are so completely focused on what you are doing that you trust yourself to make the aesthetic judge-ment but also to make decisions based on what your brain is telling you is interesting. Sometimes you don't know at that moment why that is interesting but you just know it is. So, for example, I walked into the McDonald's on the US Naval Base at Guantanamo Bay, looked out of the window and saw a statue of Ronald McDonald in what looked like a cage. Everything about it spoke of a

sense of confinement and complicity; even this smiling and waving symbol of the American way of life was confined. Perhaps I wouldn't have seen this scene and recorded this image in this way if I hadn't researched the history of the US naval base at Guantanamo since 1898. This meant I understood it represented a small town microcosm of America and a place of confinement in its own right since, after the Cuban Revolution in 1959, it has been cut off behind a razor wire fence and, for a while, an extensive minefield.

The other aspect of a creative act is that curatorial thing when my research takes me to a primary source who has put together a paper trail of evidence. That is an act that is in some way similar to the act of taking a photograph in as much as I'm looking for something which is, in terms of its evidential purpose, interesting and important and also has a visuality to it.

The *Letters to Omar* series, which are part of the Guantanamo work, were incredibly interesting documents.[4] These are photocopies and scans of letters and messages sent to a man in Guantanamo. They've been produced by a number of different stages of intervention, redacted, stamped, archived and are images that have been created by the administrative process of Guantanamo Bay—they literally bear witness to degradation, they've been used in the control of the man they've been sent to, they've added to his paranoia and disorientation. I had

From *Guantanamo:
If the Light Goes
Out*. Fellowship
Room, US Naval
Base
© Edmund Clark

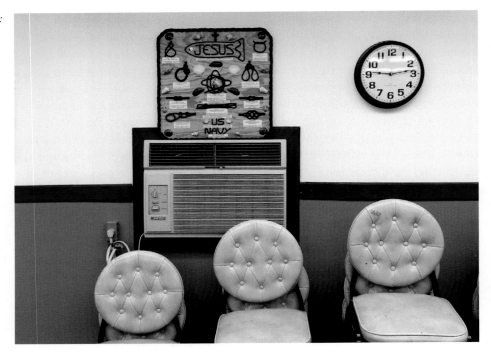

researched the Camp Delta Standard Operating Procedures, which I found through Wikileaks, which described the Behaviour Management Plan: 'The purpose of the Behaviour Management Plan is to enhance and exploit the disorientation and disorganization felt by a newly arrived detainee in the interrogation process. It concentrates on isolating the detainee and fostering dependence on his interrogator.' In the same document I came across a matrix that listed what detainees could have and how they were treated according to five levels of compliance. Omar was at the 'Intel' level, the highest level, so everything was controlled by his interrogators, including whether, and in

what form, he got any posted materials. This research directly enriched how I saw the significance of the letters and how they reflected the exercise of control and the experience of abuse at Guantanamo.

Lastly, I think it's the form. I no longer do conventional photography books, the books I do are about form. Whether it's *Control Order House*, *the Mountains of Majeed* or the rendition work *Negative Publicity: Artefacts of Extraordinary Rendition*, the form is important.[5] The object, the way in which you envisage something is shaped by censorship and control and other forces. I can never know what I'm going to have by the end of the

day so that process of reflection, refining and deciding the form is all part of the creative act.

In the case of *Guantanamo: If the Light Goes Out* the work should evoke a sense of disorientation in the mind of the viewer and this is a testimony to the disorder which was central to the techniques of disorientation of Guantanamo.[6] I aimed to do this by reconfiguring the creative potential of the images through the disjointed or disordered sequencing which mixes home, naval base and prison camps.

So I suppose what I do is a number of things—my research is constant and ongoing and feeds into a series of creative acts at different stages which take different forms right through from when I may first use a camera or choose a document to how something may look on a wall or in a book in five or six years time. They are all different stages of a creative act that are directly related to an ongoing absorption of information and ideas.

I came to photography late. I studied history not photography so, whereas some of the students I work with now have been

From *Guantanamo: If the Light Goes Out*. Officers' Mess, Tiki Bar, US Naval Base
© Edmund Clark

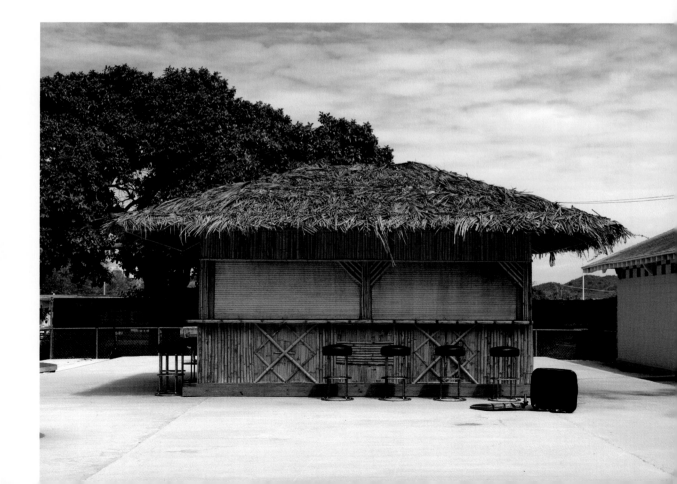

through a process of learning cultural and critical theory, I never had that and in some ways I am quite envious of them. It's a difficult one because I do come across work that is so critically driven that it is gasping for a life and so dry that it doesn't engage at all. But at the same time I think that an awareness of where your work stands in relation to theory is really useful because it helps you understand what you are doing and put yourself in relation to the canon of work which has gone before and to what people are doing now. Researching that kind of material—whether it's reading Foucault or talking to Professor Eyal Weizman of Goldsmiths, London University, who led me to reading Derrida, about the work he's done on the visualisation involved in the forensic process and how that relates to ideas of aesthetics and art and the visual imagination—is a really useful way of feeding yourself with ideas that lead you to question and redefine what you are doing.

I think collaboration is important in evaluating the work. I've built up a group of people who I use as reference points. They are people whose opinion I trust, whether that's the relationship I have with a designer or editor—there have been a number of cases when they have really brought something to my work—but also if I'm trying to explore an idea then being able to ask what someone else thinks and if they think I've got it right, that's a form of research as well.

You always feel vulnerable when showing people unfinished work. But the creative act is a vulnerable act, you are exposing yourself. It's also vain at some level we are all seeking affirmation for what we've done and that's no different from being a singer, a writer, an actor. And you want it to be seen, you want it to be covered, to be engaged with so you feel vulnerable. But I am more confident about showing people work in progress than I would have been 15 years ago.

I don't make a formal record of my work in progress. Digitisation has materially changed a lot of that, whereas before I might have been working with contact sheets, putting stuff in scrapbooks and writing notes the editing software is kind of replacing a lot of that materiality. The way you organise your files on a computer is a form of record, it records the date that every folder was created or image modified. That's a kind of log should anyone decide to research it when I'm long gone.

What I do have is a box, which is partly a memory box, for each project into which stuff will go. Films and contact sheets, some bits of reading, objects like someone's hat or something someone has given me and magazine features will go in there so it's kind of creating a project archive but I'm not logging the research process as such. Certainly my bookshelves are a kind of log, a testament to areas of interest and research.

My aim as an artist is not to dictate opinion but to raise questions, to try to engage audiences and create space for them for

reflection. I have to find a balance between explaining too much or too little. There are different audiences relating to different contexts, media and platforms. I try to present work accordingly. It is a balance between what I think is right and new or different in the way I want to explore a subject and considering how best to engage an audience with the subject matter.

Audience feedback is really important. When you let the work go and other people take control of it is, in some ways, the most liberating part of the process. That is when I have a sense of ownership about what I've done even though I'm letting it go and letting something have a life of its own. There are occasions when people say things about my work and I realise I hadn't thought of that and that's really exciting.

The way you talk and think about the work always changes and the way other people talk about it evolves and can impact on what I say. The way people are reacting to the work I did on Guantanamo Bay now is different to the way they reacted six months ago because we have heard so much more about that subject. I would definitely take an image out of an exhibition or change the order in response to feedback. I find exhibiting exciting because each time I'm invited to show the work reacts to the space, to the curator, to the gallery. It's part of the fun.

There has to be a demarcation at the end of a project and that can be a difficult time

psychologically because you've invested so much in something. But I revisit projects when I get asked to show them, and this body of work is kind of building, so when I come to exhibit the work on extraordinary rendition that will change how I revisit Guantanamo. It will be really exciting. I'm now in discussion with two museums about exhibiting several of my projects together as a body of work on one theme.

Of course, chance plays a role in this. But that's like life—chance encounters, chance discovery, opportunity dropping your way to go with the foundation of work and research.

There is an overlap between researching different projects because, hopefully, I'll have more than one project on the go. I put projects on hold for years because I know there's something I still need to find out. There's a multimedia piece about Pakistan and Afghanistan, I have visual and audio material from people I've met in Pakistan and from the internet and academic documents written by military people about ideas of ethics in war. The central core of this is about honour and sacrifice in warfare, which is a shared concept across many different cultures. In a way *The Mountains of Majeed* is about trying to create equivalence between an Afghan and a western point of view. This new body of work is the same, it comes from a line from an ode by Horace, 'dulce et decorum est pro patria mori' (it's a sweet and honourable thing to die for one's country), which was immortalised by

From
Guantanamo:
If the Light
Goes Out.
Camp 1,
isolation unit
© Edmund Clark

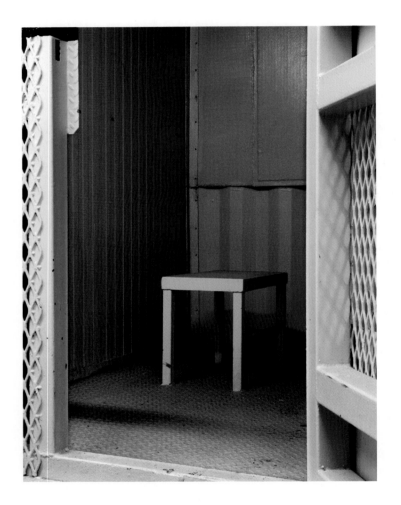

Wilfred Owen in the First World War when he used it for the title of a poem about gas attack. Today you'll find it on the memorial arch in the Arlington National Cemetery in America. I worked with two poets in Peshawar to write a Pashto version of this poem. It's a really interesting project, all based on research, but it's been sitting there for about two years—it's about finding the right form. I've just been asked to develop it for an exhibition in Dubai later this year and I need to find a multimedia expert who can understand what I'm trying to do and help visualise it. I can't work out how to make it work.

I think I need to spend more time on my practical research because conceptually I've kind of reached a point in photography. I need to explore and research other forms and skills, other techniques and beyond photography. I use both film and digital but I've never used camera-less techniques—except I did try making photograms from a computer screen for the rendition work. It was technically too difficult because you couldn't control the light. There are now things that are beyond any one person, like really good multimedia work, which would use people with experience in film and sound to augment what I am trying to explore.

The other aspect of research is the slightly prosaic stuff of getting your work out there, partly through that gradual process of developing a network of contacts but also thinking about who might be interested in your work, who might be the people to talk to, which galleries, which museums might be interested, that's all part of research. It's a Sisyphean task, as you go up you are always looking at people who have been working longer and you always think they're established, they've done it. They probably don't feel that. At what point is there a critical mass of awareness which starts to self-perpetuate without you having to do anything yourself?

Interview by Shirley Read

Notes

1 *Control Order House* (Here Press, London, 2013) is available from www.herepress.org/publications.

2 A black site is a military term for a location at which an unacknowledged black project is conducted. It has been used to describe the secret detention centres operated by the CIA in the War on Terror.

3 Alex Danchev (2009). *On Art and War and Terror*. Edinburgh: Edinburgh University Press.

4 *Guantanamo: If the Light Goes Out* (Dewi Lewis Publishing, Stockport, 2010) is available from www.dewilewispublishing.com.

5 *Control Order House* (Here Press, London, 2013, 2016) and *the Mountains of Majeed* (Here Press, London, 2014) are available from www.herepress.org/publications. *Negative Publicity: Artefacts of Extraordinary Rendition* (Aperture/Magnum Foundation, New York, 2016) is available from www.aperture.org

6 *Guantanamo: If the Light Goes Out* (Dewi Lewis Publishing, Stockport, 2010) is available from www.dewilewispublishing.com.

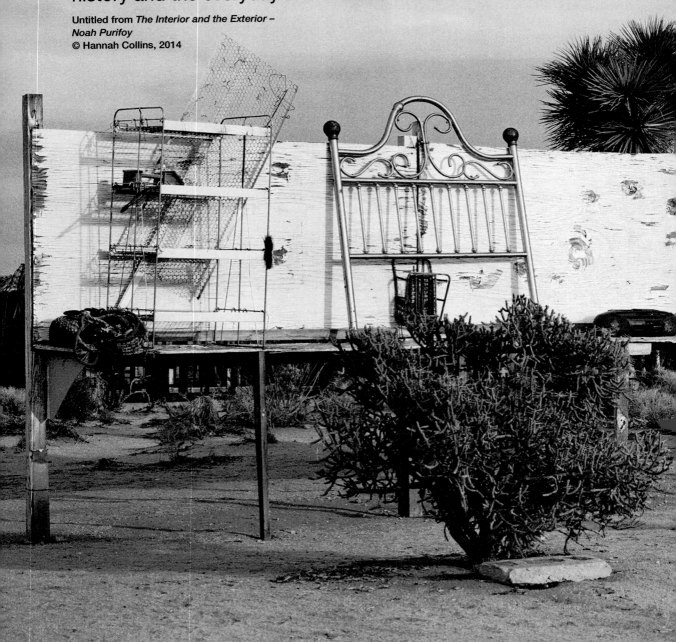

Hannah Collins

Hannah Collins is an artist and filmmaker whose work engages with the collective experience of memory, history and the everyday in the modern world.

Untitled from *The Interior and the Exterior –
Noah Purifoy*
© Hannah Collins, 2014

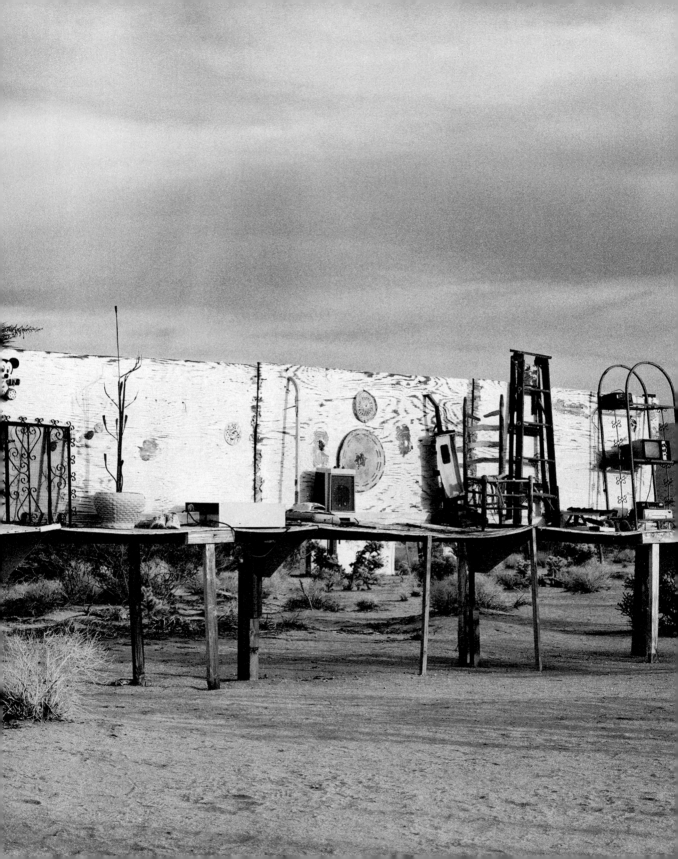

RESEARCH IS NOT ONE constant thing for me; it morphs into different things at different times and on different projects. I think that my work starts from an initial feeling about a subject or about what might be expressed through a project and in the process of developing it the research becomes the project. But for this to happen the research needs to be there in the first place. So I would say that, for me, research and the final output are very intertwined but I'm sure that would be true for everybody.

I think it works better when it's something that expands and develops rather than an idea that is complete and just needs to be executed. Phase one tends to be a very general interest in something, which starts me thinking about it. It's sometimes ten years before I do anything about it. Phase two is intensively wanting to know more and trying to find the information, then working out what to do if I can't find it. Phase three is putting the interest and research into some sort of action.

A key thing to researching is also that it's a very different world to the one before the internet existed. Everyone has access to so much information yet I don't know if it fundamentally alters what art looks like because nothing replaces on the spot research.

I saw the Purifoy sculptures outside Joshua Tree in the Mojave desert in California[1] and responded to them because they made me ask questions.

The first point of research is really the asking of the question. My question was how could somebody make all these things in this inhospitable desert place? What were the circumstances of his life? I thought that you couldn't look at this work without understanding something of the circumstances in which it was made.

What I saw in the desert was a vast field of big architectural sculptures made out of recycled and thrown-away materials, all relating both to the desert and to the city and a series of historical events I knew nothing about. They are shelters, shacks, meals, hanging places, graveyards, chains, ships—I could immediately think of one of the sculptures as something to do with lynching or as the ghosts of soldiers, but I couldn't presume anything.

The works are kind of quite witty comments and also refer to contemporary art in a very knowledgeable way. What I wanted to do was to unpick what I was looking at and re-express it and thought I could do some photographs that would be an act of clarification in looking at these sculptures. So it was partly an exploration of what it meant for Purifoy to come from Alabama to the west coast and what the situation was in the years before and after the Watts rebellion in Los Angeles in 1965. It was also about what you could become if you were an artist and an activist and what then happened to you. In a way my work is incredibly ambitious because it's trying to describe a whole period of time and another artist's work.

facing page:
Untitled, from:
The Interior and the Exterior – Noah Purifoy, 2014 silver gelatin print selenium toned
© Hannah Collins

Untitled, from:
The Interior and the Exterior – Noah Purifoy, 2014 silver gelatin print selenium toned © Hannah Collins

I stayed at the site for a weekend and made photographs of the sculpture on a 5 × 4 camera. This, in itself, was research because I was staying in the desert where Purifoy lived and I understood a lot of things by being there, like what the time of day did in terms of space and sound and light and the kind of thoughts you might have if you were there over a period of time. The way you could see the sculptures changed massively over 24 hours so at night they sort of floated then,

as day came, they sort of sank down. So one half of the work was purely visual and my own exploration and photographs.

Then there's a soundtrack. As part of my research I found people who knew Noah Purifoy and interviewed them over a period of two weeks. I think I wouldn't have been able to make the work without learning from them. They are African Americans who had all been politically active in the 1950s and 1960s and are

now very old. They tell the story of some of the issues of the period of the Watts Rebellion in Los Angeles in 1965 and around civil rights at that time and afterwards. Each of them had a different perspective on it and told me very different things. From that the interviews became a choreographed version, a soundtrack that went with the photographs. From the first to the last interview was a massive progression just in terms of knowledge and that knowledge, in a way, is the work.

So, the aim of the work was to activate this site and to make you ask questions not only about Purifoy's work but also about ideas of what is ethical and what are the issues about making art and being an artist. The questions I was asking are still there at the end and you are surrounded by my research into those questions.

I hope that you, as a viewer seeing the work, will be somewhere in a sort of no man's land between the hearing and the seeing and so be forced to take on a very active and creative role which makes you almost like the artist.

The research consolidated my ideas and also shifted the work because I began with a feeling about something and, as I slowly gathered knowledge, my feeling changed a lot. It made me think a lot about my intentions, partly because I had to think about Purifoy's intentions but also because it made visible the differences between my work about Purifoy and the work I was doing, and am still doing, in the Amazon.

With the Amazon work I stayed with the Cofan tribe in Colombia and looked at the plants that they use to cure their bodies. This was just after having cancer. So, in one sense it was for my own personal reasons, which were, I think, to do with being surrounded by machines and thinking about other ways one might be cured or other ways the world might be in relation to one's body. So I went to a place where there were no machines and no other options, you had to use nature.

But the research results were not very clear. This is because they were simply about what each plant was used for. It did show me the immense richness of the tribe's understanding of their surroundings but it wasn't very easy to feed it into work, whereas when the research is already within art, as it was with Purifoy, it sort of became more refined. Using something that is nature didn't do the same thing at all, the core of it became more diverse and difficult to pin down the more knowledge I got.

Because Purifoy's work was within art from the very beginning it strengthened the core of what I did. Whereas it's been a more extended process to become clear about the Amazon project because it involved my going a long way from contemporary culture and the gap engulfed me at times. This made it a powerful task to reconnect the work I am doing on the Amazon with the present state of art or culture to find the contribution it might make.

Untitled, from:
The Interior and the Exterior – Noah Purifoy, 2014 silver gelatin print selenium toned
© Hannah Collins

One of the questions in showing the work is whether to show what the plants are used for. The shaman of the tribe I stayed with took me around and showed me plants that were used for different things. I took pictures of them, sort of directed by him, and we talked as we went about how the plants were used—for headaches, for skin problems, for prostate, for abortions and for other purposes. But do you gain anything knowing what these plants are used for? In reality, in terms of the work, I don't think you do. The work is, in the end, a contemplation of lost knowledge. So there was a huge amount of research—with drawings, labels, names, origins and discussions—which is completely invisible in the final work.

It's an interesting opposite to the Purifoy work where the research work is visible and part of the final work. The extent of the research in the Amazon project is a hidden process—I always doubted it would strengthen the work for the audience to know what I knew. It exists only as a curatorial label, the curator writes about the process but you don't see it in the final work at all. I ended up liking the gap between intention and result. It means that one's access to the artistic process is limited to what is useful

In the case of the Purifoy work I had a huge amount of difficulty in starting because of my colour. I was a white person doing work about an African American and that in itself was problematic. I employed an African American researcher initially, which was the right thing to do politically, but I then realised that, by putting a researcher between me and the people who had known Purifoy, they missed my voice. In the end I just rang the huge list of people and talked to them and, because I knew exactly why I was doing the work, I could talk to them clearly about it. I think that it worked because I came from an entirely different background, had a lot of empathy for Purifoy's work and was just trying to learn from them and not trying to impose anything on it. Also, simply by my being sincere because I really wanted to do the work.

In each situation I make sure there's a representative from the people I'm working with who mediates my intentions and practice. When I worked on La Mina, with a gypsy community in Spain, one of the gypsy leaders worked closely with me and in the Amazon I was under the control of the shaman. I used that method for La Mina and it worked then and it's always going to be my approach now. That work was about putting the gypsies in the foreground and, in a way, in order to do that, I had to take a background role. So, even though I was still there and aware, I was trying not to be present in order for the material itself to become more powerful.

I give practical and technical research a lot of attention. For instance, with the Purifoy work I started out with a sound guy who had mixed sound for me before. I could trust him but he thought we should carry out all the interviews in a completely controlled environment, which I knew wasn't possible because, with people who are 80 or 90, I could not move them to a studio. I had to be able to get to the interviewees when they felt well enough to talk so I learned to use good sound equipment. I really worked at doing it well and then, when it came to mixing it, I worked incredibly hard to control the environment. At the point where it's technical I try to be absolutely precise about it.

For instance, for the Purifoy pictures I took the biggest format camera I could and controlled every aspect as much as was possible. But I'm also often dealing with uncontrollable things. I mean, taking a camera to the Amazon, and trying to

Both: Untitled, from: *The Fertile Forest 2013–2015*
© Hannah Collins

take accurate pictures of plants, is the maddest thing to do because it's a very alien environment and is aggressive, damp and hot; you can't control it and no film camera is going to like that. It's asking for trouble, really.

I sometimes slip up because I don't have the right equipment but I accept the limitation. I quite like things not being perfect. While the intention and route need to be precise, often excluding many possible branches along the way, the carrying out of something is fluid and uncensored so the actual practice of making something has nothing to do with it being perfect. I work with film and you are taking a risk with film, always, because of temperature and putting it through machines. In the 1980s and 1990s you had control and now you don't because less is manufactured, there are fewer choice of types of film, what you get might be older. I quite like it. If I run out of colour film I use black and white. But I think there are very good reasons for using film. The quality is better, or at least I find it more sensitive, and you can't take as many pictures so you have to make more choices. It's an act rather than being a reaction.

I think it's a lot to do with how much time you give things because I know that if I haven't done research the one thing that would absolutely panic me would be if I then don't have time—which happens because nobody but you understands how long it takes to make images. People expect you to be quick.

I'm bad at keeping records, though I did it with the interviews I did in California and I've got much better at filing negatives. Although I do keep records they are a bit patchy because they reflect my interests at that time, not my interest in my own history. I've never had the idea of a career that is progressive and for which you therefore need to make a record of the progression. I think it's a bit of a male idea of a career, actually. I have been driven by the momentum of the work itself and less by external opinion though, of course, I take it into account.

I pay attention to the challenges and questions of each piece while drawing on previous experience but the final work and the research become one at the finishing of a piece so I find I cannot evaluate either separately. I think I'm quite unwilling to evaluate a finished piece. I wish I did want to. It's the bit that is difficult to judge and is, I suppose, judged by other people. Quite often, I think I don't understand what I have done, even though I'd like to think I knew what I wanted and achieved it. But, in practice, if it's worth something it has often gone beyond what you initially understood it to be because it's gelled in a different way, and the pieces where you understood every element are the lesser pieces, because the process itself is alchemy in some way and can take you to unexpected places.

Sometimes, I'm horrified by things I've done. I always wish they were more which is very irritating because you should always think that, if you can get near your

purpose in making the work, then that's it, you've done it. Some pieces are much more successful than others. Some things don't have a life when they're made then have a life years later so the external, showing, life isn't necessarily when you think it's going to be. La Mina, my film about Spain and about Spanish gypsies, which I think is the best thing I've ever done, has barely been shown and never bought by anyone in Spain. When it is shown it gets a massive audience and that's sort of ignored. It's never had a decent piece of criticism in Spain. So I think it's hard to work out where you stand in relationship to a piece of work sometimes.

The people who worked on La Mina are deeply loyal to the film; they write to me, they talk to me; they think about it and want it for different events. This is not particularly true of my other work so what does that say about it as a work? I think it says the film is talking about something a lot of people don't particularly want to talk about or see. It doesn't really speak about whether it's got any value or not because it certainly had value for the people making it, and for me. I think La Mina will always be ignored because, for the Spanish, the gypsy population is the most peripheral population in Spain and is a difficult proposition. So to make a work entirely centred on that was madness really. I had huge ambitions for the work. I really wanted something that would allow this population to be visible in a good way. I was also an outsider, so I was perhaps

equipped to make the work, because I wasn't a Spaniard even though I'd lived there for 20 years. On the other hand, I realise now that I wasn't entirely in tune with what the culture would allow me to do in Spain and it was just one step too far.

I chose to work with the gypsies because I identified with that population and was interested in its cultural place and the fact that it was so invisible. The task of making a whole culture that has a very limited visibility explicit, visible, poetic and central was a really interesting task. I think I failed, although the very existence of the film is a success but real success would have been if it had had a real audience and real discussion.

To what extent does research complement or enhance intuitive thinking? I start with intuition then order takes over then intuition comes in again at the end. So, for instance, I went to photograph Mandela's birthplace and that was done on intuition. I was trying to find a place to work in Africa that would counterbalance a work I'd made about African migrants in Europe so I wanted to go to Africa, even though my experience was as a transitory visitor not that of a migrant. So I went to where Mandela was born, which has a site devoted to it, and that was done on instinct because I thought I would encounter something interesting. But, in reality, order had to take over because it turned out to be fairly difficult to do because of where it was—it was in the Transkei, in Mvezo,

all sorts of reasons made it difficult to go there on my own and I couldn't get any help there either.

Then once I had sorted these things out I could become intuitive again—so intuition is usually at the beginning and end I think. So, for instance, the work about the Amazon began with an intuition, order took over because I had to find the tribe and the place, to look after the equipment and the information gathered. Then at the end when I'd done all that I had space to work with what I'd done and make it into something in the editorial or curatorial stage. But there can be a sort of battle between research and intuition because the minute you have research and knowledge it sort of pushes your intuition aside. I've always had a battle between what I know and what I feel and they tell me different things, which can be difficult.

Interview by Shirley Read

Note

1 Noah Purifoy (1917–2004) was born in Alabama and spent most of his life in California. He was founding director of the Watts Towers Art Center. He was a sculptor who worked with found objects and saw art as a tool for social change. He lived in the Mojave Desert for the last years of his life where he created 10 acres of architectural sculptures, which is described as 'one of California's great art historical wonders'.

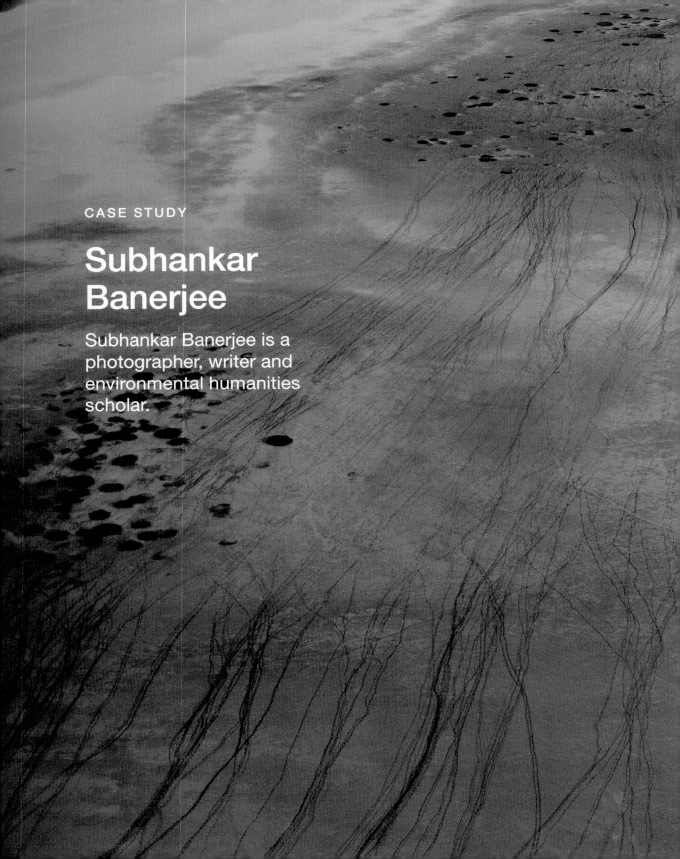

Subhankar Banerjee

Subhankar Banerjee is a photographer, writer and environmental humanities scholar.

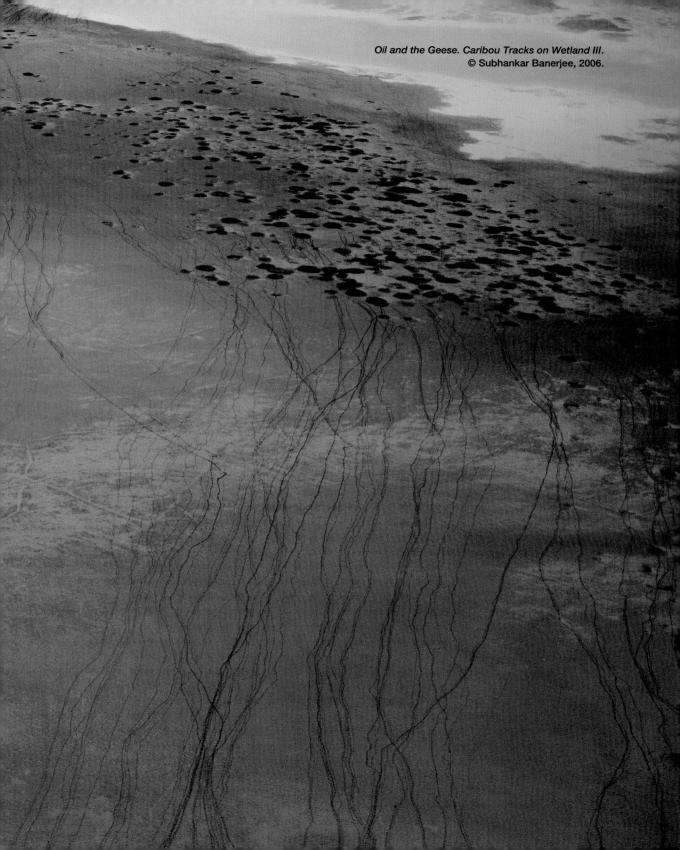

Oil and the Geese. Caribou Tracks on Wetland III.
© Subhankar Banerjee, 2006.

FOR THE LAST DECADE OR SO, I have led a dual life. One part of me has been a photographer and the other part an independent environmental humanities scholar, so research is fundamental to many of the things that I do. I think of photography and research in very specific ways, but for me they are inseparable. One of the key components of my research process is the literature review (books, journals and online resources).

But equally important in the research process is fieldwork. For example, conversing with indigenous peoples, scientists and conservationists is crucial, as from this I begin to unravel the complexities and multiple perspectives within my subject. All of these things are part of my research, and are different from the way I work with photography, which is a much more informal and intuitive process.

Caribou Hunter – Jimmy John. Gwich'in and the Caribou. Photography by Subhankar Banerjee, 2007.

For many artists, there is an idea in the beginning, and this dominates almost everything; but for me it is different. If you think about it as a contrast, an example would be Hiroshi Sugimoto. Sugimoto, for each of his well-known series, articulated an idea in the beginning, and the idea then provided the conceptual basis for many years of photography. But philosophically speaking I cannot have an idea at the start of a project; all I can have is a desire. In the Arctic, it was a kind of a romantic wish to live in a land untrammelled by tourism or industry. After the initial desire I begin to engage, and then the practice of photography and the research become like a DNA strand, the two co-evolve. And through that co-evolution process ideas emerge and only then can I begin to articulate the different strategies needed to explore and shape the ideas as they develop and mature. Let me give you some specific examples of how that has worked out.

The first time I went to the Arctic was in late 2000. It was a small preliminary trip before the project began in earnest the following year, where I spent seven months in the field. And what I did during that time was frantically point my lens at everything, documenting what I could. When I came back, I realised that it was a futile attempt to try to *document* the Arctic for various reasons. The biodiversity is complex, the land is vast and there are multiple indigenous cultures, and documentation of all of that was not what I had gone there for. So I had to come up with a certain set of strategies related to

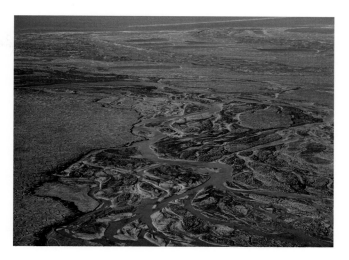

Hulahula-Okpilak Delta I. Oil and the Caribou.
Photography by Subhankar Banerjee, 2002.

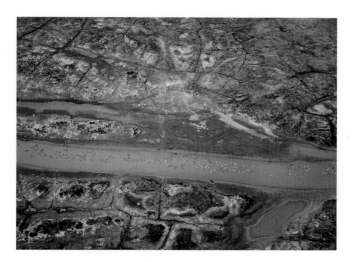

Brant and Snow Geese with Chicks. Oil and the Geese.
Photography by Subhankar Banerjee, 2006.

what it was that I wanted to achieve, and how I wanted to communicate this through my photographs, now that I had the desire and the actual fieldwork had started. The research then began on many different

fronts and I came up with a set of motifs, which would help to guide what I wanted to do.

From the research that had already started I asked a rather basic question: How do we perceive the far North? And the answer was primarily through the way that the pro-oil-development politicians have articulated it — 'as a frozen or barren wasteland', or a 'flat white nothingness', and also how the Arctic is depicted in popular culture — 'as a land of snow and ice.' In fact *60 Minutes*, which is a popular news magazine TV programme in the United States, referred to it as a 'hostile wasteland'. I realised perhaps that colour is a visual language through which we can unlearn some of these intolerances. So colour became my primary motif, not a medium (as colour has always been my medium), but colour as a way of understanding the environment.

I began asking very simple questions such as: Can I make work with white only, white and brown, white and blue or white and grey? The reason that I say this is because in the second year when I returned to the Arctic, I was consciously thinking these things. I had a sense, from being in the landscape, that this was possible. There were also aspects of minimalism or modernism coming in, which seemed appropriate as the colour that can be found in the Arctic has a restrained presence in a rather vast space. Like any other environment many different colours exist in the Arctic in all seasons, and with colour, we can create a language of justice

or a language of how we really think, feel and talk about the North. The fact of being there alerted my mind to the possibilities, which I think is a really important aspect of fieldwork. But to become alert you sometimes have to make pictures in order to find out what you don't want to do.

In the early years when I would be teaching a class, maybe giving an illustrated lecture for example, one question I would often get asked was: "What books did I carry out in the field?" And my response was always the same. When I am out in the field I have absolutely no books of any kind with me, and in a way it is like having a Jekyll and Hyde personality. When I am back home I am doing nothing but immersing myself in the literature, and when I am out in the field I am completely removed from that because I want my senses to be responsive to what I am *seeing* rather than responding to a set of preconceived notions that I might impose on them. Being in a particular place for months and months, I become attuned to the possibilities of seeing.

But there are times when the reverse happens, a situation that actually became the corpus of my latest book, *Arctic Voices: Resistance at the Tipping Point*.[1] This was essentially a very simple photograph that I had taken in the second year I was out there. It was of a Gwich'in indigenous hunter[2] on the land of one of the watchtowers. It was one amongst several other photographs of a hunting camp in the Arctic National Wildlife Refuge (NWR), near Arctic Village. On seeing the

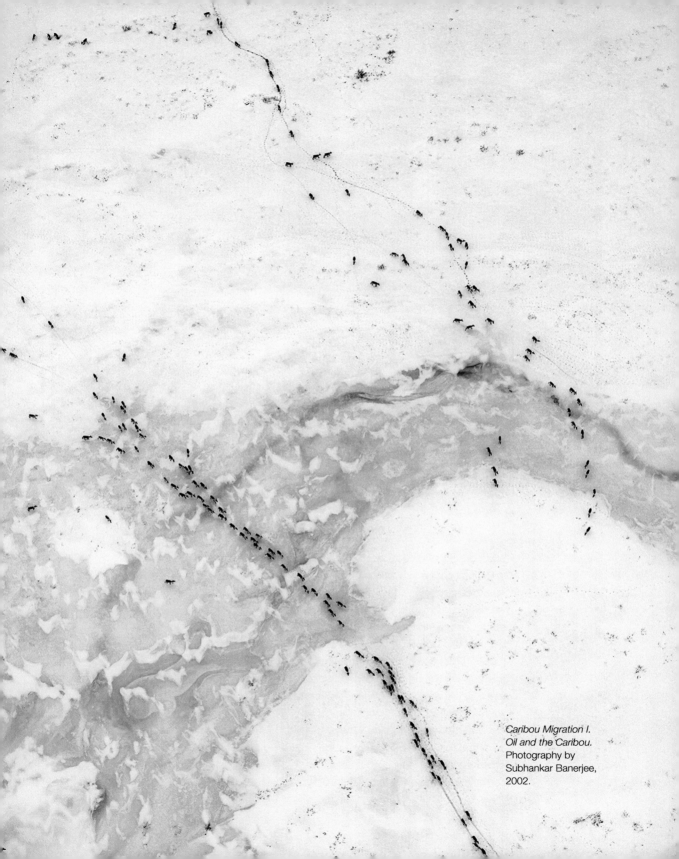

Caribou Migration I.
Oil and the Caribou.
Photography by
Subhankar Banerjee,
2002.

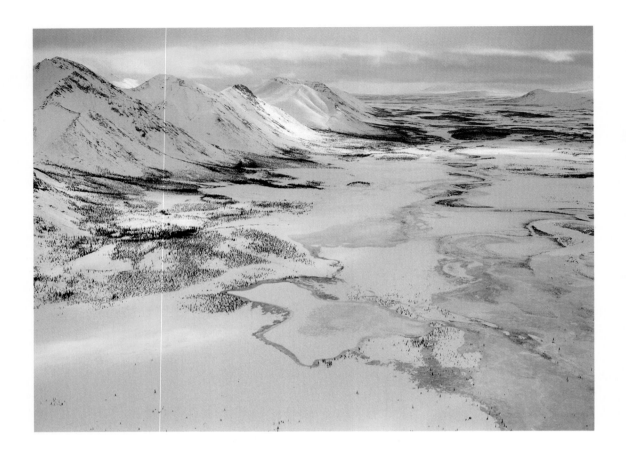

Sheenjek River II:
A Gwich'in
Homeland. Oil and
the Caribou.
Photograph by
Subhankar
Banerjee, 2002.

photograph, one dedicated young environmentalist asked me a question: How could there be a hunting camp in a wildlife refuge? So, a photograph raised that question, and it caught me off guard because I had not really thought about it myself. I had taken it for granted that these things are there and I am photographing them. But that question led me on to many years of research into environmental history in America, and what came out from that was the sheer scale of the injustice done to Native Americans. And sometimes what environmental history has

missed I have tried to retrieve by going into art history. A lot of my current research is at the intersection of those two perspectives.

To give you an example of how that works, I am conscious when I come back to the photographs that I begin to question the difficulties people might have in seeing certain images. In 2009 when I was the Artist-in-Residence at Dartmouth College, I presented a large Caribou migration photograph, with four small caribou harvest photographs and there were three

points of tension I was seeking to discuss with the juxtaposition: emotive response, scale and viewing distance, and environmental conservation. I have noticed that many viewers are attracted to the caribou migration photograph but repulsed by the harvest images in which blood is visible. Our modern cultures have got used to purchasing meat neatly packaged in plastic that seeing blood in meat has become disturbing for many people. The suite of caribou harvest photographs is addressing a historical problem and is an attempt to decolonise American environmentalism. It is also addressing a philosophical problem and is an attempt to recognise where our food comes from. The next point of tension is scale—to see the large caribou migration photograph we pull back, but to see the small harvest photographs we draw near. And, finally, environmental conservation as we feel compelled to protect the caribou and its habitat as wilderness that is untouched by humans. But humans have lived and depended on that caribou and the very same wilderness for many millennia and have established an ecospiritual[3]

At the Corral – Nikolayev Matvey Gathering Reindeer. Even and the Climate. Photograph by Subhankar Banerjee, 2007.

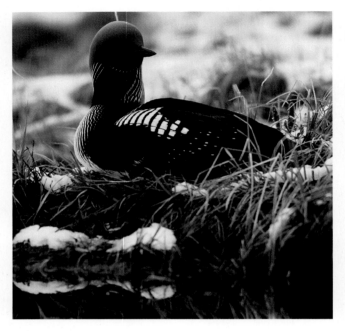

Loon Nest. Oil and Caribou.
Photography by Subhankar Banerjee, 2002.

about what the loon does. What ended up happening was that I photographed the pair of birds (both parents share nesting duties) for almost two weeks—nothing but the loon on the nest rotating its head, through varieties of weather conditions that included clear days as well as days when snow fell on the tundra. The corpus of about 30 photographs became about survival. And that would not have been possible unless I was open to the idea that something entirely new could emerge. Then, of course, it led into research about the loon, and I came to know that loons are among the oldest surviving species on earth having been around for about 20 million years, but it was the engagement that led to that whole process.

What has happened is that my work has become gradually progressive, developing in stages over time. From the Arctic project, which required a huge amount of equipment and a lot of travel (including aerial photography with a large ecological footprint), to the *Desert* work where I was geographically bounded, working in an area literally within a five-mile radius of my house in New Mexico with a small amount of kit in a daypack. Walking around for a couple of hours and coming back to eat lunch and going out once again, with no particular schedule. Photography for me has become a philosophical engagement, because I myself am evolving and it is photography that is ensuring that process and forcing me to think differently.

relationship with the caribou. But that juxtaposition would not have been possible had I not gone into the research, but I would not have gone into the research unless the watchtower photograph had raised a question. So that is what I mean when I say it is like a DNA strand, the two processes are interlocked.

Another case of how fieldwork has contributed to my research in a significant way occurred when I was out on the Arctic tundra. I was observing a Pacific loon on a nest by a lakeshore. Nothing particularly significant, and I could have simply photographed the natural history of it. But for some reason I was very immersed and alone at that time and became curious

However, to think differently is almost reaching towards a particular set of values

with how I engage with the world—the idea of simplifying and slowing down. In the desert I was forced to slow down and look closely. Things that are far away are often considered exotic and rather easy to see, while things that are near and familiar are very hard to see because we take them for granted. My little five-mile area became an ecological paradise not unlike the Arctic. Even though visually photographs from the two series look entirely different the underlying themes are the same. I was actually doing the same thing in the desert that I did in the Arctic— building a social-ecological story of a particular place that has connections to global processes.

The research process seen through the various stages of individual development is really about what we learn and re-apply or re-shape, so it's not just specific to one thing in that sense, there is an evolution. With each project every artist has their own specific set of ideas and requirements, but across projects there is also an evolution that one goes through. In some of my lectures I have talked about art as knowledge, and for me that is really fundamental. That art or the interpretation of art can lead to a particular kind of knowledge that otherwise would not exist. Creating photographs is about extending my own knowledge and understanding of the subject, which raises

Caribou Skeleton. Oil and the Caribou. Photography by Subhankar Banerjee, 2006.

Caribou Hunt – Joe Tetlichi, Jamie and Shane. Oil and the Caribou.
Photography by Subhankar Banerjee, 2006.

Beluga Whales with Calves. Oil and the Whales.
Photograph by Subhankar Banerjee, 2006.

questions of what and why am I doing what I am doing. Information can come from anywhere, from the scientific, the historic, the philosophic or even the vernacular. It is all about how we interpret that knowledge and how our interpretations are then translated into new understandings through the work we make.

The kind of knowledge that we may arrive at through the creation and interpretation of art is different from the kind of knowledge that is achieved through science. In science consistency within a particular theory is paramount, whereas in art and humanities the conflicts or contradictions within a particular space, ecological or social, can be important and this is about keeping an open mind. Art and humanities can hold those contradictions in place, as often these cannot be resolved anyway. In both of my engagements, with the Arctic and the desert, I came to realise that contradictions exist. If we ask a simple question—'What do you think of the Arctic National Wildlife Refuge?'—we might potentially get the following answers. 'It's home. To us it's home,' says Robert Thompson who is an Iñupiaq[4] and lives in the Arctic. 'It's a beautiful landscape,' says the tourist. 'It's a pristine wilderness untouched by man,' says the conservationist. 'It's a frozen wasteland,' says the politician. 'It's a nursery. This is where I was born,' a bear or a caribou would say if they had a voice. They are all talking about the same piece of land.

I would have never imagined that my desert work would also highlight conflict in our imaginations. If we ask a simple question about a desert plant—'What do you think of a cholla?'—we might potentially get the following answers. 'I love the scarlet bloom on the chollas,' says an Eldorado resident, where I lived and photograph. 'It is a plant of the disturbed Earth' or 'it is a key indicator species of Native American habitation,' says an anthropologist. 'I removed them all from my thirty thousand acre ranch as they compete with grass,' says a rancher. 'Chollas have been our food for ten thousand years. A few buds have more calcium than a glass of milk,' says a native Puebloan in New Mexico or a native Tohono O'odham in Arizona. 'It's a nursery. This is where I was born,' a bird would say if it had a voice. These contradictions inform my photography, which in turn may lead to a potentially different knowledge and appreciation for the landscape and its ecology.

I think that this kind of engagement and questioning sets arts practice apart from other types of research in that we are more open, more inclined to accept intuition and chance as valuable and important aspects of the creative process in the way we work. And there is something about the creative process and a visual language that provides a certain kind of freedom or emancipates us from the stricter confines or boundaries of other disciplines. For example, one of my

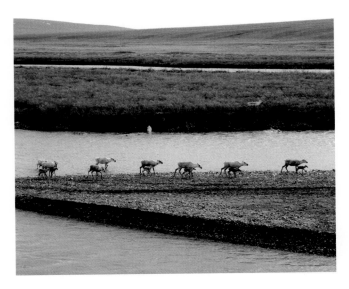

Caribou and Calves Crossing the Kokolik River. Coal and the Caribou.
Photograph by Subhankar Banerjee, 2006.

Known and Unknown Tracks. Oil and the Geese.
Photograph by Subhankar Banerjee, 2006.

much-exhibited works is the *Caribou Migration*. This particular photograph grew out of a close working relationship with a biologist who had studied this particular caribou herd for decades, and who told me a number of interesting and relevant facts, and encouraged me to take photographs of the herd. But when it was exhibited in 2014 at the Tufts University Art Gallery, an art critic for the *Boston Globe* reviewed the show giving a religious interpretation, which was not my intention.

So the visual language opens doors for people to decide, and we have no control of what they might think. We have our own intentions but ultimately we cannot know where it will lead.

This, for me, is a really interesting part of the creative process, and one that still remains under the umbrella of research because once you create something it's not an end but the beginning of something else. As one process finishes

Flaring at Prudhoe Bay.
Photograph by Subhankar Banerjee, 2002.

the work then has its own journey. As we progress we also reflect and when we reflect we may see things differently to when we first engaged in the research or the making of a particular body of work. And if we speak or write about our work we might connect things that previously we hadn't seen or realised at the time, and this is a fascinating thing because curiosity is the hallmark of all research.

Interview by Mike Simmons

Notes

1 Subhankar Banerjee (2012). *Arctic Voices: Resistance at the Tipping Point.* New York: Seven Stories Press.

2 Gwich'in are the indigenous peoples of the Northwest and Yukon Territory of Canada, and also of northern Alaska. See the *Gwich'in International Council* at www.gwichin.org/gwichin.html for further information.

3 For further information see: The Ecospirituality Foundation at www.eco-spirituality.org/menu-e.htm.

4 The Iñupiaq are Alaskan indigenous peoples. For further information visit the: Alaska Native Knowledge Network at http://ankn.uaf.edu/ANCR/Values/Inupiaq.html.

Beluga Whale Hunt. Iñupiat and the Whales.
Photograph by Subhankar Banerjee, 2002.

Grace Lau

Grace Lau is a
photographer working on
the uses of photographs
of the Chinese in the west.

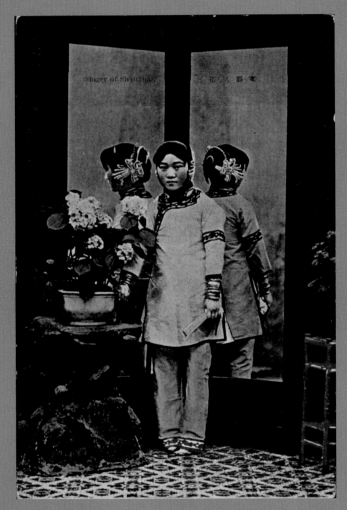

From the postcard collection of Grace Lau
© Grace Lau

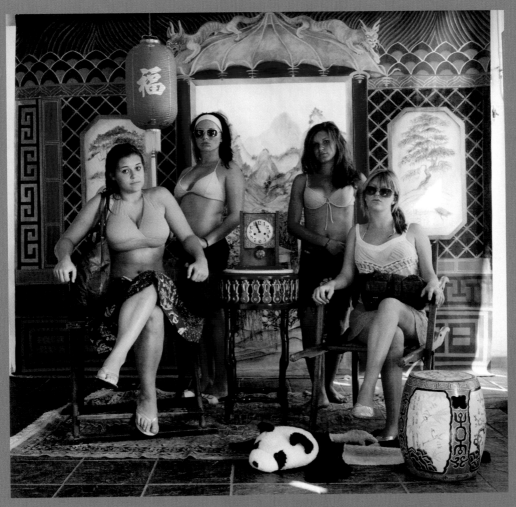

From the series: *21st Century Types*
© Grace Lau

For ME, THE MAIN IMPORTANCE of research is to provide factual and contextual information around the subject being covered in terms of its historical, cultural and current positioning. I trained as a documentary photographer and at Newport College of Art and Technology (now the University of Wales, Newport) we were encouraged to carry out library research into the issues that informed our projects. This was in pre-internet days so it was mostly based on looking at books, journals, magazines and newspapers; Newport had a lot of photographic monographs, with a big representation of Magnum members and also a lot of major American photographers. So, it mostly involved looking at photographic work

From the postcard collection of Grace Lau
© Grace Lau

and we were also encouraged to visit photography exhibitions and attend public talks and conferences on photography.

When I started my career I was documenting contemporary fringe issues in subcultures, feminism and racism. Most of that work needed very little formal or academic research primarily because my personal involvement with the subject matter meant that I knew the issues and context well so could be there and take photographs without needing additional information. For the work on subcultures I went to the clubs, got to know the people, became part of the scene and copied their dress codes—for example, I acquired leather and rubber outfits (but no nipple clamps) and got a tattoo on my thigh at a tattoo convention. So I could, for example, photograph other people being tattooed. Feminist and anti-racist activity were central to the lives of all the people I met then and I was also part of that. At that time Val Williams was researching and writing about women photographers and when I started documenting women body builders Camerawork magazine invited me to write on gender issues and the body. I was also a member of the Steering Committee for Signals, the Festival of Women Photographers, which took place across Britain in the mid-1990s.

However, over the years my interests have developed into working on longer-term projects and looking at historical perspectives—on issues of race, in particular—and that has involved far more in depth research.

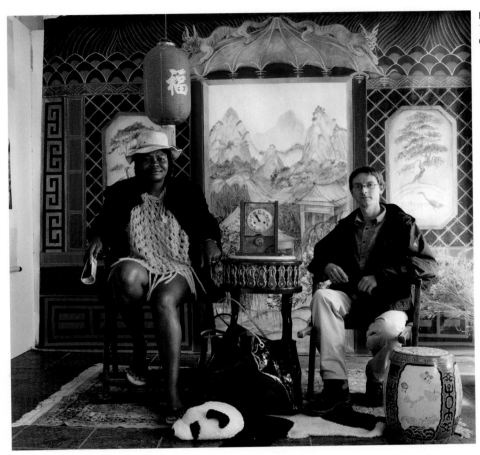

From *21st Century Types*
© Grace Lau

When I start a project I look at other artists' work on the subject, I also check their reference sources and do an online search, which will lead me to libraries and journals, which in turn lead to further reference sources. Funding has sometimes enabled me to take the time for really in-depth research but nowadays I never work on a personal project unless I have time for thorough research. In part, this is also because funders will support work that is backed by solid research.

For the last decade I have been working on the issue of cross-cultural influences between China and Europe since the invention of photography. I started in 2004 when a writer colleague in Shanghai commissioned me to write a book on early western photography in China. Research for the subject was an immense undertaking. Colleagues in London and Shanghai proved to be a generous source of research materials; they included Dr Frances Wood, head of the Chinese Department at the British Library, and

From *21st Century Types*
© Grace Lau

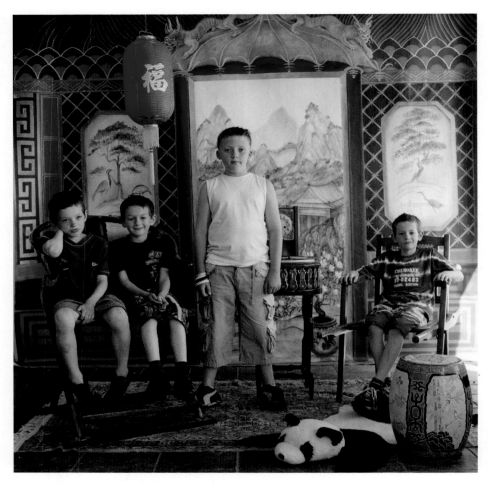

Lynn Pan, who is a writer and scholar of Chinese history from Shanghai. I used archives at the British Library, the School of Oriental and African Studies (SOAS), the Wellcome Collection, the Getty Collection, Magnum Photos and missionary libraries. The Wellcome Institute has original glass plates from John Thomson but I spent more time with the missionary societies because they were so very generous with their time and in letting me use their images. I also read a lot of

the missionary journals, which were fascinating and detailed things like how they taught children British manners, the hardships and illnesses the missionaries suffered, the food they ate and wonderful details of their daily lives. So, in part my selection of archives was dictated by the levels of helpfulness I met with and their costs for loaning pictures for reproduction.

I also accessed private collections including that of Michael Wilson, based in

London and San Francisco, whose collection of vintage works includes William Saunders and Felice Beato and that of Régine Thiriez, based in Paris, who has the largest collection of vintage Chinese postcards in the world. Her interest in postcards triggered mine because she pointed out their significance—thousands of cards were printed in black and white or hand tinted and sold as souvenirs to travellers so they form an unique record of the connection between China and Europe and show how 'orientals' were viewed by the west.

This led me to a desire to see how the images had originally been used originally in the books that had first published the pictures and I ended up trawling second-hand bookshops, mostly in London, for historical information. I noticed that some books included images that had been published as postcards and that also sent me to scour postcard fairs all over England where I located early twentieth-century postcards, mostly featuring topography, portraits, missionary work and 'exotic' punishments. The inherent racism of these became immediately evident, for example Chinese workers were described as beasts of burden on one card, another was captioned 'Chinese types'.

During this period I was looking at studio portraits of the Chinese by, for instance, English photographers John Thomson and William Saunders, who both set up portrait studios to photograph the diversity of Chinese society, I became aware that the subjects had been selected to typify

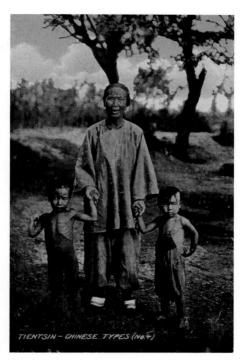

'Chinese Types' from the postcard collection of Grace Lau
© Grace Lau

Chinese types and were, for example, most commonly courtesans, coolies and opium smokers. The photographers all used the conventions of western formal studio backdrops and props such as pot plants and chaise longue and the images fascinated me and stayed with me after I'd finished the book. So, my research for my book *Picturing the Chinese*[1] led directly to my developing the personal photographic project *21st Century Types* where my aim was to subvert the Victorian traditions of these portraits by constructing an imagined Chinese portrait studio of the Victorian period in which I could photo-graph contemporary 'western types'.

It is essential to get facts right before you start on any body of work addressing

issues because, consciously or unconsciously, you are going to have a point of view and you need to be able to support and defend it if necessary. I do not believe it is possible to be objective in photography. When you start on a project you have to be very clear about your intended message and this will make it easier to find relevant resources and stop you from researching too widely or without purpose.

So, I'd include researching historical, social and cultural facts but also opposed positions and opinions which form the bedrock from which you develop your own perspective and piece of work. Then I look at other imagery from differing points of view—you need to see how other artists and photographers have dealt with the same issue—so I look in books, magazines, exhibitions and online, which helps me find my own route or shift my position if there's a danger of duplicating what someone else has done.

My starting point for *21st Century Types*, before I undertook the research described in question one, was to read Elizabeth Edward's *Anthropology and Photography* because she talks about types and the way Victorian scientists measured up primitive peoples.[2] She talks about photography as a political tool and how it was used to dominate and control colonial peoples and show the supremacy of the white race and this influenced my initial ideas on the subject.

So, you need to get all these things clear before you start or the danger is that the

work itself will be the route through which you sort your position out and it can end up being quite inconsistent or not holding together well.

I have always relied on film rather than digital and used both 35mm and medium-format cameras and am familiar with them so I don't do much in-depth technical research because its not really necessary for what I do. But, for an instance of practical research while exploring Victorian portrait photography, I was reminded that photographers all used heavy cameras set on heavy tripods with slow film so I duplicated this to the best of my ability using my Hasselblad medium format camera set on a tripod with slow film. This also made my subjects more comfortable with being asked to pose in a formal way in a studio setting because I explained that this was an old-fashioned portrait studio and they had to be still, without smiling, and look straight at the camera. They were familiar enough with Victorian portraiture to understand exactly what I meant so it gave them a more participatory role in the tableau. Having researched Victorian portrait studios in England I showed my sitters some of these images, most of which were postcards, and generally they enjoyed the performative aspect of the shoot. They were also pleased and felt involved because they knew I would give them a digital print afterwards.

There are several ways in which the research I do impacts on my work and it is not always predictable. Having looked at

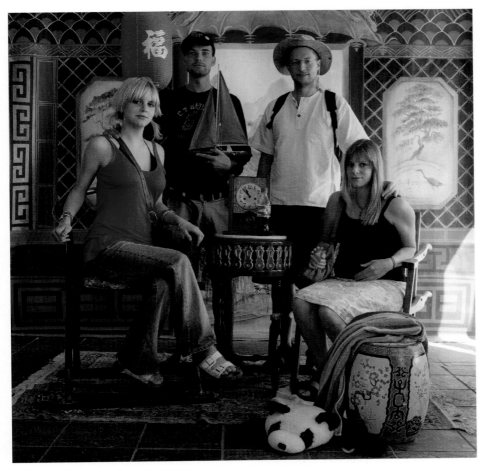

From *21st Century Types*
© Grace Lau

how other people address the issue means I sometimes have to shift my approach; it's important that the work looks visually different even if the message is similar.

So, for example, knowing August Sander's[3] work *People of the 20th Century* helped me shape my thinking about social typology in the twenty-first century but I didn't want to duplicate his approach and did want to make reference to the Chinese studio portraits of John Thomson and William Saunders, which is why I built an elaborate set rather than using a background relevant to the sitter's profession, as Sander tends to do. Looking at Sander's use of quite simple backgrounds inspired me to focus more on how my studio background could reveal more of what I'd learned in my research. And thinking about Sander's portraits meant that when people wandered into my studio with the tools of their trade, their shopping, sunglasses,

mobile phones, ice creams or biker's helmets I encouraged them to pose with them rather than leaving these things out of the picture as most of my sitters expected me to ask them to do. This helped point up the differences between the nineteenth and twenty-first centuries.

But it's more than that—the research tells me what to photograph and focuses my interests around what I have to say. The process of making a piece of work would be a lot more random and exploratory without that concentration that the research brings.

Looking at other people's work and collecting information and ideas inevitably forces one to sharpen and focus one's own work and ideas. For me, research is almost more exciting than the actual practical work of making images because, after the first level of basic research, which supports and quantifies my project, has been completed, there are almost always other research results that lead me in another direction or enhance my project in some other way. So, the research work leads the practical. For example, research-ing the Victorian tradition of dressing children in their best for post-mortem photographs led me to asking my subjects in my current project, *Ad/dressing Death*, to pose wearing their favourite clothing in which they would want to be remembered. Thinking about the children, who were us-ually posed as if asleep, led me to the idea that I wanted to see if I could show how our contemporary attitude to death has shifted now that the idea of the after-life is less prevalent so I make it plain that these

are imagined post-mortem photographs by asking my subjects to pose in a coffin.

I was aware of the problem of the societal taboos about death but reading *Photography and Death* by Audrey Linkman[4] and looking at the ways other artists and photographers, for instance Andreas Serrano, Elizabeth Heyert and the contributors to *The Dead* exhibition at the Barbican Art Gallery,[5] have addressed the issue encouraged me to proceed and freed up my ideas to make my own exploration of what death means today. But the project came to an abrupt halt last year when four close friends died suddenly and unexpectedly. This brought it too close and made it impossible for me to do further research work so, despite the fact that I'd argue that it's impossible to be objective, I do believe in maintaining a critical distance from the work.

The research and the practical go hand in hand. I don't stop researching when I start photographing and so that ensures that I am constantly evaluating the work as a project develops. I keep a record in the form of a workbook with notes, references and reading resources and also log comments and critical feedback from colleagues and refer to it from time to time.

I work in the art world so the outcome is almost always going to be a publication or exhibition. *21st Century Types* is both an exhibition, which has toured, and a book. The work is on temporary loan and hang-ing in the High Sheriff's conference room in Lewes County Hall; this very formal setting was an entirely unexpected venue

but I wouldn't have changed anything had I known the work would end up there.

If I were a commercial photographer I would feel bound to consider audience as a priority but, in fact, I don't think a great deal about audience because I think it would weaken the work if I tried to tailor it to meet people's expectations. However, I do show work in progress to colleagues whose feedback I value and that always brings the possibility that I might change some aspect of the work in response to their comment so I consider them as audience although they are both well informed and supportive which is, of course, not going to be true of everyone else who sees the work.

Issues like gender and race are always there in my work because my work is subjective and these are the issues that motivate me most. I take pleasure in subverting the stereotypes that make these issues such rich areas to explore.

I don't think you can ignore the role that chance plays in research. For instance, when I was mulling over the idea of a painted backdrop for my portraits I visited Brighton Pavilion[6] and instantly saw how a version of that could be recreated to provide an appropriate and highly decorative 'Chinese' backdrop for my portraits. It was then an easy task to find an artist who worked painting backdrops for the theatre to produce an imagined nineteenth-century Chinese one for my studio.

Additionally, I believe that the wealth of material researched in one particular project can lead to new projects and directions. For example, the varied portraits I made during my first major work[7] led me to take a deeper interest in the contemporary genre of portrait photography and in how this could shift from literal representation to artist's interpretation. My continued reading around the art of portraiture informed the portraits I made for *21st Century Types* and *Ad/dressing Death*.

Interview by Shirley Read

Notes

1 Grace Lau (2008). *Picturing the Chinese: Early Western Photographs and Postcards of China*. Hong Kong: Joint Publishing (HK) Co. Ltd.

2 Elizabeth Edwards (1994). *Anthropology and Photography*. New Haven and London: Yale University Press in Association with the Royal Anthropological Institute, London.

3 August Sander (1876–1964), German photographer best known for his portraits of Germans from a wide variety of social and economic backgrounds and for the organising principle behind his (unpublished) book *People of the Twentieth Century* in which he grouped his subjects into seven types (The Farmer, The Skilled Tradesman, The Woman, Classes and Professions, The Artists, The City and The Last People).

4 Audrey Linkman (2011). *Photography and Death*. London: Reaktion Books.

5 Andres Serrano, *The Morgue*, *Portfolio*, number 21, Edinburgh 1994/5. Elizabeth Heyert, *The Travellers: post mortem photographs*, Edwynn Houk Gallery, New York June–July 2005. *The Dead* curated by Greg Hobson and Val Williams, Barbican Art Gallery, London 1995.

6 Brighton Pavillion, built 1789–1823 as a seaside retreat for George, Prince of Wales, is remarkable for its magnificent 'exotic oriental appearance' and its collection of chinoiserie.

7 Grace Lau (1997). *Adults in Wonderland*. London: Serpent's Tail.

John Darwell

John Darwell is an independent photographer and a Reader in Photography at the University of Cumbria. His long-term projects reflect his interest in social and industrial change, concern for the environment and issues around the depiction of mental health.

From the series: *A Black Dog Came Calling*
John Darwell © 1999–2003.

Research in its various forms is inherent within all my projects now, but this has not always been the case. Undertaking a PhD strongly influenced my ideas about the nature of research and how as part of the creative process it is imperative to have an in-depth under-standing of the subjects that interest me. All my work prior to that point had been documentary in approach and had a very strong polemic. The projects were concerned with my personal take on social or political issues and, looking back, I see how this was a rather self-righteous attempt to set the world to rights, and I was becoming uneasy about it. Not only about my own work, but also about quite a lot of the work that I was seeing at the time, and I know exactly when that started.

I had just come back from Chernobyl where I had been photographing within the exclusion zone. A no-entry area with a 30-kilometre radius that was evacuated after the nuclear meltdown at the Chernobyl Power Plant in 1986. The area contained one major city, Pripyat, and over 70 villages and scores of farms. The people living in these locations were given 24 hours to gather their possessions and were then moved to locations around the Ukraine, in most cases never to return. On my arrival back in the UK, the press had written about my having risked my life in such a dangerous place, which wasn't the case. I'd gone there, taken some photographs and then left again with everyone patting me on the back and saying I was a hero; but I was just a

glorified tourist who chose to go there. The people affected by the disaster in Chernobyl had no choice but to live with the consequences every single day of their lives.

Between completing the Chernobyl project and starting my research degree I began thinking that I had to change the way that I looked at the world, and the kind of work I was making. What became important to me was to look at issues that were relevant to my life rather than attempting to impose my world-view on other people's situations in the way I had been doing. As a result my work became far more intimate, looking from an internal perspective rather than an external one, and importantly, equipping myself with the necessary knowledge to make informed decisions appropriate to each project.

The research process helps me to understand what it is I'm looking at, and helps me to understand why I am drawn to certain subjects. This generally involves background reading and includes literature from a range of relevant sources. Depending on the project this could encompass historical or social perspec-tives to environmental concerns. This helps me to underpin the arguments I want to engage with, which would then be combined with visits to specific locations if appropriate. But as part of that process I also think it is important to look at what other photographers and artists are making work about. How others have thought about and approached certain subjects can be very stimulating.

I know many photographers concentrate purely on the visual, spatial relationships of how elements sit within the frame, which is important to me, but I'm not that interested in the mechanics of photography as such. Much of my work tends to involve quite intimate close-up perspectives with a lot of differential focus. This came about sometime in the 1980s when I moved from using a rangefinder camera for all my projects to using a through the lens camera. Suddenly, I could see through the layers of focus, and this is something that continues to be a

From the series:
A Black Dog Came Calling
Photography by John Darwell
1999–2003.

From the series:
A Black Dog Came Calling
Photography by
John Darwell
1999–2003.

fascination and a delight to me, even after decades of observing the process.

But it is the research I do that ultimately influences what the final work will look like. In many ways my work has responded to things discovered within the research process, and for me is a crucial part of my creative process. I cannot imagine undertaking any project without having engaged in a process of research, my work would be far more superficial without it.

Research also helps to extend the boundaries of my work because the research process is by definition about taking risks; unlike my earlier work, which could be considered quite safe in that I had a reasonable idea of what I was likely

to end up with. Research materials have to be interpreted and to do that you have to continually ask questions in order to examine and understand what emerges. Often, this is about finding reference points that take me in different directions and bring the work together in new or unexpected ways.

The unease with my initial documentary approach I mentioned previously was reinforced by a personal event in my life that led me to turn to photography in a more inward-facing and expressive way. In the 1990s I suffered an extended period of clinical depression, which sometimes left me unable to function on a number of levels. Following my rehabilitation I wanted to understand what had happened to me, and I began a concentrated programme of research that eventually led to the series *A Black Dog Came Calling*. The initial premise for this was to explore the possibility of creating a body of work that would approximate the experience of depression, in a manner that could be recognised or understood by others with first-hand experience of the condition.

The project ultimately led to my gaining my PhD and became a huge undertaking. It was a very different experience compared with the familiar context of my arts practice. For most arts practitioners whatever the discipline, research has a small r. By this, I mean that research involves activities that are fundamental to the development of the artist such as experimenting with the tools of the trade and pushing the boundaries of their

From the series: *A Black Dog Came Calling*
Photography by John Darwell 1999–2003.

From the series:
A Black Dog Came Calling
Photography by
John Darwell
1999–2003.

representation of someone suffering from melancholia or depression. This often took the form of a solitary figure sat with their head in their hands in the corner of some darkened room, which I personally found very frustrating. There is no shorthand for depression, no 'one size fits all' and I wanted to get away from a clichéd image that only served to block understanding and undermine the complex and unique nature of mental illness.

Reading first-hand accounts by people with depression provided the most relevant information for me. What this did was to allow me to understand that the experience of others with mental illness wasn't that far removed from my own. I was interested in the signifiers that were in their writing, phrases such as '. . . the black hole' or '. . . darkness' or '. . . the grey light of depression'. I recognised these terms and they had a resonance for me, which fed into my work as elements from my own experience. I began to consider that, if that was the case then, I could maybe develop a language of universal signs that could be recognisable to others. In essence, it wasn't what was in the photographs that counted, but how they made *me* feel. The subject matter somehow had to spark a sense of recognition within me, to approximate some element of my own experience of depression.

practice through subject matter or specific goals. In this context the research is largely invisible or completely hidden, and the only concern is with the work itself. With a PhD the research has a capital R and it is the research process that is under scrutiny. The images are just one step in a broader inquiry that is judged by the significance that the research brings to the subject area, in other words the research has to contribute something original to the knowledge pool.

The contextual research for the *Black Dog* series involved reading around the subject including the history, current medical literature and looking at how mental illness had been depicted visually, and certain things came to light. A benchmark had been set sometime back for the

I began the work with the idea that what I had experienced, although specific to me, may have overlaps with other people who had experience of depression first hand or

who had witnessed the depression of someone close to them. I wanted to create something that was well and truly grounded in reality, but a reality that was internalised, not necessarily a visible reality. I had to find a visual language based on the real world but using metaphor and for quite a time that old Garry Winogrand quote had been going round in my head: 'I take photographs to see what things look like photographed.'[1]

So, how does this influence my practice and how I go about taking photographs? I have never been very good at isolating what works in the viewfinder, so I take an awful lot of photographs to evaluate later. What I am interested in is the photographic-ness of things and exploring the nature of photographic seeing, which was something I had already begun to explore in my earlier projects, but this has become a more explicit aspect of my work.

In this sense, while creating the images for the *Black Dog* series there were certain locations that became very relevant. So I returned to the hospital where I had been an outpatient, which was now closed down and derelict, but I obtained special permission to go in and photograph. The image making started to become about the intuitive sensibility of exploring places that had some kind of resonance in terms of my experience. For a long time during my illness I felt that I was part of some process and had ceased to be an individual. So certain kinds of things, signs on shelves that said 'knickers' or 'pyjama

tops', became so relevant for me at that time when I felt like I was being processed.

I guess when I'm actually taking photographs I'm fumbling around looking for a way to interpret what's in my head. I have learned that intuition is vitally important within my process, particularly at the image-making stage and it is this moment of recognition that brings the work together. As an example, during the process of production I often find I have ten almost identical images, yet something occurs in one of the images that make it come forward to correspond with what I was thinking. What this 'something' is will differ from image to image and so it is a case of knowing it when I see it. To quote Louis Pasteur 'chance favours only the prepared mind'.[2]

From the series:
A Black Dog Came Calling
Photography by John Darwell
1999–2003.

From the series: *A Black Dog Came Calling*
Photography by John Darwell 1999–2003.

From the series: *A Black Dog Came Calling*
Photography by John Darwell 1999–2003.

Obviously, I want to present whatever I am attempting to say with some degree of coherence and for my work to resonate with others, so the audience is hugely important. The experience it brings to the viewing process often allows me to understand things I would never have recognised otherwise. I made a number of presentations as the work was developing, and the more I talked to people the more I realised that their experiences were very similar to mine. I discussed the work with psychiatrists and psychologists, with sufferers and their families, and what became apparent from this fieldwork and through my contextual research was the paradox that exists between the lived experience of mental illness for the sufferer, and the way such conditions are described or perceived by those on the outside, so to speak.

For example, we persist in using words to explain or interpret mental illness, which can often be difficult if not impossible to put into words. Whereas images allow us to go somewhere different, to express and communicate in alternative ways. When I have shown the work, for instance, I have had people in tears or saying that they understood for the first time what their husband, wife, son or daughter, friend or relative is going through or had gone through. And that is exactly what I wanted to achieve, to allow others to understand the experience of mental illness through my work, rather than it being specifically about my own experience.

The photograph helps to create an alternative vocabulary to explore mental illness, but I think you have to look at this as a journey using the images to create a beginning, middle and an end. I think a lot of photography works like that, it's a medium that lends itself to storytelling, so that each image is linked to its neighbours like bricks in a wall. Nearly all of my projects are displayed as grids now (for example, 40 images become a block panel of 5 images by 8 images). I'm trying to relate one thing to another in a number of different ways so links or associations can be made diagonally as well as up and down, and all these different elements feed together to tell the story. If you take one image out of context it might address some sense of the subject, but the narrative breaks down and becomes meaningless. One image in that series cannot stand on its own, you may be able to see the signifiers, but for it to be relevant you need to see the whole sequence as story telling with a particularly visual narrative. I think this allows people to engage with the work on their own terms and in different ways, where they start or end on that particular grid becomes a personal choice. Two people looking at the same material might come up with completely different conclusions because how anyone interprets visual work is both fluid and personal.

In retrospect I learned a lot from undertaking my PhD as it allowed me to understand things that had been ticking away on an intuitive level, both from the

From the series: *A Black Dog Came Calling*
Photography by John Darwell 1999–2003.

From the series: *A Black Dog Came Calling*
Photography by John Darwell 1999–2003.

From the series: *A Black Dog Came Calling*
Photography by John Darwell 1999–2003.

things that I had read or things that I had experienced. I did come out of the process with a far more rigorous approach to my own practice than I had previously. I question things more now and that helps me to understand what I am dealing with in a deeper way on any given project, in contrast to what it was before.

So, for example, later projects including *After Schwitters*[3] became primarily a means to allow me to explore my own preoccupations about the potential inherent within the medium of photography and to be far more than merely pictures of things.

I was very intrigued by the Schwitters story and this area of Lake District had been largely undeveloped since Schwitters' death. Although Schwitters was the catalyst and the thread that ran through this particular journey. I chose to explore what interested me in the crumbling building and the contrast of objects both natural and manmade, and it pushed my photography in a direction that I had not taken it before. I think that to keep challenging what you do is hugely important as a practitioner. It's that uncertainty hovering somewhere over

From the series: *A Black Dog Came Calling*
Photography by John Darwell 1999–2003.

your shoulder and kind of whispering in your ear—'Are you sure this is right?' What it boils down to is that for any work to be 'right' or, more accurately, relevant, it has to be informed, and the only way you can attempt to achieve that is by doing the groundwork.

Interview by Mike Simmons

Notes

1 An Interview with Garry Winogrand from *Visions and Images: American Photographers on Photography, Interviews with Photographers* by Barbara Diamonstein, 1981–1982, New York: Rizoli. Accessible from: www.jnevins.com/garywinograndreading.htm.

2 Quote taken from Pasteur's lecture to the Faculty of Sciences at Lille on 7 December 1854. René Vallery-Radot (1923). *The Life of Pasteur*. New York: Doubleday Page and Company, p. 79. Contemporary copies (2008) are available published by Bibliolife, Charleston, South Carolina.

3 This project grew out of an initial invitation to photograph the Cylinders Site in the English Lake District. This is where the German artist Kurt Schwitters started work on his project the *MerzBau*, which was left unfinished by his death in 1948. Schwitters (1887–1948) was a German Dadaist who originally created a *Merzbau* in Hanover between 1923 and 1936. This was destroyed in a bombing raid but an archive and reconstruction can be found in the Sprengel Museum in Hanover. Further information and links can be found here: www.merzbarn.net/hanovermerzbau.html.

From the series: *A Black Dog Came Calling*
Photography by John Darwell 1999–2003.

From the series: *A Black Dog Came Calling*
Photography by John Darwell 1999–2003.

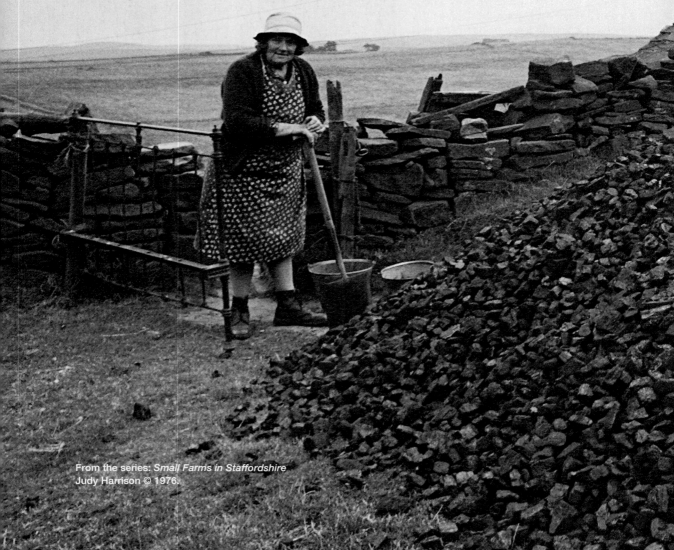

Judy Harrison

Judy Harrison's work explores themes of visual narrative, personal histories, representation and social and cultural identity.

From the series: *Small Farms in Staffordshire*
Judy Harrison © 1976.

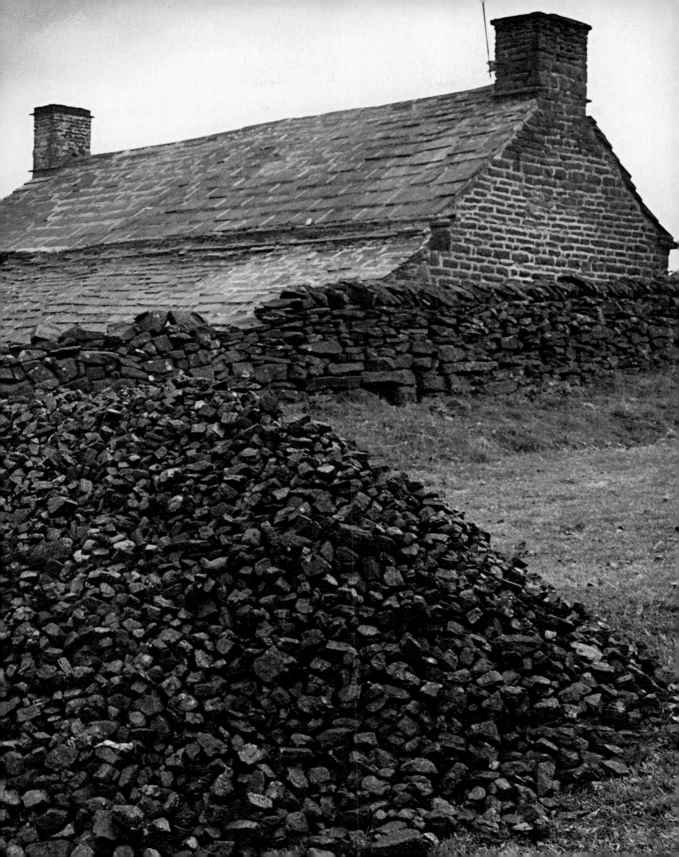

I READ THE PHRASE 'you learn how to think' in one of Edmund De Waal's texts[1] and I think that's what creative practice is about. So many different approaches to research weave in and out of each other, often in oblique ways. It may be reading and seeing lines, groups of words and the spaces around these, which leads me to reflect, visualise images, processes and the interpretation and formation of my own words. Listening to a radio programme or going to a talk or a lecture can provide another space of connections and possibilities. It could involve visiting exhibitions, looking out of the window or having conversations and forming narratives. Research is about encountering new experiences, taking notes, meandering sideways and making sense of your own life and that of others. Research for me also involves an interaction with places and exploring the social landscape, whether that be the domestic, the industrial or rural, and how that can trigger my own experience, memories, meaning, imagination and interpretation.

Research is all those things to me. It is something that I am constantly doing. Having the time to think is important, to formalise this research and place elements into some sort of structure. Whether that's in a sequence of images, a piece of text or a publication, different ways of thinking, diversions and tangents, experiences and methods shape these processes and outcomes of the research.

Often, things happen by intuition or chance and that's a delight, but this may only happen by being open to seeing things differently, open to being taken on a journey. It's about questioning what's happening in the world, however large or small that may be, and how cultural and political situations have shaped our lives. I have always been interested in anthropologies, histories, cultures and communities and the contextual framework that they hang within. I worked on an oral history project on histories of migration with the Sikh community in Southampton over 20 years ago but the unresolved issues of migration, displacement and racism are as real now as they ever were.

I was brought up in a very political family; both my parents were members of the Communist Party. My father used to give me fireside chats about Marxism when I was about ten years old, so naturally I became politically aware from a young age. Although I didn't understand half of it at the time it did resonate with me, and over the years I have come to realise how much and how often my early life, family background and my own life experiences have influenced my work.

When I look back, right from when I first started out in photography, key themes have threaded through my practice. I have always been interested in people and communities who have been marginalised in some way and the context that may have brought that about. The research into that is, first and foremost, about

communication. Talking to people and learning about the social, cultural, religious and political dimensions of their lives are the things that interest me and feed into my work.

I don't see photography as being just one thing or being separate from the world around it. Nor do I see my work purely on a visual basis or belonging to a particular style or genre, I'm interested in it connecting and crossing over with lots of other things, working within a wider critical framework. I like words and lines of words and writing is now becoming intertwined with my photography. I also want people to interact with my work and to collaborate with it in some way. The work has to have some connection and context with other people's lives as well as my own. But when working with photographs, I see them as documentary fictions. That's what interests me—the overlaps and spaces between fact and fiction.

I tend not to work in an over-planned way and I don't often go into a new project with a specific plan or approach—I don't work in that way at all. I obviously have a broad plan and do as much preliminary research as possible but I consider myself an explorer and often feed on chance. For me it's more to do with chance encounters and experiences that actually bring out the results perhaps more than the chance encounters in the camera, and that's how the farm project happened. I started the *Small Farms in Staffordshire* project while I was studying for an MA at the Royal

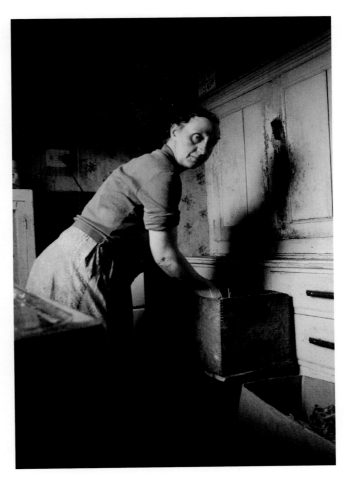

College of Art (RCA), and I carried on working on the body of work for a number of years after that.

I grew up in Stoke-on-Trent, in a landscape where industry ran in parallel and intermeshed with wilderness and nature. Pot banks, slag heaps and mine shafts edged onto farm land and beyond, and opened up into the grit stone hills and contrast of the Peak District. It's a place I

From the series:
Small Farms in Staffordshire
Photography by Judy Harrison, 1976

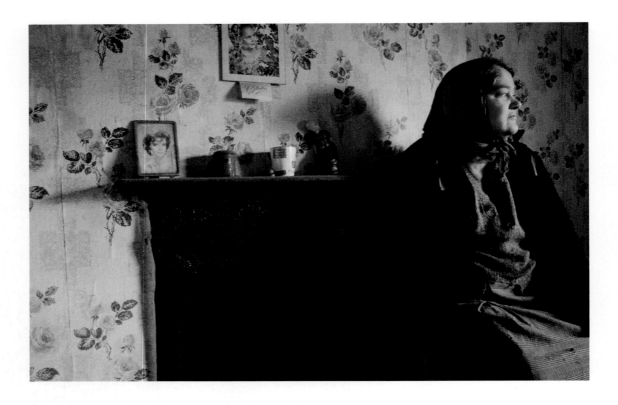

From the series:
*Small Farms in
Staffordshire*
Photography by
Judy Harrison,
1976

go back to a lot and still feel very much part of, a place where I belong. *Small Farms in Staffordshire* was based in the Peak District, and I worked within an approximate twenty-mile boundary between Leek and Buxton, crossing the boundaries and edge lands of the undervalued landscape of the Staffordshire moorlands and Derbyshire dales. It's an area of harsh, often barren landscape with sparsely located small holdings, and farmers, who at that time, were struggling to make a living.

I walked through the hills and moorlands, walked miles and miles with my camera equipment and began meeting people. I would meet farmers and listen to their

stories and then one farmer would recommend me to the next farmer or I would pass somewhere and knock on doors and ask people if I could photograph them, but often I didn't do this straight away. Getting to know people and building mutual respect before I introduce the camera is hugely important for me. It often results in more interesting and in-depth work; it is about how I get to something, what I reveal and the form that I use.

There were many unmarried women who were either on their own, sisters, or living with one surviving parent. They ran these farms in a stoic, strong manner

maintaining their independence, often in isolation. I was interested in the vernacular and the banal, the spaces of the rooms, the objects and a way of living that was fast disappearing elsewhere. But here time seemed to have stood still. I took slow, studied formal portraits of them, of the everyday and photographed their cupboards and fireplaces, and drank cups of tea and returned again and again with more photographs to give them. I took contact sheets to show them and involved them in the process of choice. I wanted them to see the results as soon as was possible. This is an important part of collaborative portraiture for me.

Some of the farms were cut off so I walked for miles with cameras and tripods through rain, wind and snow. I studied detailed Ordnance Survey maps and the formalities of mapping, listened carefully to weather forecasts and researched the local topography and histories of the spaces. We sometimes wrote letters to each other and they told me about the weather and narrated events and fleeting moments of the day. I was very much influenced by the work of James Agee and Walker Evans, August Sander and Josef Koudelka at the time and all of this practical research and way of working influenced my later work.

I worked on the farms project for a significant length of time and found it quite difficult to bring it to closure. I think it was only exhibition deadlines that forced me to do that. I like spending time on a project, reflecting, researching, developing and

refining what I'm producing. There seems to be a process at work that builds momentum, often in a very organic way. It's evolutionary in that it is not fixed or rigid, which is an interesting aspect of the research process for me. When I look at my work more objectively and talk to other people about it, I can begin to see how

From the series: *Small Farms in Staffordshire* Photography by Judy Harrison, 1976

From the series:
*Small Farms in
Staffordshire*
Photography by
Judy Harrison,
1976

things connect that perhaps I didn't realise in the beginning. I suppose it's the unconscious at play; I am always letting my mind wander and making connections from the most obscure elements. I became very good friends with a lot of the farmers and although the majority are no longer alive, I have returned to the actual sites of the farms to see how things have changed and, most are still standing, although some are now unrecognisable. I go back regularly to the area and have always felt a real affinity and relationship with this landscape, the dialect and sense of place and, strangely, feel it's where I belong. I was very guarded about publishing the images, becoming very protective of the pictures partly because the images were intimate encounters with people and place, although no one in the images objected to me exhibiting or publishing them. The Victoria & Albert Museum in London bought ten of the photographs for their photographic collection.

I am interested in the use of collective, universal memory and asking questions about power and control. I read all the time, both fiction and non-fiction, from photographic books to essays and use writing in conjunction with my photographs. For example, *Threads* (2010) and *Wedlock* (2011) are two autobiographical pieces, and are part of an ongoing body of work based around personal memory. The way things stay lodged in the mind and how we fabricate things out of our memories interests me. Memory is a kind of fiction and photographs, no matter how objective we set out to make them, are constructs. The stories we tell are fabrications too, but it's the bringing together of these facts and fictions and the connection between them, which help us to make sense of things. It was liberating to work on various projects that weren't wholly photographic,

From: Rejection (installation)
Photography by Judy Harrison, 2011

with no new photographs made. Writing took over and at first I wrote extensively from the photographic images and memories. I edited the texts and stripped them back to their bare minimum, to a level of stark rawness.

Addressing the inherent problems of representation is hugely important in all my work and is what I reflect on again and again. Growing up through the '50s, '60s and '70s shaped how many photographers thought and worked, how we questioned what we were doing as documentary photographers, holding debates on representation and the recognition that it is a political issue. It didn't come from our photographic education, it came, I suppose, through certain theorists, writers and photographic practitioners. It came as well from our experience of a particular time and place and our reactions to the years of political control and repression at the time.

During those years whole working class communities were stripped, robbed I would say, of their working lives and culture, their sense of place and community. Heavy industries like mining and steel were lost in Stoke-on-Trent, where I grew up, and no money has been put back into that city, just a dual

From: Wedlock (installation)
Photography by Judy Harrison, 2011

From: *The Mount Pleasant Photography Workshop*
Photography by Sukhdev Singh Roath, n.d.

carriageway slicing through the neglected waste of the six towns. It's full of beautiful crumbling civic buildings, abandoned factories, pot banks and bottle kilns standing like ruins and ghosts in a void, which was once home to generations of skilled pottery workers who made and created world-class ceramic collections. I do a lot of reading on ceramics and have spent years researching the history of Wedgwood and the pottery pioneers and philanthropists and it's an area of study I want to take further and to make more work on.

But this isn't about nostalgia, it's about respect, dignity and pride. *Rejection* (2011) is the title of an archival installation that addresses these issues. It brings together, in a constructed setting, pieces of beautiful ceramic domestic cream and white

tableware made in Stoke-on-Trent and classed as rejects after their first glaze firing, with each piece containing a blemish, mark or craze that I had collected over many years from factory shop skips. The room was painted very dark grey, almost black, with shelves to resemble a museum space. The materiality of the form, contours and physicality of the surfaces, lit by artificial lights, makes reference to that of a forgotten world. To me, it looked like a black and white photograph, resembling the tonal range inherent in that medium.

Narratives are suggested that may link the objects together but the new layer of meaning suggests a craft that had once been, which is no longer there. Both elements engage with my response to the rapid decline of the pottery industry

in Stoke-on-Trent, so this piece came out of two different strands of my life, and research I didn't recognise as research until I started work on *Rejection* many years later. It was also led by exploring new research on ceramics and photography in relation to the object, archives and memory. I have been influenced by the writings of Walter Benjamin, W.G. Sebald, Gaston Bachelard and Brian Dillon's *In the Dark Room*[2] and am really enjoying exploring both the writings and ceramic installations of Edmund de Waal.

I feel that research within the scholarly world is considered as an objective process, but whatever research I do and the information I gather to inform the way I think and work is open to interpretation. I might start research from an objective point of view, but ultimately how I interpret things and how I edit and make decisions about whatever I am looking at or exploring is subjective; taking out what I need to take the work forward. And in that sense research is a continuous process in that it relates to the ongoing and continuous nature of creative practice, as the research for one project will overlap or feed into another project in some way. My recent book *Our Faces Our Spaces*[3] is a good example of that because my initial idea, and the process of doing that book, progressed into a whole new research project in its own right. It became a collaboration between myself, the participants of the Workshop and the theorists who contributed to the publication. The

Workshop's main ethos was built upon collaborative practice and it was fitting that the development of the book took on the same process.

The book is a reflection on the Mount Pleasant Photography Workshop, which began in 1977 when I was awarded a two-year Arts Council Fellowship based at The Photographic Gallery at the University of Southampton. The remit was very open

From: *The Mount Pleasant Photography Workshop* Photography by Guljar Singh Pottiwal, n.d.

and the aim was to work with photography and children. I had to do a huge amount of research before I could start doing anything. Southampton was a new place for me and I didn't know the area or any children. But, eventually, after significant practical research, I began working with Mount Pleasant Middle School in Southampton, which gave the project its name.

Around 97 per cent of the school's intake was minority ethnic, predominantly Asian children and English was not their mother tongue. The teacher, to help deal with this, was making small basic reading books, and I immediately thought the illustrations could be replaced with photographs taken by the children. At the time there weren't any books that addressed differences in

culture and that's what interested me, using photography with children for a purpose, in a context where it could actually be useful. When the fellowship finished I researched all sorts of ways to raise funding, and raised substantial amounts of capital and revenue funding, which enabled us to build a darkroom in the school and that's when the Workshop began in earnest and grew into a large community photography project spanning thirty-six successful years.

I left the RCA at a time when people were questioning the role of documentary photography, and I naturally became of part of that and began to attend discussions and meetings at Camerawork in London. But it was my involvement at the Workshop that actually gave me the

From: *The Mount Pleasant Photography Workshop* Photography by Balbir Kaur Pottiwal, n.d.

practical context and theoretical framework to respond and develop my thinking in a far more pragmatic way. Working with the young people and their families taught me about the politics of representation and what that actually means. All this was research in a way for an ongoing philosophy for how I approached photography and contextualised my own practice. The boundaries of documentary practice have shifted and changed and I have responded to that, not only as a practitioner but also as a lecturer and teacher, wrestling and questioning and continually learning from working in collaboration with others.

I always saw photography as a fictional device and I could see how easily you can manipulate things, right from the start when I was a photography student at Manchester Polytechnic. Everything is subjective to a degree, it comes from reality but how you interpret things is wholly subjective. Confronting what we were doing as documentary photographers made us feel vulnerable and exposed, but times have moved on and I think documentary photography has changed and expanded beyond recognition and for the good. It's overlapped now with so many other different disciplines and the whole ethos of research and critical thinking has fed into that. Documentary photography has a whole new momentum within much of contemporary photographic exhibited work. Digital technology has brought about a whole new ethos of people

From: *The Mount Pleasant Photography Workshop* Photography by Maryam Shafik, n.d.

representing themselves, a commonality and sharing this with the public at large.

When the book project started a significant amount of time had passed since I had founded the Mount Pleasant Photography Workshop so there was a huge amount of material, and the starting point was editing and categorising to define certain areas that I wanted to look into or to take further. I found as many young people as I could who had taken part in the workshops, and I managed to find nearly everybody wherever they were in the UK.

Some people had stayed in Southampton but it was quite easy to track people who had moved away through their families and the arranged marriage system. Because of the depth of knowledge that I had gained

From: *The Mount Pleasant Photography Workshop* Photography by Tanzeela Ali, n.d.

about the Asian community in Southampton, particularly the Bhatra Sikhs[4] and Muslims who were the main participants in the workshops, I was coming to the research process with the knowledge that I had gathered over the years about the community and the culture, by being part of it.

Once I had located everyone, contributors were either interviewed or wrote their own essays. They articulated their reflections and observations about the impact that photography had on their lives, and the confidence they had gained through making visual statements about representing themselves and their families, was stated with moving conviction and passion. Representing their social and

cultural lives and their religions was important to them. From the racism that they had come up against at the time when they were youngsters in the 1970s and '80s, photography became a compass to navigate through and to challenge the politics of space. The ownership of the camera gave them a new confidence and freedom and became a 'right-of-passage' to reclaim the streets as a space which had previously been denied to them. The street as well as their homes became their studio.

The photographs the children created were used in the school for active learning, as language aids and tools for information and cultural expression. We produced a huge oral history project about the migration and history of the Bhatra Sikhs[5] from the Punjab to Southampton and that took a huge amount of research over a few years. Parents gave the young people their old photographs to copy and we had started to amass a rich archive of generations of family portraits taken in Indian photography studios and it grew from that into an in-depth research project utilising local people's archives. We collected stories from the many transcribed interviews we had done. The text in the exhibition was typeset in both Punjabi and English. The exhibition could be hired and from this it toured for many years all across the UK.

When you work with other people there is a huge responsibility to ensure that a balance is struck between your own

interests and aims and that of the people you are working with. Becoming part of that community and working with different people of varying cultural backgrounds and religions was very important to me. I don't think the Workshop would have worked if it had just been a short project. It was the longevity of the project that empowered young people and their families to use photography as a radical empowering tool for positive social change. I worked on the project as Director for 15 years but the Workshop itself was in existence for nearly 40 years.

In doing the book I wanted to reflect on the organic progression of the Workshop. I didn't want it to be a historical account; I was interested in looking at it from the context of today, getting the young participants of the time to reflect and question if and how photography had impacted on their lives. I think the longevity and the political positioning it held is what made Mount Pleasant Photography

Workshop unique and hold the value it has within the histories of photography. The trust, respect and collaborative integration took years to build. It was an important part of the children's lives, part of their upbringing, and I grew up together with them because I was only in my mid-twenties when I started the project. I went to classes to learn Punjabi for a number of years and attempted to learn as much about the cultures and religion as I could. It became an important part of my life, it still is and I am grateful for that. What was interesting for me in producing the book was revisiting the work and finding out the strength of the impact on their lives and that fact that in producing the book, the participants picked up where they had left off. Research for me remains a collaborative two-way process and the research that I started as a young person has shaped and changed my life as much as it has the lives of the participants.

Interview by Mike Simmons

Notes

1 Edmund de Waal is a ceramicist, artist and writer. See page 220 in *The White Road* (2014) published by Chatto & Windus, London. See also *The Hare with the Amber Eyes* (2011) published by Vintage, London.

2 Walter Benjamin (1892–1940) was a German philosopher and cultural critic known particularly in photographic theory for his essay *The Work of Art in the Age of Mechanical Reproduction* first published in 1936. W.G. Sebald (1944–2001) was a German writer and academic. His writing often included photographs as a secondary narrative to the text. Gaston Bachelard (1884–1962) was a French philosopher whose work *The Poetics of Space* is often found on photography

reading lists. He influenced many subsequent French philosophers such as Michel Foucault, Jacques Derrida and Pierre Bourdieu who are often referred to in photographic theory. Brian Dillon is an English writer and critic and a tutor at the Royal College of Art whose writings cover, amongst other subjects, contemporary art.

3 The Bhatra Sikhs are the pioneer Sikh community to migrate to Britain. See: http://www.bhatra.co.uk/index.php

4 *Our Faces, Our Spaces. Photography Community and Representation.* Edited by Judy Harrison and published by John Hansard Gallery. 2013

5. See note 3

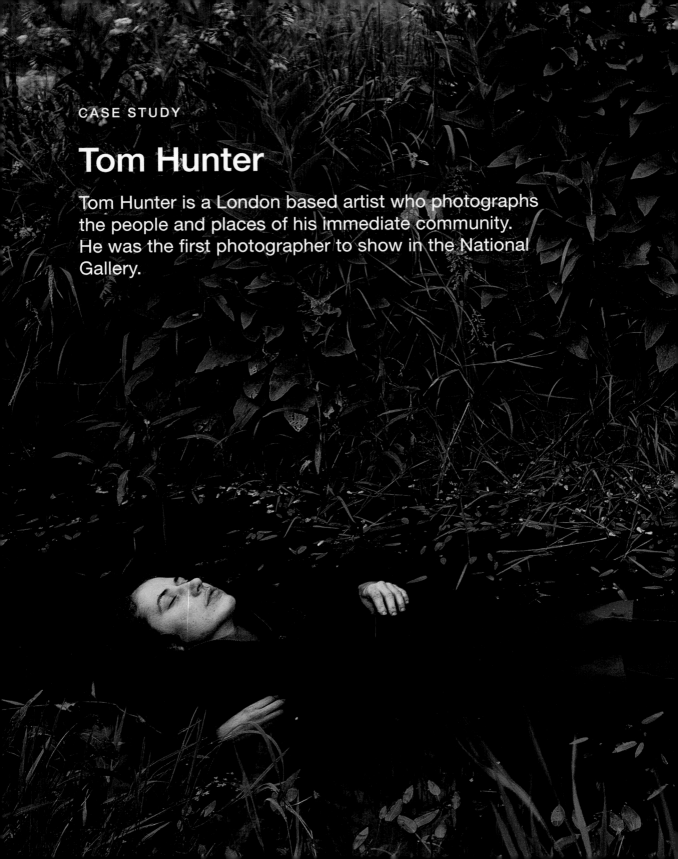

Tom Hunter

Tom Hunter is a London based artist who photographs the people and places of his immediate community. He was the first photographer to show in the National Gallery.

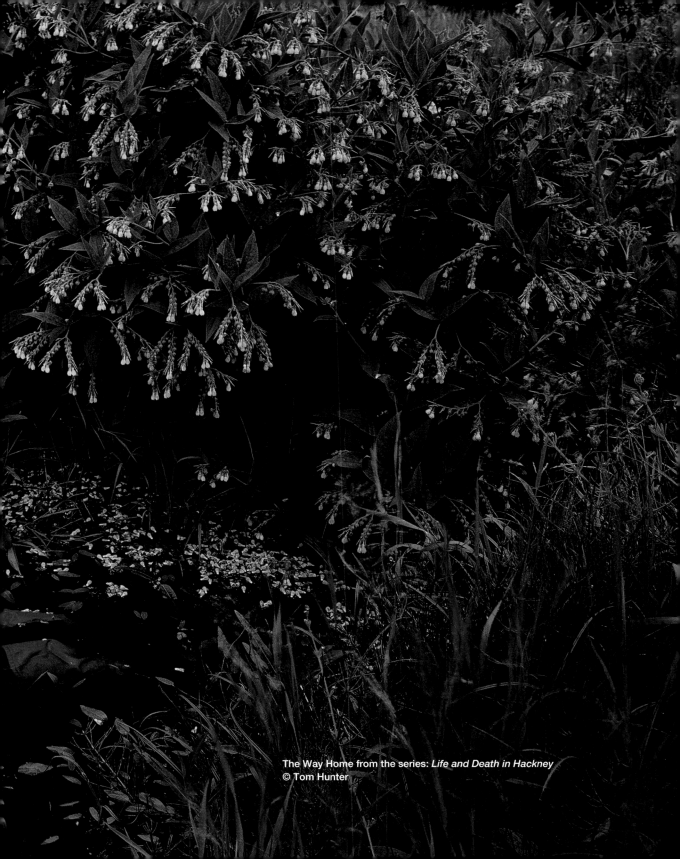

The Way Home from the series: *Life and Death in Hackney*
© Tom Hunter

My WORK IS ABOUT COLLECTING stories, historical stories or contemporary stories, and reinterpreting them. I see research as having many functions but the main one is to provide background information. There is theory-based research—the ideas—and then there is the practical side. Some people separate those but I see them as interconnected. The product in my case is the exhibition, book or film. The research is everything I explore to come to that final result. Its influences, ideas, methodologies. It could be films, radio, TV, popular culture, literature.

Quite often, I don't just produce the final image, I am making a lot of working images over what can be a sustained period. I think that as I keep on doing projects all this research gets mixed together and becomes an ongoing discussion with myself. Ideas keep on recurring and get added to. It's a fluid process. Layers and layers of knowledge, information and influences get built up. They change, modify and mutate. When they mutate is when it gets most interesting.

In some ways my whole life is my research. I suddenly find that everything around me relates to what I am talking about and permeates it. You have to be tuned in to everything that is going on, not just your specific research, as I think that in some ways it is your job as an artist to be part of the zeitgeist. When an artist's work works, it's because lots of people are thinking about the same ideas at the same time.

I feel like I am a human library a lot of the time. I very rarely write things down. I used to but realised it doesn't help me. If it is going to stay there, it will stay there. If I've got to write it down and keep referring to it, it means it's not that interesting to me. The images that make an impression on me stay with me.

I keep on coming back to the same things; the same images, themes and motifs keep sparking things off. I've got a huge backlog of images in my mind, they stick with me and it can be years until there's a story that reminds me of the picture that I saw by John Constable, or Velasquez, or Vermeer. Then I go back to look at the original again. I think about the image and how it would work.

Then I research the artist. I read biographies but mainly the history of the period and what was happening in the lifetimes of the great artists. Why was Caravaggio, for example, painting prostitutes from his neighbourhood as Madonna figures in a church? People may admire his work but not realise that what he was doing was incredibly radical in its time. Researching the history and context makes the painting come to life for me.

Many people think the interesting aspect of the picture is the aesthetics so they recreate it. To do this you have to have period costume, the same set-up and light. But it is a mimicking and has always seemed strange to me. When the great artists looked at a nude or a reclining

figure they wouldn't copy it. They would be thinking about what it was about the reclining figure, the form or religious meaning that was influencing them and how to make it their own.

Anyone can copy a picture. But making it my own and talking about my life and times, my surroundings, the political climate and the things that are going on now is very important to me.

When I am researching these things I don't see it as a job. It's a pleasure. All the bits that I am most interested in just naturally sit there. Reading about Vermeer, or Caravaggio or Velasquez brings a whole picture to life and a whole backstory around it.

I see myself as having been an artist in residence in Hackney for nearly 30 years. I find everything connected with Hackney

The Vale of Rest
from *Life and Death in Hackney*
© Tom Hunter

Woodberry Down from *Unheralded Stories*
© Tom Hunter

interesting. Stories come to me in lots of different ways. The *Hackney Gazette* talks about stories every week. I very rarely cut them out anymore—they just stay in my head. Stories come from the pub, from tearooms, and now from the school playground where I pick up the kids and parents talk.

An important research theme for me is housing. I moved here and ended up in a squat because I couldn't find or afford anywhere else to live. It was a desperate situation. It's unstable housing and you can get kicked out at any minute.

I went to the National Gallery as a kid and one of the paintings that I've had in my head from childhood is of *Adam and Eve in Paradise* by Cranach.[1] Cranach presents a world where there is no rent collector, no mortgage, no banks. It is a Garden of Eden and all you do is eat your apple under a tree and life is paradise. The theme of paradise runs through my work. When I left school I became a tree surgeon and worked for the Forestry Commission; I have always been fascinated by trees. They are the lungs of the planet and provide shelter, food, wood and materials for life. There is something incredibly symbolic about the Tree of Life. Hackney is an inner-city area but I've always tried to find my Garden of Eden here, looked for my little paradise in an aggressive, very urban environment, mostly concrete rather than mostly trees. The tree motif has brought a lot of nature into my work over the years.

Cranach's image came back to me when I was involved in the *A Palace for Us* film project with the Serpentine Gallery. One of the participants in the project described the estate as 'a palace' to her when she first moved there from the slums in Shoreditch. But I was there when the estate was being pulled down and I saw the steel shutters going up to keep squatters and homeless people out.

Then, incredibly, in the middle of this estate there was this beautiful pear tree. The girl playing with her dog became everything that Cranach is talking about; the religious struggles in Northern Europe, the Protestant Reformation of Martin Luther, about Church corruption and about finding paradise and not getting confused by wealth and money. I wanted to bring in that concept of Adam and Eve and the apple that everyone has in their subconscious, but make it about London today and our young people.

This girl and her dog were there. There was very little to do. It was very simple. But that is because for 20 years I had been looking for that tree. All the research had already been done. I'd noticed this place two years before. The ivy was growing over the metal shutters and I saw this as a perfect spot to place someone. So I was just waiting for the right time to create that image, *Woodberry Down*.

I've got very clear ideas and that can make things easy and quite quick. So I did

Death of Coltelli
from *Unheralded
Stories*
© Tom Hunter

maybe 10 different images, slight variations. The dog moved slightly—it's a slow shutter speed. I produce my images on a large-format camera; there is no flash.

But then I get to produce a large-scale photograph that has a presence, an aura like a painting in a church or a museum has. When Cranach made his picture, all he wanted was for people to just stay with it. I'm hoping for the same thing. It may just mean that the audience look at that picture for one second more and then

move on. Whereas someone else will know Cranach's painting and can unpack it. I'm hoping that it works on different levels and that there will be some new people who think, 'There's something interesting about this, what is it? Why has he done that?' Then they might go onto my website, or read one of my books, which give more information about my work.

People argue about whether my work is documentary. A lot of my work is a

document of what's happening around me but I'm *staging* photography. I love that imaginary boundary between documentary and fiction. Where does one finish and the other start? I like to think that my work skirts around it.

When you read people like Thomas Hardy his writing is the most clear, unflinching document of that time. But if you want a factual document you'd have to go to the parish records to read about births, marriages and deaths.

But what do you get from that? When you read about Tess of the d'Urbervilles or Jude the Obscure, you really get inside the mind and life of someone. You're there. That's what literature does so well.

I don't think there is a clear division though every photograph is a document of a particular time. But people do believe the photograph, more than they believe Thomas Hardy's writing. They think that writing must be fiction.

Anchor and Hope
from *Unheralded
Stories*
© Tom Hunter

When people see my photograph they believe that is a real girl and a real place. And it is—when I took that photograph she did live there, that was her dog, that's the tree on the estate, that's where she played, those were her clothes. I'm not making it up or dressing her. But I did say 'Do you mind just standing over there, that's how I want to present you to the world?' A documentary photographer would move around and change his perspective, whereas I move the subject.

It was the same with *Ophelia*.[2] I saw that picture and it stayed with me. I got really interested in the Pre-Raphaelite Brotherhood, how they were talking about Victorian England and Britishness. I was thinking about how I could talk about beauty, about narrative, about the urban environment around me. A few months later a friend fell into the river after a rave party in Hackney Wick. I thought this was a contemporary narrative I could recreate. It's not the Shakespearean narrative—it's *my* Shakespearean narrative. Then it took me ages to find the location, work out what time the light came, then find the right person, time of day, clothes and when the flora and fauna were right, so that all the elements would be right when I pressed that trigger. The final image, *The Way Home*, took me 18 months.

Locations have never been a problem. Walking around, cycling, running, driving. It's the landscape that I inhabit. I found a location before Christmas and it is still buzzing around my head. That could stay with me now for years until the right story or person comes along. Finding the right person is harder.

Research doesn't stop when you take the picture. I process them and then often I don't look for another week. Then I put them on a light box and leave them there, for months sometimes, to get a bit of distance. I go out to capture something with a clear idea of what I want to capture. So I press the button and come back with what I was looking for. But is that what I really want?

In *Unheralded Stories*, a series of Hackney stories, I found a location for the image *Anchor and Hope*.[3] I took this girl there and said, 'Let's just try something very simple'. When I took the picture I didn't think it had worked. But then I realised later that it had actually come together. There are lots of times when you create something really interesting. But you don't know why, because it's not what you wanted. It takes a while before you can recognise it. You can get too fixated on what you want and not what's grown organically.

How to have a dialogue with your own images, how to look at, read and play with them, is a really important part of research. Let an image be, let it filter through and then look at it with fresh eyes. Painters do that. They let things build up.

(facing page)
The Art of Squatting from *Persons Unknown*
© Tom Hunter

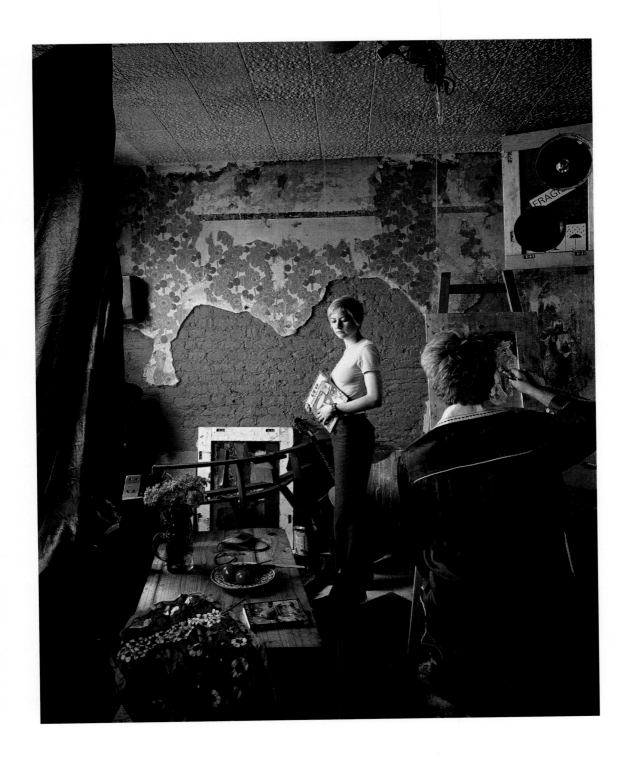

But photographers don't normally do that. During that time I think about the stories and what I am trying to say. What does this landscape mean? How does the body fit into it? What is the conversation between body and landscape?

The film project *A Palace for Us* involved a different kind of research. The first six months were spent visiting groups round Hackney to try and find a community I could work with. We ended up finding this amazing group of older residents on the Woodberry Down Estate who come together for a coffee morning every Wednesday. They were very vocal and passionate about the issues that were affecting them as their estate, which they had grown up on, was being transformed. They were being moved out and then back in. It was a huge upheaval for them and for the whole community.

I saw myself as a facilitator, rather than someone trying to document their lives. I spent six months going on day trips, having tea and chatting, and getting to know them. I decided to do oral histories. They had so much to say and no one was listening and I wanted to get some of this down before it was lost. I did about 30 oral histories in which they talked about their lives, how they came to the estate, and what it was like when they arrived. It was very much practical research rather than reading. It was learning from them—I got all my information from them.

The Serpentine Gallery was very supportive and helpful. All the stories came across as interesting, strong narratives. For me, the photograph gives you a narrative, but it always presents a lot of ambiguity, which is what I like about photography. But for the film I wasn't looking for ambiguity but to get the stories heard.

The *Unheralded Stories* series is saying, wherever you live, it's interesting. The deeper you go, the more interesting it is. You don't need to go to Afghanistan to find war zones, or to Africa to find poverty. You don't need to go travelling—there is everything in your neighbourhood.

I wanted to make a comment on the artists who, from Gauguin on, go to what they perceive as exotic cultures. I'd been looking at the painting, *The Death of Sardanapalus*, by Delacroix[4] for a long time. It's a painting that Jeff Wall and a lot of artists have looked at. But Jeff Wall has concentrated on the form and structure of the chaotic space. I thought about how it depicted a different culture as exotic.

The original painting is of a Sultan on his deathbed and a girl who is part of his harem and about to be killed. The Sultan is having his horses and everyone around him killed. It is an incredibly brutal scene. It is completely overpowering but I have always been drawn to this painting. I was most interested in the girl who is just there on the bed and completely tranquil. For

(facing page)
Hackney Cut from *Unheralded Stories*
© Tom Hunter

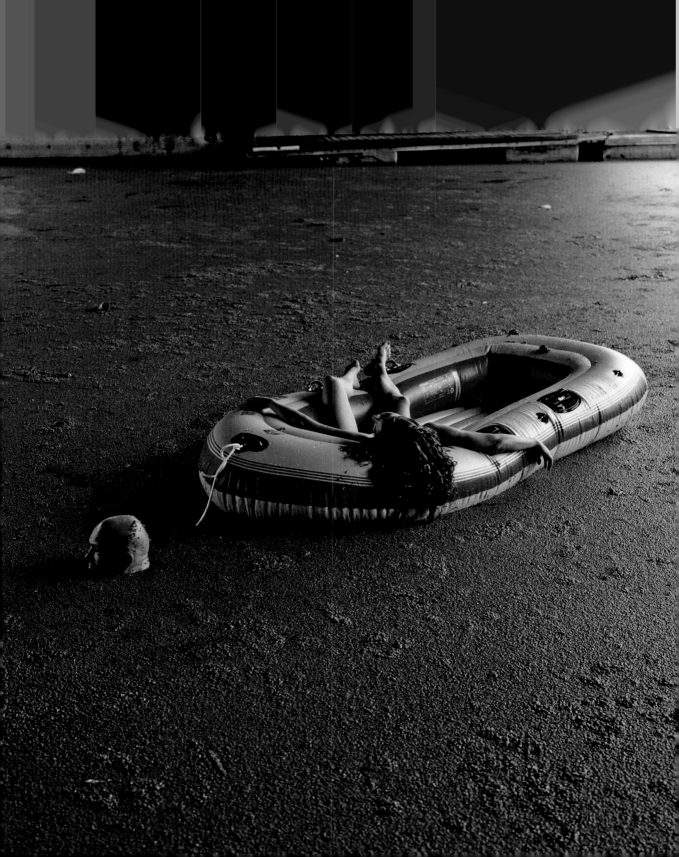

me, all the focus is on her. I started thinking about what makes this painting so interesting. What I have done in my picture, *Death of Coltelli*, is put just her in the scene and take out the narrative strand of the original. As a viewer you've got to imagine the whole scene around her. It becomes like a negative space, which is really important to me.

I was thinking about how I could do that in Hackney. Then at the café round the corner someone said the old lady who had owned the café had died and asked if I'd like to see her room, which was exactly as it was when she died. The café has been here since the 1930s. An Italian woman arrived and built this amazing Italian Catholic culture in Hackney, selling coffees, ice creams and pasta. I went upstairs and the room was a requiem to her culture and her life. In some ways that is what Hackney is about — the mixing of cultures. I don't need to go to the Middle East. The cultures are right here.

In my picture the granddaughter is lying on her grandmother's deathbed. It is a real deathbed. The stains are the fluids that get released when someone dies. There is all this religious iconography around. The image is about her Italian and Catholic past. The Italian granddaughter is the new English. She speaks with a Cockney accent. She has the Italian name Coltelli. I wanted to talk about contemporary Italian culture and contemporary English culture and how it's changed.

Interestingly, this is now a Turkish kebab shop — which takes us back to the Middle East. That is what is so amazing about Hackney. It's always been a place where immigrants have arrived. They have set up shop, brought their cultures, their food, their languages and integrated it into the life around them. They have made it an incredibly rich, diverse and dynamic place. But they have changed as well.

So it is a comment on multiculturalism. It's a celebration and also a record of a simple life. Someone who came here, survived, made a life for herself and produced children and a granddaughter. It's all about the granddaughter. I didn't want it to be a death picture — it's about life and death at the same time. Her eyes are very open and she is engaged with life. She is actually being born out of this. There is all this going on — but for some people it is just a picture of a girl on a bed.

I showed this picture at the National Gallery with the original painting by Delacroix, and with Jeff Wall's picture. When you talk about 'audience', it was a dream come true to have my picture in that context, where people would spend a lot of time thinking about it in a place which is lit like a church. Having the original painting there you do take on all the religious iconography and symbolism in it. You do think about life and death and where you fit in. You think about the history of painting, how we paint our environment, how we talk about our neighbourhood, how we present ourselves and our culture.

The devil is in the detail. If I set this up in a studio—people pay a lot of money to get that right—the right wallpaper, the right bedspread. But in my picture everything is as it was. Nothing has been touched. I knew exactly how it would look. What I have done is just tiny little things like adding one light, which picks up the colour of her skin. I could have shot it in a studio. But for me having that link with reality gives it a whole other layer. It *feels* real. Lots of people I know—and they are great photographers—say they'd have photoshopped it or exaggerated one of the stains. You can change things and, to you, it looks better. But I think you actually lose the authenticity of it. You lose something that really connects. Years of research, taking and looking at pictures means I know what will and won't work, but, of course, I get it wrong at times. And if I start overcomplicating things I lose the simplicity of the message and the amazing link with reality that photography has. So, my picture looks staged—and yes, it is—but it is that real person and real place. It is on that very edge of what is fiction and what is documentary.

Who you represent is a political thing. My work is about the ordinary people who actually live in a place. It is not about bringing in models to make these pictures better. I've been told how to make better pictures by lots of people over the years. But it's the real body, not a manufactured body, and not the particular look of a model. It's very important for me that I never use models or a studio. The reality of the place and the reality of people are very important. I do think all these people are beautiful.

There is a beauty in diversity. There is a beauty in the diversity of race, sex, gender, body size and I represent that. *Unheralded Stories* gives everyone a chance, gives ordinary people the chance to shine equally.

Interview by Jennifer Hurstfield; edited by Jennifer Hurstfield and Shirley Read

Notes

1 *Adam and Eve* by Lucas Cranach the Elder, 1526, can be seen in the Courtauld Gallery, London.

2 *Ophelia* by John Everett Millais, 1851/2, can be seen at Tate Britain, London.

3 *Unheralded Stories* is a series of images depicting the folklore and myths that have built up around Tom Hunter's community and surroundings in Hackney over the past twenty-five years.

4 *The Death of Sardanapalus* by Eugene Delacroix, 1827, can be seen in the Louvre, Paris.

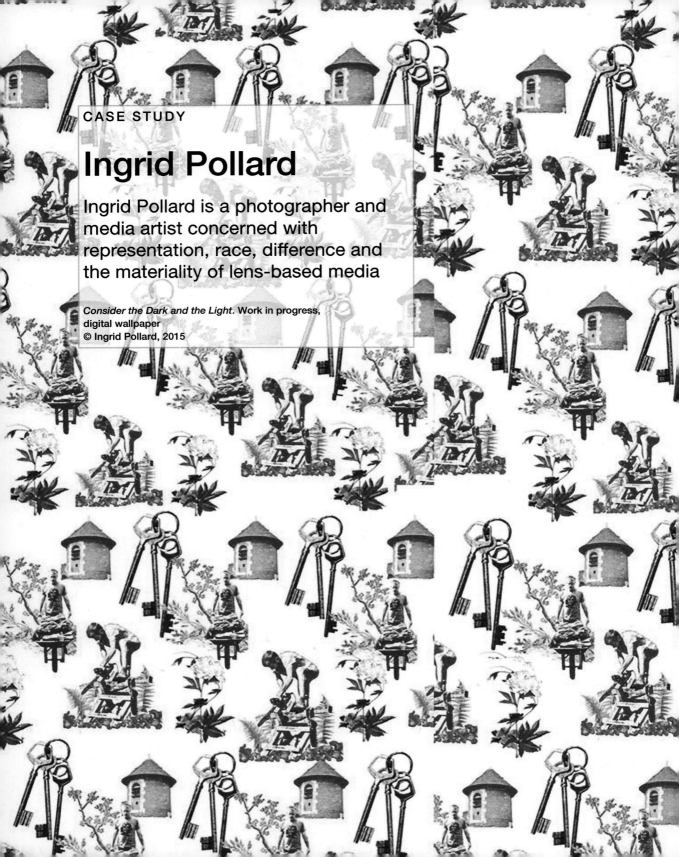

Ingrid Pollard

Ingrid Pollard is a photographer and media artist concerned with representation, race, difference and the materiality of lens-based media

Consider the Dark and the Light. Work in progress, digital wallpaper
© Ingrid Pollard, 2015

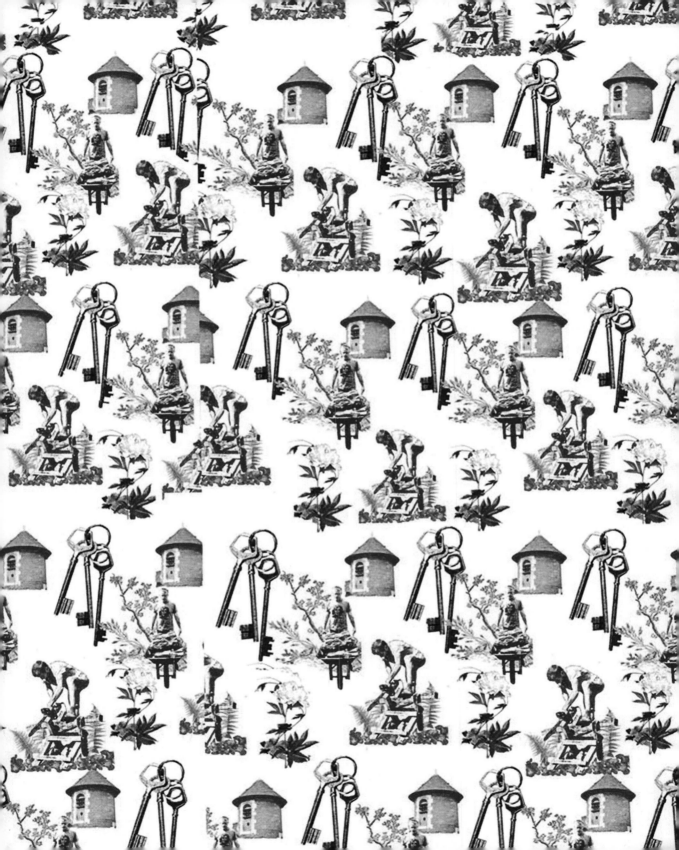

My WORK HAS ALWAYS HAD A research element to it but I don't know that I ever call it that formally. It's more like an area of interest that might carry me to look at some books, see a film, talk to people or travel to a, b or c as a start point. It encompasses a bit of everything. It depends on what I'm working towards and whether the end point is an exhibition or larger project or an ongoing line of enquiry.

Residencies, for instance, tend to be a useful research model. Sometimes a residency is a time for me to do research or just to follow up an idea but that's rare. I've had 20 years of doing residencies of different type, place and duration. They offer travel, new situations and communication with people. Sometimes, a bit of running away from London. There are a different set of issues associated with each, but there's seldom enough time for them to get really problematic. It can be a truncated and squashed time, three weeks, three months or a year. But there is a depth to the interactions.

The shorter residencies can be tougher unless I am familiar with the place or have been working there previously, when the residency can be a way of completing the research. I need the time. Having an end point, a means to disseminate the work, is always good for me. But, even so, the end of residencies is usually the time it feels like the moment to begin; even a year never feels enough time. Longer residencies do work better for me, being in a new situation and testing out and

adding depth to ideas. It might also be about relationships formed, the geological interest of a new place and new materials to explore. The materials I explore and the place always have a direct relationship to each other, which runs through the work I'm doing.

The enduring issues that I return to are landscape and people and ideas of hidden histories—the interactions and the outcomes about how the landscape influences people's behaviour and shapes the land through ownership, commerce, development, politics.

My work tends to be lens-based-photography, obviously, and through to video, print making or books—I maintain a commitment to the still image. Vision, light, the eye and how we see light and how we manipulate it—I can't separate all that from the camera.

I undertake research that can be archival, literature, images or anthropology. Issues of black representation and black history continue to be central aspects. It is about investigation into the things that then make sense of the present, or provide us with different ways of translating the world. It's also something about looking afresh at these things—combining sometimes incongruous elements that often don't go together. I like the throwaway, the postcard as an authoritative voice, as the voice of the state, for instance. I work with things that are not usually valued, or given importance, like the unknown figure at the

scene or the voice we'll never know. You may have just one letter in the archive and I think it stands in for others that we will never be able to retrieve. The use of anecdotes in research, and for me as an artist, is valid because we'll never know about those dark spaces or those dark matters of the unknown figures, they'll always be shrouded. So, I make it up based on premise gained from research. Kim Hall, in her book *Things of Darkness* on research on Renaissance text and race,[1] maintains that it's feminist practice to do this type of insertion into history, because those are voices and lives that we won't ever find, so it's quite legitimate to fill them in by educated and reasoned guesswork.

Stuart Hall[2] said to me 'theory is just a tool'. A book could just have one phrase, one idea in it and this can be enough to hook me, to start a train of thought for me to work with. Just one phrase can be very, very rich, so sometimes it feels like that is enough to get a burst of thoughtful energy to go forward to do the hard work of research and practice of complexity.

For example, I took part in a residency in Northumberland. I read books about the technical aspects of mining, books for mining apprentices that had quite a lot of instruction, what kind of pick they use for instance, identifying coal seams, complicated machinery, etc. I found fossils on walks through the local landscape and fossilised marks of a river and mud from the same period as the local coal seam. I made connections between form and geological features. I gained a basic understanding of coal being formed by the heat and compression of plants over many aeons of time, plants that I could see in the diagrams, beautiful illustration. There were also issues raised around rural economies, the people who worked the local farms, the historic monies and privilege gained through exploitation of natural resources. The form of my work, the real objects were reflections of the original apprenticeship books which I interpreted through making flick books. I used blind embossed prints as an expression of the pressures and events that went into the formation of coal. The important research took place in the Mining Institution in Newcastle with its

Consider the Dark and the Light (2015). Camera obscura portraits (digital prints) © Ingrid Pollard

Consider the Dark and the Light (2015). C type digital print
© Ingrid Pollard

literature around mining and digging, geology and history below the surface.

Initially, these elements of reading, investigations into psychology, visiting galleries and history archives are all there, then I start to fine tune it into what I'm actually looking at and it gets honed down. But, in terms of looking at books, biography, landscape and geology and interrogating photographic processes, it is always something that motivates a line of inquiry, even when I'm not working on a project. I struggle with text and language and that's always very important.

I am constantly trying to find someone who has made research into a form of practice, used it differently. For example the book *I Send You This Cadmium Red*,[3] which is a correspondence between John Berger and John Christie, in which one might send a poem and the other reply with a painted yellow circle, it's just refreshing.

There are ways that the labelling of me as 'only' a woman and a black artist has been imposed on the work I produce from the beginning. Circumstances meant I did film and video, which has formed the way I research, I think, starting with an empty space that is filled, filled with light, surface, the beginnings of a narrative, rather than blank canvas.

The making and the research are happening at the same time. When I first began making images for exhibitions it was more about pictures in frames on the wall, whether they were analogue, black and white, or light-boxes. Now they have many more different elements. With some works I can envision how it's going to look from the start and how to achieve that— I know if it's going to be wallpaper or it's going to be a book. But how and why it is that form, is the thing that has to be worked on quite carefully for quite a long time and includes all those research elements, biography, literature. The end point is sometimes a matter of stopping; I get a deadline and have to stop because otherwise sometimes I'd just go on and on.

Analogue and digital are different tools and ways of working. I want to have as many tools as possible. Certainly, I use negatives. A lot of the time I'll scan negatives I've produced using camera obscura recently, photographing the image that's on the ground glass or on the viewing tabletops. So, form and tools are expressive implements, part of research, it's always what does the job really. But I know whatever I do will eventually get scanned for publication and disseminated that way.

I've committed myself to the understanding of the photograph as evidence of research and as a research outcome for many decades. It is a type of research because it's got particular elements that can be seen as theoretical research, which can be a set of concerns, a hypothesis, issues and questions, which have been resolved and the conclusion is the book or the exhibition. The differences

Regarding the Frame (2013). Print image (blind embossed and relief print) from digital source
© Ingrid Pollard

in my work as an exhibition, an installation, a book or portfolio don't really reflect different research methods; it feels very obvious to me that they are all outcomes in various forms of the same research process I've described.

My practice involves the use of whatever tools are at hand and these different forms require that I acquire new skills, modes of enquiry and expression; that's a major component, the continual breaking into new forms. For instance, when I was doing the residency in Northumberland I joined the ceilidh band, the choir, and took part in the Scottish dancing classes. These, in a strange way, felt like research, even though it was also fun and a way of getting to know people and about embedding myself in that community in a more structured way, too.

I did make photographs of the Scottish dancing and showed them as flick books; as a way to emphasise movement, it felt appropriate. But, then, I knew how to make flick books before, but I didn't know how to do Scottish dancing or be part of a ceilidh band. There was a skill to be gained but I can't divorce it from getting to know the people and being immersed and included in that community. So, the skills and the outcome and what I'm doing there are wholly linked.

I haven't set out to 'do research' formally as an exercise; I tend to be following an interest, which can become a work, but I have set out on something and found it wasn't going to go anywhere. It was a much earlier residency, which was also a type of commission. It was in those early heady days when digital was just starting for me, I remember it took hours to do complete layering in Photoshop; we had to leave it over night to complete the transformation. I didn't know very much about the digital beyond transformation or manipulation and storage but it was a way to gain new skills that I wanted to learn. At the same time, the residency was an investigation of a particular location and the people who worked there during the summer season. But the three elements— the location, the new digital tools and their outcomes—were *also* obliged to fill the gallery's three spaces. I found these could not work together for me. The elements of process, materials and practice and investigation and study were all too much of a mash in that moment and it was frustrating and torturous.

I do make recordings, use sketchpads, pens and pencils, scrapbooks, notebooks and cameras, which are all so lovely. I print pictures, though less now because it's expensive. I do pin things up, print them; digital work can stay in the computer much longer so I tend to have fewer waste prints around.

I'm now doing a PhD by Publication and the requirement is to evaluate a body of my own work, commentating on my particular hypothesis, making conclusions about why those pieces of work constitute research and contribution to new know-ledge. I have to draw out connections that they didn't start out with. I think I've made

Regarding the Frame (2013). Collage digital print © Ingrid Pollard

it more difficult for myself by pulling out strands that connect quite a few pieces of work. If it was someone else's work it would almost be easier, but looking at your own work—I'm the expert, I know so much about it, but I'm in the position of staying on track to answer the research questions only. I'm examining six bodies of work and picking out things that were important and how they were linked through ideas of migrancy, home and belonging. It's something I can carry forward, learn and adapt, distilling ways of examining the work of others and student work.

I'm always very interested in audience response and how my work is perceived; it can be the element in the dissemination of work you don't always come in contact with. I can get critical responses and other forms of review, but often these take some time to filter through. That is also something that is different and useful about residencies. The local community can respond to what I do and the work produced very quickly; they're also much more involved in it. They usually let you

know what they think about what you're doing. They may well be more familiar with that location than I am. I was told by someone from a residency that they like going to the artists' exhibitions because they get to see what someone else, from outside the area, thinks of the place they live in, which is great. They tell you if they don't like it as well, of course.

It can be slightly different with peers and the professional community being much more slippery in telling me what they think. It is usually really good friends who will properly tell you what they think; it feels like most people try not to. I find it just as difficult; I try to be honest and direct but it's hard in way, which is different from a published review. I know how much people put into producing their work. But the response and evaluation of others is always important. I take some sort of validation and it is a marker that people do keep asking me to keep them informed of future works and events of mine. That's one of the guideposts. But as Mark Sealy[4] says, 'You're only as good as your

Regarding the Frame (2013). Digital print © Ingrid Pollard

last exhibition.' The formation of relationships is as important as the political and cultural institutions that I've worked with over the years. These relationships that have formed, the moments that are shared over a long period of time, with artists or non-artists from the local communities that I am embedded in during residencies, can become genuine, long-term, friendships.

I do have a little mantra about research, which I say to students: 'reflection, dialogue, question'. It means doing the work of making pictures. I include evaluation as part of the reflection. Do it, look at it and reflect on it and then do it again based on your reflection and research. I think that if you mention the word research to a lot of students they may become restricted by that, it becomes a thing that appears not connected to their practice at all. It's a problematic word and students may think research can only be found in a book, or looked for online, but is not necessarily an activity they do quite naturally, such as talking to people, for instance, so I try not to use it or define it. You know, going to the cinema is research. I can see a lot of students who are already doing it, they just don't know they are doing it, some are really incorporating research in their practice and it's all mixed in together. It might include travelling or conversations or even playing the ukulele. I'm still waiting for my tango project.

Interview by Andrew Dewdney; edited by Shirley Read

Notes

1 Kim F. Hall (1995). *Things of Darkness: Economics of Race and Gender in Early Modern England*. Ithaca, NY: Cornell Press.

2 Stuart Hall (1932–2014) was an influential cultural theorist, writer, teacher and campaigner, and founder of *The New Left Review*.

3 John Berger (1999). *I Send You This Cadmium Red: A correspondence between John Berger and John Christie*. New York: ActarD Inc.

4 Mark Sealy, Director of Autograph ABP, www.autograph-abp.co.uk.

Deborah Padfield

Deborah Padfield is a visual artist specialising in lens-based media and interdisciplinary practice and research within Fine Art and Medicine.

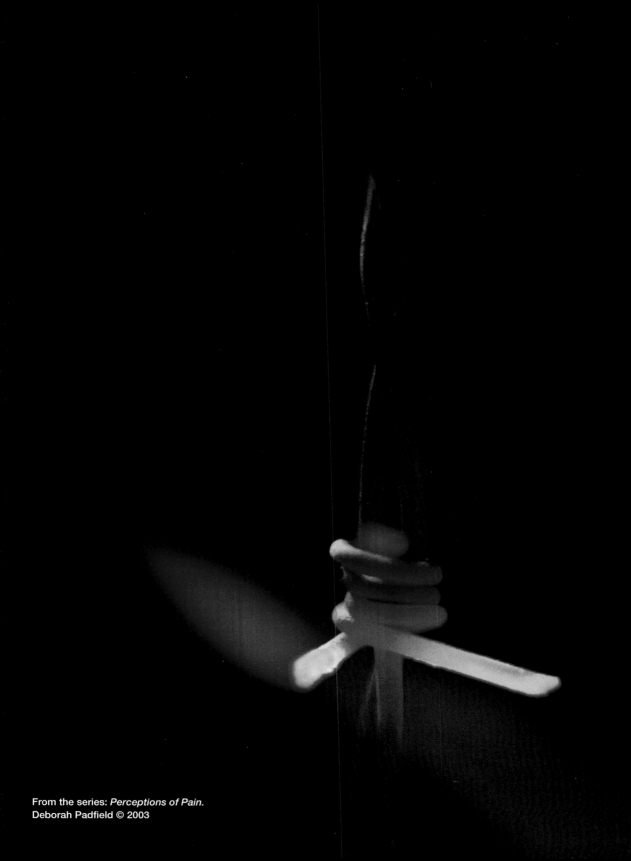

From the series: *Perceptions of Pain.*
Deborah Padfield © 2003

IF I THINK OF MY DEVELOPMENT as a photographer and artist, I would agree research has influenced my work in many different ways. However, I have found myself drawn into a more academic framework within the last 10 years or so, both working in a clinical context and completing a PhD at the Slade School of Fine Art in London, where research, even when practice-led, is more formalised. But it didn't start that way. My approach to research at the outset was a more natural organic process that I think most artists go through in exploring a particular subject they are drawn to. I began to realise, however, that there were some fascinating insights gained from working within other disciplines and in other environments. You have to take a step back to consider how you can explore these different perspectives and approaches within your own process, rather than trying to understand it through a process or discipline you don't understand—in a way, using the approaches of other disciplines to inspire and reveal but not to try to replicate or translate them directly.

It was during my BA studies at Middlesex University (as a mature student) that I became interested in pain as a subject. Prior to this, I had a career in the theatre but following a period of illness and chronic pain following poor surgery, I needed to find something less physically challenging and re-trained in fine art, in particular lens-based media. It was no accident that I was drawn to photography where something seen or imagined can be

directly controlled or constructed by the photographer, which has relevance to visualising pain, which I will come back to. During my time at Middlesex a lot of the tutors were trying to get me to look at pain directly in my work, but at that point it was so close and so raw I didn't want to or just couldn't. There was none of the distance necessary to translate or transform it into anything that would resemble art, or that would be relevant to anyone else, so I made work about other things.

It was following an exchange visit to the Czech Republic with FAMU, the film and TV school in Prague, that things began to change. It was partly to do with arriving in an unfamiliar setting, with a language I couldn't speak which forced me to look at everything afresh. I began photographing different institutions, from the Houses of Parliament to a hostel for the homeless and various hospitals. It was during that process I realised I was photographing something to do with isolation within different architectural spaces and that that had something to do with pain. It was from that point that I began to acknowledge what the subject of my photographs was, in a way that I hadn't before. I was photographing the isolation of pain and/or the pain of isolation.

I began talking to my own pain clinician, Dr Charles Pither, then a consultant pain specialist at St Thomas's Hospital in London and medical director of the INPUT Pain Unit there. He talked about the difficulty for patients in communicating

From the series:
a stitch in …
Photography by
Deborah Padfield,
2008.

their pain and with clinicians in understanding it. I was surprised to learn that pain's incommunicability was as problematic for clinicians as it was for patients. Pain is a subjective experience but we often attempt to measure pain using objective methods such as the pain scale, where clinicians ask the patient to rate their pain on a scale of 1–10. Dr Pither described how he was interested in the way visual communication might create a bridge to the problem of describing pain more effectively. Using a body map he asked his patients to draw or mark the location of their pains. Some patients would draw on it, some would use different colours and others would go beyond the body map outline in an attempt to convey

some sense of their pain through this visual method. I talked about how photography gave me a certain sense of control over what I was photographing, over the subject, which I was beginning to realise for me was reversing the sense of having no control or being out of control as a pain sufferer in a hospital. I began thinking about how that process might be useful for other people.

It was through our conversations that the *Perceptions of Pain* project began to take shape and with a research grant from the Wellcome Trust's Sciart programme.[1] I began working with patients at INPUT with musculoskeletal pain to make photographs, which would help them

From the series: *Fragile Boundaries.* Photography by Deborah Padfield, 2007–2008.

communicate or open up different conversations with their clinicians or with their families about their pain. I was interested in the way images generate verbal dialogue, and how I could explore this in more depth. I came across research from academic disciplines very different to my own, and clinicians who were looking at the challenges of pain in very different ways via different methodologies and, in particular, the growth of interest in 'narrative medicine' as coined by Rita Charon. I started exploring whether it was possible to make something as invisible and intangible as pain visible and shareable and, if so, what

type of language would this lead to. Would it be possible to co-create images with someone else, which reflected their experiences of pain. Could those images be useful in a clinical context and to other people suffering from pain or those caring for them? That's what drew the project along and into more academic interpretations of research, but I still think it's not entirely academic because it is a creative process, and somehow you have to try to keep that sort of intangible element in there.

There is very little space in the methodologies and analysis of clinical

research for individual insights or perceptions. Whereas in the creation of artwork, there is a lot of space for individual insight or observations, so there is a tension at the meeting of these processes. The challenge is to find a middle ground between those processes, a parallel perhaps with the tension between the patient's and clinician's perspective. If you come with different agendas and different bodies of knowledge, creating a mediating space through the interpretation of an image allows the tensions that exist to be unravelled and shared within that space, rather than straight across at one another.

The photograph becomes a third or mediating space.

What is interesting is not only how images can facilitate an improved mutual understanding between clinician and patient, but also observing how photographs, in particular, or the conversations they generate can help us navigate other situations where there are two or more different perspectives. Here, the image can create a negotiated space, maybe a freer space, allowing the imagination or unconscious to work. It encourages a sensual response revealing other ways of knowing and understanding.

From the series: *Fragile Boundaries.* Photography by Deborah Padfield, 2007–2008.

From the series:
Perceptions of Pain.
Photography by
Deborah Padfield
with Nell Keddie,
2001–2006.
Reproduced by
kind permission of
Dewi Lewis
Publishing.

Research is a practical creative process. When I began working with patients at St Thomas's, it seemed important that the patients I was working with were very much part of the process of creating the images. I felt if I came along and re-appropriated their experiences I'd just be re-presenting them in much the same way as their experience and identity had been re-appropriated numerous times during the diagnostic corridors. I felt the process of making images reflecting their experience had to be a collaborative one, but in that there is potential conflict.

There are aesthetic decisions you want to make and directions that the patients want it to go in, which you have to acknowledge and so it's a constant negotiation between the two of you. Interestingly, it also leads the work in directions it would never have gone in without this collaborative process and the input and creativity of the pain sufferers I worked with. They forced me to work with new materials, for example, and I started using ice, moulding different body parts and making reliefs, which I filled with water and froze to make ice sculptures and photographing these as they dissolved. Some patients had talked about the dissolving and changing nature of their pain, as well as the literal sense of the coldness and texture of ice. Then there were other processes such as setting fire to various objects, learning how to make concrete (a common metaphor for pain experience) or printing on balloons or other surfaces with liquid emulsion. Because we were using purely analogue photography during *Perceptions of Pain*, there was

I think there are tensions for those working in creative disciplines where it isn't always easy to evidence value, unless you adopt the methods or evaluation strategies of other disciplines. It feels sometimes as though you are always trying to do that in order to get published in a medical journal, or get more funding or pursue it in academia and the danger is that the very thing you offer as a creative practitioner gets lost. The value that creativity and creative practice brings is a quality that engages the senses, engages the unconscious, engages people's own stories and associations, it engages the viewer's responses to it, and I don't want to pin that down, so part of me is still fighting for a way to stretch what is possible to publish within a medical or allied journal.

(left) From the series: *Perceptions of Pain*. Photography by Deborah Padfield with Nell Keddie, 2001–2006. Reproduced by kind permission of Dewi Lewis Publishing.

(right) From the series: *Perceptions of Pain*. Photography by Deborah Padfield, 2001–2006. Reproduced by kind permission of Dewi Lewis Publishing.

nothing digital about it at all—the images were all physically manipulated in a very labour-intensive process. They were torn and stitched, and printed under different levels of glass in the darkroom and then reprinted and re-photographed with fragments of glass on top, so in the end they were quite complex. These were things I wouldn't have gone to and aesthetics I would never have arrived at through my own process if together we hadn't needed to suggest a certain sensation or a certain material quality in a particular way. There's a real desire to have pain validated, and there is something validating about a photograph I think, more than any other medium. Because of the 'authenticity' we still ascribe to it, its apparent ability to

document 'reality' it is the perfect medium for validating subjective reality.

A lot of the images ended up being quite surreal, which may have come from the influence of being in the Czech Republic and falling in love with the Czech surrealists and their photomontage. There are so many aspects of your life that end up influencing the work that you make but you don't realise at the time. Equally, pain itself is surreal and the way you can depict it has to be through some surreal juxtaposition of objects or forms or through metaphor. David Biro claims pain can only be described metaphorically.[2]

I see collaboration as part of my research but it's a specific part of the research.

From the series: *Perceptions of Pain*.
Photography by Deborah Padfield with Nell Keddie, 2001–2006. Reproduced by kind permission of Dewi Lewis Publishing.

(left)
From the series:
Perceptions of Pain.
Photography by
Deborah Padfield,
2001–2006.
Reproduced by
kind permission of
Dewi Lewis
Publishing.

(right)
From the series:
Perceptions of Pain.
Photography by
Deborah Padfield,
2001–2006.
Reproduced by
kind permission of
Dewi Lewis
Publishing.

I don't think I really articulated it in the beginning as a co-creative process, it just became obvious when I was having discussions with people about their pain—they had the most amazing imaginations and range of metaphoric images for pain. The process we were both involved in was trying to make those tangible and put them onto a 2D plane, to make them sharable with other people. With everyone I worked with it was a different process, because they were different people, bringing different things. They wanted to work in different ways and I realised these were important negotiations. How we worked together never really became fixed. I think that's why the images went in so many directions, ending up with a bank of images that somehow still have a sort of homogeny, I suppose inevitably because I

was involved in all of them as some sort of constant, but they were also very varied reflecting each individual.

I have a very strong belief in the ability of images and the creative processes to help us share experiences and to understand each other. I think the co-creative process is the thing that probably has had more influence on my practice than anything else, and I have realised bit by bit that this has become part of my practice. I felt if I'm going to photograph other people or other people's experiences they need to be recognised within that process, so that I'm not objectifying them and then again by extension being re-objectified by the viewer. I wanted them to have some control over the process. On the other hand, as a practising artist, I didn't give

From the series:
face2face.
Photography by
Deborah Padfield
with Alison Glenn,
2008–2013.

pain to be willing to have these large-scale images exhibited in their own hospital and beyond for other people to see. A lot of the patients said they wanted to exhibit them to take the stigma out of pain and others wanted people to start talking about pain and increase public awareness and understanding. There was a general feeling that maybe the response we got from the comments cards and from relatives and friends saying they understood pain experiences much better was valuable. Also that the conversations that developed generated by the images was equally valuable.

them total control, or it would be their work. In the discussion with participants I told them I would retain the copyright but that they would always be credited as co-creators, if they wanted to be, and would be asked for their consent to show the images in public. Everyone, without exception, wanted to use his or her own name. It was important because it was a stamp of ownership and recognition of their experience and input. I also needed to recognise my own time and experience, I wasn't going to take myself out completely, so it became very much a joint project.

At the end of the *Perceptions of Pain* project some of the images were exhibited at St Thomas' and Guy's Hospitals, printed very large, before touring nationally funded by Arts Council England. It was courageous of people with that level of

As a photographer or as an artist I cannot surpass what clinicians already do, and do brilliantly. All I can do is stretch the boundaries or suggest other ways of looking at something they are already looking at. I try to get the process away from a more reductive questioning and open up a broader type of dialogue that might still be relevant to have in a clinical space. The images appear to be a tool or a trigger for the patient to direct those conversations more, a space to be able to bring in things, which might be deemed less medical but are relevant to their experience of pain. The images create a space for sufferers to be able to describe the impact pain or its management has had on them and to have a space where they take control of the narrative in the consultation. Although welcomed by pain sufferers, I think at the moment it is still uncomfortable for some clinicians, even for those who are fascinated by and supportive of the work.

The *face2face* project was a development from *Perceptions of Pain.* I was again working collaboratively but this time with facial pain specialist Professor Joanna Zakrzewska and patients from the UK's only specialist facial pain clinic at University College London, and later, running workshops in association with the National Portrait Gallery. The photographic images developed during the *face2face* project are now the subject of a multi-disciplinary project *Pain: Speaking the Threshold* where we are exploring the value of images and image-making processes in the diagnosis and management of chronic pain through different methods and lenses and have developed a resource of images or PAIN CARDS, which we are currently piloting for clinical use. We hope to make this more widely available once we have researched and understood its potential value. We have come together as a multi-disciplinary team, and I therefore imagined the type of dialogue we would have would expand and be quite multifaceted. The conversations have been rich, and as the process has developed, have in fact got richer and more complex but at the beginning I felt there was a dominance of medical language and a medical methodology—which we all allowed to happen. That is not to undermine those who bring that to the table as it allowed us to produce analyses that medical professionals would take seriously. However, I feel that the language of the arts and the insights of the arts find it more difficult to assert themselves. They are less fixed if you like, they're more ambiguous and there is very little space for ambiguity

From the series: *face2face.*
Photography by Deborah Padfield with Alison Glenn, 2008–2013.

From the series: *face2face.*
Photography by Deborah Padfield with Alison Glenn, 2008–2013.

From the series: *face2face.*
Photography by Deborah Padfield with Alison Glenn, 2008–2013.

in medicine and that worries me. I think the challenge is the risk of losing something quintessential about the creative process. I'm hoping that the images might help to promote a certain tolerance to ambiguity. I think it needs both clinicians and patients looking at the images not to be threatened by them and to not mind talking about them. Maybe there is a call for not just working with patients but also working with clinicians in handling or looking at images, exploring images together so they become more familiar and loss of control over the direction of conversation becomes less threatening.

Although there is a lot of discussion and a lot of funding available for interdisciplinary approaches and teams, there are few journals at the moment that will accept papers integrating rigorous quantitative scientific methods with the processes and values of the arts. It is paid lip service to, but actually if you go too far away from scientific methods the journals will not accept your paper. I think this presents a challenge to us as a team. Equally, there is clearly a solid desire from everyone in the team to make it work, and a vast amount of expertise available. So, despite some difficult conversations, a year and a half later we are still all meeting regularly, the analyses are being done by the different disciplines which will inform a final interdisciplinary paper and, for me, it is a really positive and exciting process. What is equally exciting is the distance we have all travelled. I feel this has influenced each other's perceptions and we have all learned from each other. This would never

have been possible by any one of us working on our own. The challenge of reaching medical as well as arts, photographic and academic audiences remains. The greatest challenge will probably be to get a multi-disciplinary analysis from multi-disciplinary perspectives into a medical journal, but we are trying. If we can do this I feel we will really have contributed to a shift in medical thinking.

To report the findings of this project to a medical audience, I have sometimes had to reduce the images back into numbers, (which carries a certain irony) because many medical journals will only accept quantitative papers. I would like to contribute to a movement to stretch the influence that the arts and humanities can have on existing medical practice because I feel sometimes the actual value that the image brings can get lost, particularly if we try to translate it or reduce it into something it isn't and can only fall short of. I am hopeful that in the end, when we bring it all together, we could produce an interesting piece of work and a much richer one than I would ever have arrived at alone. It will also probably be more objective, as had I analysed the value of the images alone, it would have been an entirely subjective process. I think the sharing of our different approaches and exchange of methods and insights has benefited the work. The co-creative process has extended from the making of the photographs to the collaborative analysis of them and their potential to improve doctor–patient interaction and

From the series: *face2face*.
Photography by Deborah Padfield with Yante, 2008–2013.

From the series: *face2face*.
Photography by Deborah Padfield with Yante, 2008–2013.

communication. It continues to enrich my work and understanding of the subjects I investigate. If we can use the tensions between disciplines as a source of creative energy and a fuel to more flexible understanding of complex subjects all of us benefit. However, in this desire we must not lose sight of toleration of ambiguity or of not knowing, which is an essential part of being human.

Interview by Mike Simmons

Notes

1 The Sciart programme was an initiative developed and funded by the Wellcome Trust, between 1996 and 2006, designed to support collaboration between the visual arts and scientific research, which has now been replaced by the Trusts Arts Award programme. Further information can be found here: www.wellcome.ac.uk/Funding/Public-engagement/Funding-schemes/Arts- Awards/index.htm.

2 Dr David Biro is an American dermatologist interested in ways to communicate pain more effectively. More about Dr Biro can be found here: www.davidbiro.com/index.html.

Susan Derges

Susan Derges uses camera-less photographic processes—often working in the landscape.

Tide Pool 39.
© Susan Derges, 2015

[handwritten note: Doesn't really research, lets her work "research" for her?

Veiws her work as an ongoing enquiry.

Her research comes in the form of consultation and/or collaboration]

...mple of the kind of research process ...t I follow.

...expand a little further, the process of ...king feeds back into the idea and ...rms it, usually in surprising ways, so ...: it's an ongoing enquiry rather than an ...a that first needs to be researched and ...manifested.

...that instance of immersion, I was seeking out a state of immersion in myself, looking for a way of not being a voyeur with a camera gazing at an object through a lens. It was a desire to be more

and so the process that I adopted for making that work was to actually immerse the photographic paper in the riverbed, in the flow of the water. This is quite a clear

Vessel. 2001 light display transparency 16x12 inches
© Susan Derges

Sublimatio. 2001 light display transparency 16x12 inches
© Susan Derges

connected with my subject matter. And through this desire for an immersive state the idea came to use paper in that way.

The idea is never clear at the outset. I don't begin with a totally clarified concept but more of an intuition of something that I'm trying to articulate. It is *sensed*; the territory of it is defined but not completely distinct. So, the process of researching or investigating an idea, which I use as a method of testing the idea, is the process by which the nature of that idea becomes clearer to me. The research will disprove some of it and back up other parts, fleshing it out in surprising ways. The process of research is part and parcel of an idea coming into full fruition or formation.

Another example is my current body of work *Tide Pools*, the initial impulse of which was a dream. The dream touched upon themes of impermanence, fragility and change. The rockpools presented themselves to me as supporting those concerns and a whole process of exploring how to work with the pools then unfolded.

I made several series of images in specific locations, which led to my removing subject matter from these places, into the darkroom. Then, with the advice of a marine biologist, I began animating these things in a recreated water environment, which I could study more closely.

This involved exploring how to work with specimens, sea creatures, water-flows,

movements and simulations of tidal surges. I was building up a whole picture of this changeable fluid environment; learning how I might work with it to explore that initial idea that I was groping towards articulating to myself.

Quite often, my knowledge isn't sufficient to encompass what I need to know and rather than learning about it alone, I will seek consultation or sometimes collaboration, as I have with working with a marine biologist on *Tide Pools*. Neither of us knew at the outset how it was going to unfold. It developed in a very particular

Aeris. 2001 light display transparency 16x12 inches
© Susan Derges

Not completly against research - Read Literature.

Was surprised Jeff Wall had studied something similar to her study.

Likes having her work critqued, finds it helpful

She says the idea is the most important part but

he had illuminated his but it was interesting that he had covered some of the same ground and had worked with marine biologists to maintain this environment.

Comments from critics have been incredibly helpful leads into some of the other ideas I've been dealing with. For a current project regarding boats, David Chandler described how in Sweden, in relation to rituals around mortality, sailing and the sea, ships were suspended from the roofs of churches. These floating talismanic objects were loaded not only with their relationship to water but to death, safety or fragility, either through being on or traversing water. This fed into my thinking about boats being in the sky whilst at the same time on water and in a transitional state; so becoming another metaphor for mortality, vulnerability, change, loss and other similar themes.

There has to be an intuition first, otherwise the research gives you nothing. It has to be led by the intimation of an idea but one must be prepared for the research to take you into the unknown and away from it, in order to bring you back to it again in a stronger more amazing manifestation. That, for me, is the kind of process that seems to go on in making work, when it is functioning well.

I often begin with something that is unknown to me that I have a sense I need to know about. I'm trying to dig into the

way because of our different areas of expertise, and her sense of what I might need to know.

Another element in parallel to this is a contextual search; questioning the frameworks of, for example, the cases that I'm working with. I studied a lot of material relating to the themes, both in historic and contemporary contexts, as well as in science, literature and the work of other artists. I learnt that Jeff Wall had made a huge glass tank that he kept populated with marine creatures in his studio for a period of time—I had no idea that he was doing that! I'm not sure how

Must be prepared for the research to take you into the unknown for your idea to come back better and stronger.

She prefers to work on the unknown - calls her work research.

She doest use images in her work that don't speake to her

River Bovey 2. 2007 Ilfochrome photogram 24x67 inches © Susan Derges

unconscious and into to the unknown and that, I think, is very different to how a scientist would begin. They would define a hypothesis that needed to be explored through research methods and proved. It would be much more consciously articulated than the way that my work happens. In the past I have called what I do *unfolding enquiry* and this is now (especially within academia) termed *research*. I think there's a difference between academic *scientific* research and the way that I use research.

There are parallels but I am dealing with my unconscious as much as my intellect. In science, research is about contributing to consciously articulated bodies of knowledge, whereas for me it's a more poetic activity, more to do with the processes of imagination. It's certainly not conceptually driven. I think many artists *are* conceptually driven and the term

'research' is valid to their whole way of working.

I begin with an intuition or a sense of an area that I want to explore but it's not fully conscious. At the very end, the way in which I evaluate what I've done and how I edit out certain images and include others depends on whether I'm moved and convinced in a quite visceral or intuitive sense. A piece of work might well do the job but if it doesn't move me I don't use it; if it doesn't speak to me on multiple levels then I'm not really interested in it.

It has to be more than just an intellectual statement, it has to have the potential to be very much alive and it's quite difficult to articulate what those ingredients are that make the difference. I think what often does make the difference is the degree to which one has let go of the known and been open to trusting what's coming in

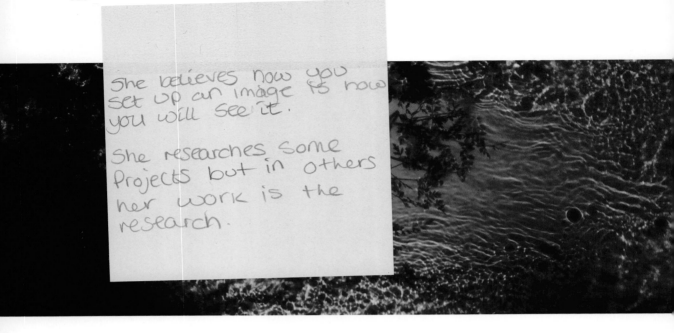

*She believes how you
set up an image is how
you will see it.*

*She researches some
projects but in others
her work is the
research.*

*River Bovey.
2007* Ilfochrome
photogram 24x67
inches
© Susan Derges

during the period of the research and development and been led by it.

The Observer & the Observed is a good example. I was fascinated by the notion of the observer and the observed as it's discussed in physics where, in simplified terms, how you set up an experiment to look at an electron will actually determine what you see. If you set it up one way you will see a waveform and set up another way you will see a particle; and both are reality! That paradox absolutely fascinated me because it takes us into a very, very creative relationship with the world.

As a maker, it suggested parallels with photography, which is not a neutral gaze; how you frame, set up and do something photographically is going to determine the result. That inability, the impossibility of making a neutral statement which you can say is the truth, is all relative and I was very interested in that kind of relativity. I decided to find a way to show this phenomenologically and I appropriated this small experiment that I found in an early science book, which took water and a little musical fountain, as an example of a visual paradox.

You take a flowing jet of water and, in the era when this experiment was made, it was vibrated by a tuning fork and illuminated by a magic lantern that had a card spinning in front of it so that it flashed on and off like a strobe. The vibration of the water, when it synchronised with the vibration of the light created the visual illusion of tiny droplets suspended in time and space. Yet when you turned the light on full and constant you just saw a jet of water and the drops disappeared. And then you'd set the strobe up and you could put your fingertips in between two droplets and they'd be wet so there

was water that you couldn't see running in the gaps.

That experiment was such an extraordinary thing to set up and witness—it was a complete enigma. I did a lot of research, spending days and days making really boring documents of water drops or jets suspended in space. They were so banal; they just looked like quasi-scientific photographs. But then at one point the shutter jammed in my camera, which was behind the jet, and I looked in front of the jet and at the moment when my face came into view, the shutter released and a picture was taken. I didn't think anything of it at the time but when I went through the negatives my face was blurred in the narrow depth of field of the image but totally focused in the little drops and suddenly the observer was there in the observed. It was a kind of perfect way of making that ambiguity manifest in the image.

The prints operated in the same way; if one stood a long way back one just saw a face but then people had a shock when they moved closer and the face disappeared into a blurred backdrop and suddenly small perfectly focused faces became apparent. I think that's just maybe the neatest example that I can give of the research process. I couldn't have calculated how to do that or predicted it. It happened as part of the process of my research.

In terms of projects where research has been less important the *River Taw* body of work, again, is a good example. I made a

very intense initial study of the technical implications e.g. immersing photo-paper in water in the landscape at night, testing exposure times, distance of the light source from the paper, depth and speed of flowing water, speed of the burst of light of the flash and methods of housing and transporting the prints.

Once that was finished then the whole subsequent period (which lasted several years) was all about the making. Further research was made following a course of the River Taw over the period of a year and taking paper to the shoreline and exploring different weather conditions as well as moon cycles and wave, tides—it was making although, yes, it was also research—but I would say I wasn't so conscious of conducting research, I was just making.

For the project *Natural Magic*, I was in residence at the Museum for the History of Science in Oxford. I began again with reading, initially into natural philosophy and the work of Giovanni Battista Della Porta (the first person to describe the camera obscura).

The whole process of research on that project was probably the most collaboratively conducted research that I have ever carried out, both in terms of practical, theoretical and literary input and consultation with the curators of the museum.

Following my discovery of alchemical apparatus in the building I worked with a

Likes to think about how others experience her work, feels that women will understand her work with nature on a primal level.

Always think about target audience!

...ry hugely; an awful lot of work and time ...at gets invested in each body of work ...'t seen.

...ink contextual research is less ...nnected with the demands of the ...cipline and more driven by the nature of ...e subject. I am always led by the subject ...erms of what needs to be done but ...en also I look at as much work as I can ...th in historic as well as contemporary ...ntexts.

project that gave me a huge amount of material to work with in subsequent projects. I fed off that research for many years after that.

That project was quite different to anything I'd done before. I was working with a large 5 x 4 camera and flashlight, illuminating vessels from within that were bubbling away. I had to learn an awful lot about photography that I hadn't required before. To deal with ideas of the dark box and luminous, magical objects, in front of it meant developing a whole new idiom for that work.

Themes dealing with fluid processes have run through all my works. Translucency, internally illuminated imagery are common to *The Observer & the Observed*, the *River Taw* and the work in *Natural Magic*, as well as my current work. I think there are ways of looking at the world from a slightly unfamiliar perspective, a non-perspectival space, a translucency of internally illuminated things, which provide a more imaginative reading. The ways in which I might need to work with each project can

With my current research project, *Tide Pools*, I looked at the early prints of Philip Goss and other artists dealing with marine subject matter, natural history illustrations, Victorian nature prints, Anna Atkins' cyanotypes, all of the early photography recording specimens—there was a huge enquiry into rock pools and shoreline and natural history in the nineteenth century. So I inform myself about that background whilst looking at contemporary artists' treatments such as that of Jeff Wall and his marine environment.

I look, as well, at some of the ecological connections that resonate within my area of practice. I'm very interested in how the environment, for example, is articulated.

There will probably always be, for me, an area of interest in philosophy whether it be spiritual or more general, to inform the world-view that I have on the things that I am depicting. In terms of social concerns, I'm very aware of an approach that is non-reductive or a non-mechanistic existentially limited approach to art making.

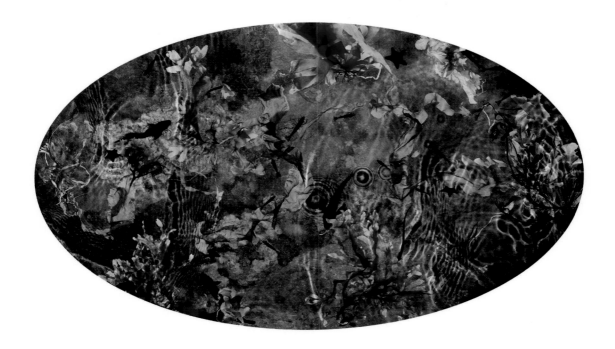

I'm trying to contextualise my own experience within a wider understanding of how people experience the world or what their questions are about life or death. I guess there are a number of different contexts that would be relevant. I'm definitely not placing myself within any religious context. That whole area of dogma and religion is not something that I feel comfortable with but there is a non-mechanistic, non-reductive concern that is often expressed well in Eastern thought and I find that helpful in terms of a more profound approach to the things I'm concerned with.

In terms of gender, I am aware there is an element where I am working of a feminine component. I think the preoccupation and ongoing connection with moon, birth or life cycles connotes a kind of womb-like space. That's a very visceral, felt connection with the natural world and it feels very close to me. It's not that this kind of territory is privileged to females but it's likely that someone who has sensed that relationship on a very primal level would explore it in a slightly different way to someone who approaches it rationally.

Sometimes, I wonder about my showing work in contexts with makers who are male. I think there is some slight difference—something to do with a more chaotic rather than a conceptually planned conduction of the making of work. I do think I'm involved with something that's more fluid and I sense a difference but

Tide Pool 28 2015
digital c type 48x24 inches
© Susan Derges

*Keeps notes of ideas &
so she knows how/
what made the image
come to life.
Doesn't like to think about
the end result.
likes people to draw
their own conclusions
Lets Process lead her!*

...ailed images are often highly
...tive—keeping them is an important
...my process.

...ng evaluation, the work has to be
...lly completely resolved but there
...be something that will hold my
...beyond just the reading of the
...nk that's where I really think
...about the audience; I wouldn't
...audience to keep looking at a
piece of work if all I was doing was
illustrating an idea. One wouldn't demand
that something holds attention for any
length of time if that's all it did. I think of it
as being like a trigger; I'm not telling
someone how it is, I'm triggering them to
open up to their own experience to either
remember or grasp and explore a set of
imaginative or reflective processes. It has
got to catalyse an internal event in the
other person. It's very much about an
exchange or communication.

...an early stage in the formulation of a
project. Once the process is progressing
and I have tested it against my own
response, then, I believe there is a point
when I can question it, and only then will I
think about presentation; it's left open for
as long as possible.

With the current work, I wanted the
pieces to be much more objects in
themselves, smaller, unique artefacts in
their own right, rather than framed prints
that could be any scale. They're very
specific things.

I write a lot at the outset of a project. I
keep a notebook recording technical
notes and tests that I'm making in my
work, so that I can refer back to a
particular image and understand how it
was arrived at. I keep a second notebook
for more open, free writing, a sketchbook
of ideas. I keep a lot of images now on
the computer whereas I used to keep
them in boxes of rolled prints; plenty of
rejects set aside to be looked at again
later, to inform where I've got to with
the work and whether anything can be
used and pulled out of those failures.

The *River Taw* project was very intuitive in
the way it evolved, I didn't conduct that
period of activity in the ways that I have my
other projects where there was more
rigour involved. I was continuously making
notes but it was also very much led by the
process itself. The weather, the tides, the
moon cycle, all of these external
conditions determined when I would be
making the work and at what times, so it
was quite different to making an actual
research study into something. It was as if
something was telling me what to do and I
wasn't in control, whereas with the
darkroom work such as *The Observer &
the Observed* and the current work, I'm far

more in control of a process that is not governed so much by chance.

With the *River Taw* I was very intereste[d] that time in all the writings about chao[s] and living life on the edge of chaos an[d] being a participant in some broader movement rather than an independen[t] author of something. I was reading a l[ot of] work about complexity and chaos an[d] was fully prepared to relinquish contro[l of] how the work unfolded. Of course, on[e] can never do that completely but there was a willingness to open it up to the wider forces within which I was working — the environments that I put myself into.

I don't talk about it as being research. It's like what I do with my life — it's a total thing. I'm sure many other people researching in all sorts of fields are equally dominated by their research and the processes that they have to employ for doing it. I don't think historically that this kind of terminology has been applied to *art* practice. I don't think of any of the people I look at as being researchers and I don't see them publishing papers; I see them being compelled to do something because of their philosophy or their world-view or life experience and going about doing it in ways that only they possibly can. That feels quite different to a delineated kind of example.

I think there's a lot of compromise, and mediocre work gets turned out in both academic and commercial areas because people are made to address totally inappropriate targets. That's the same with residencies; they are too often run on the basis of what the outputs are going to be with ridiculously short time spans, so that people feel compelled to jump through too many hoops. It's just an ill-informed understanding of what's required to do in-depth research on the part of the people doing the commissioning, because this kind of research is different to just production. I feel that's very important to make clear and to protect the wider processes of the research component.

Interview by Sian Bonnell

feels like people are compelled to do research but believes photography is research & her work reflects that

Doesn't like deadlines

Mandy Barker

Mandy Barker's work explores the impact of marine pollution.

SOUP: Refused. From the series: *SOUP*.
Mandy Barker © 2011

THE MOTIVATION FOR MY WORK is to raise awareness of plastic pollution in the world's oceans and the harmful effect this has on marine life. Because the ideas for my work are drawn from quantitative scientific data, it is important that I have a

sound understanding of the facts; so, knowledge gathering prior to developing a body of work forms an essential part of my practice.

There is, of course, a considerable amount of information available in the literature (scientific journals and online), but working directly with oceanographers and ecologists who are studying the problem first hand is a key aspect of the research process for me. Developing such relationships has extended my knowledge of biodiversity around the world and allowed me to understand the extent of the problem in detail. For instance, I would never have known that hermit crabs in Taiwan use bottle tops to make their homes unless the experts had alerted me to these facts and explained them to me. It is this level of detail that informs my work.

But dealing with factual information also brings with it a keen sense of responsibility. The work I make has to be accurate and align with the scientific evidence if it is going to fulfil its purpose. So, for example, representing something that wasn't happening or real would be out of the question. Being alert to my ethical responsibilities is essential to the integrity of my work and something I feel very strongly about.

Plastic Bag: 1–3 Years. From the series: *Indefinite.*

A person uses a plastic bag for an average of 12 minutes before disposal. When a bag enters the sea suffocation or entanglement may occur but ingestion is the main issue. Sea turtles often mistake bags for their favourite food of jellyfish and squid when seen floating in the water column.
Photograph by Mandy Barker, 2010.

And part of my role is to reciprocate the trust shown to me by the scientists who have supported me. I have an obligation to ensure that I do not to distort information purely for the sake of making an

interesting or aesthetically pleasing image. Although aesthetics are important to the work I create, it has to do something more than simply look good; it has to be grounded in facts.

I see myself first and foremost as a photographer not an environmentalist, and my commitment as an artist is to transform the science into something visual and create artwork that is accessible and relevant. My interest in the environment stems from my childhood when I used to wander the beach collecting driftwood and other natural objects. Over time I noticed that there were fewer natural objects and more plastics and other manmade items washed up on the shore, which was shocking to me and this was something that I wanted to make other people aware of. To make that happen it is crucial that my work reaches as broad an audience as possible.

Initially, my early work began by my simply taking photographs of objects on the beach where the tide had left them. But because we are all so familiar with that type of image they failed to have any impact, and people by and large ignored them.

My challenge was to find a way of holding people's attention by creating images that encouraged them to think or to engage with the work more actively rather than simply to look. Finding a way to do this came about through a lot of practical research and experimentation, and crucially through looking at the work of

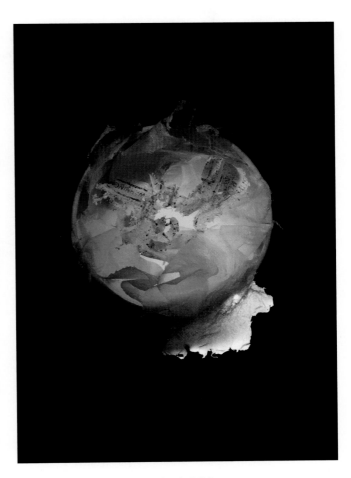

Plastics: 400 Years. From the series: *Indefinite.*

Plastic never biodegrades, it merely breaks down into smaller fragments. These micro plastic particles and fibres are found in filter-feeding barnacles, lugworms and amphipods, which are in turn eaten by larger sea creatures including fish, and ultimately humans.
Photography by Mandy Barker, 2010.

other photographers to identify what I was attracted to or what made me think and why it did so. The way that the photograph can transform the way we see and understand things became a crucial part of the contextual

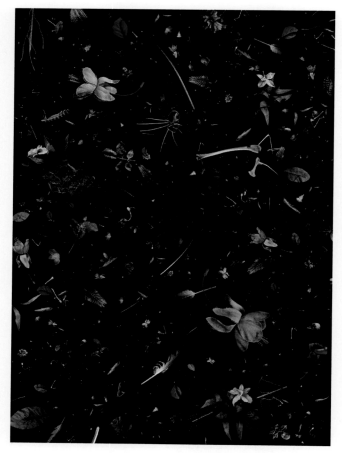

From the series: *SOUP: 135°–155° W 35°–45°N. SOUP: Ruinous Remembrance.*

Ingredients; plastic flowers, leaves, stems and fishing line. Additives;
bones, skulls feathers and fish.
Photography by Mandy Barker, 2011

It was the isolation of the subject that became important, and the idea that if you remove the subject from its context you might see things very differently.

The series *Indefinite* grew out of the idea of decontextualising and reframing the debris found along the shore. I took the unwashed and unaltered objects back to the studio and, concentrating purely on single objects, carefully lit them against a black background to avoid any unnecessary distraction within the image. The enveloping black space became a metaphor to evoke a sense of the deep sea and the objects became strange sea creatures emerging from the deep ocean. The paradox of transforming a discarded and harmful object into something aesthetically interesting became an important characteristic of the work, something that might hook people in and introduce them to this vast global problem.

However, it needed something else, something that would convey a message about pollution in the marine environment, something that would provide information about the detrimental effect that this plastics debris has. Text was an obvious choice, but I needed to create a balance between drawing people in to the images through the visual qualities and form of the photograph, and then hitting them with the scientific facts and the dangerous nature of these seemingly beautiful objects. I remembered coming across the work of Cornelia Parker, who had created a photogram of a single feather, and the first

research that informed the early development of my work. I had always admired the photographs of Edward Weston and Irving Penn, and the way that a simple pepper or a discarded cigarette could become something sensuous or sublime held a great fascination for me.

impression was of a simple yet stunningly beautiful image. But alongside the image text added another interesting dimension. The text stated that this feather had been to the top of Everest and that just brought so many different questions to my mind— How did it get to the top of Everest? Did she take it? It was the fact that I wasn't just looking anymore, but I was thinking, and it was the text that had altered my experience and understanding of the image. It was not that the image illustrated the text or that the text described what was seen, but that together they created something far more engaging and opened my mind up to other possibilities, and that individual connection made it personally relevant.

Another key influence was Simon Norfolk. He had made a series called The Hebrides: A slight disturbance in the sea. The work was concerned with military activities in this remote and beautiful part of the world. I remember one image of a tranquil sea at sunrise. It was a seemingly straightforward and again beautiful image, but the caption revealed that a nuclear submarine had accidentally sunk a fishing trawler here and drowned the fishermen working on it, and this information was very unsettling and destabilising.

The way the addition of text can change the way we understand what we are looking at became a fundamental aspect of my working method for this series, and has continued subsequently in all my work. I feel that short captions that get straight to the point in a few words can be far more compelling than a whole paragraph written about an issue. The text I eventually used for Indefinite states simply the number of years it takes each plastic material to decompose in the sea. These simple statements juxtaposed with images of different types of plastic, presented a narrative in time culminating with an image of a piece of polystyrene, which stays in the seas indefinitely and gives the series its title. In addition, at the end of the series I provided a thumbnail of each image with statistical information about the particular type of plastic in the photograph.

Getting ideas or vague thoughts I have for images out of my head and onto paper is something that I have always done, as I feel it makes it easier to see how I am thinking about things. I record all my ideas and activities in journals, a process I describe as thinking out loud, which forms a key role in my research strategy. It enables me to reflect and allows me to see how different aspects of my research connect and very often how elements that I may have initially put to one side become relevant again or take on new meaning. It is a process that fuels my imagination and keeps my ideas moving forward, which is imperative in terms of artistic growth.

When I actually get down to constructing the images I may have to change things, for example, compositionally to make the image work. The way the sea currents bring different elements together in the ocean is unpredictable, so the working

methods I adopt need to reflect that randomness. The sketches I make enable me to think in broad terms about an idea, but it might look very different when it comes to creating the work, and so I keep an open mind and am happy for chance to play a part. For example, in laying out a range of elements to photograph I noticed the word 'sea' written on the end of a commercial plastic bag, and the word 'hazardous' that had come from the side of an inflammable oil carton, and also the word 'waste'. All of which had come together quite accidentally but became an essential part of the work.

The more research I carry out about plastic debris in the oceans the more it feeds my imagination and my determination to try and raise awareness through my work. Having become familiar with the various organisations that research and campaign about the issues of plastic in the sea, and identifying and speaking with the scientists and environmentalists who study the movement of plastics across the world's oceans, I became aware of the Great Pacific Garbage Patch. This is the name given to the mass accumulation of plastics in the North Pacific Ocean and has been described as 'plastic soup'. Due to the sheer scale of this problem and the way

that waves and the light reflects and distorts, it is impossible to represent this phenomenon accurately or in detail in situ. Constructing images that represent what is out in the oceans is the only way to achieve the desired results.

The starting point for this new work was to create something that related to the depth and extensiveness of the way that the ocean currents bring together plastics on such a vast scale. I made many practical experiments initially using a large format studio camera and film and trying many different ways of floating plastics on water, hanging pieces of debris from fishing wires and using layers of glass. But it just wasn't possible to achieve the depth or scale necessary to duplicate the random way that plastics come together in the sea and create the feeling of floating rather than being static in one fixed position.

One of the main influences, which led me to think about how I could tackle the problem, came again from my contextual research and in particular the work of Andreas Gursky. Gursky's work tackles issues around consumerism, which has resonances for me, and the way he manipulates foreground, middle ground and background in linear layers was

facing page:
'WHERE . . . am I going?'

Marine Debris balloons collected from around the world. Ingredients: Silver Wedding Anniversary, Now I am 3, Age 5, 60, plain: red, blue, yellow, green, pink, orange, silver, white, Ruby Wedding, It's a Girl, Thomas the Tank Engine, Barclays, ghost face, unidentified motifs ×15, balloon stick, balloon inflation stoppers, Happy Birthday, Happy Retirement, Happy Birthday, Happy Meal, HAPPY?
Photography by Mandy Barker, 2012.

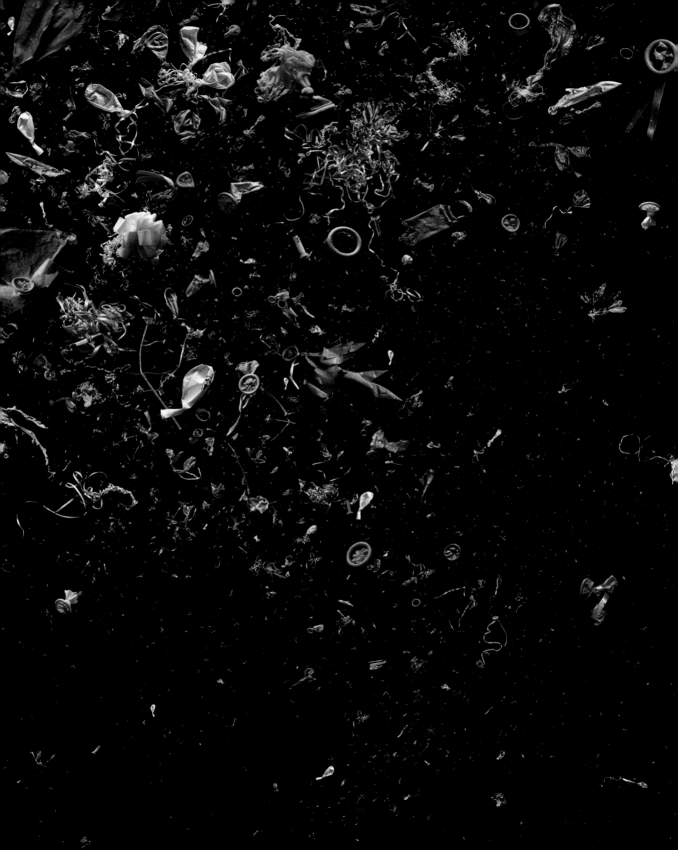

something that I found interesting and valuable, and this fed into the way I began to approach my work. Digital technologies gave me much more control in terms of the kinds of images I could make. For example, through montage I could combine different images together rather than trying to create something in one single image.

It was also important to me that the plastics I photographed were salvaged from beaches around the world, to replicate the way that plastics become dispersed naturally through the oceans' currents. For example, the oceanographer Curtis Ebbesmeyer sent me four samples of children's bath toys from Alaska. The toys had gone into the sea off the coast of Hong Kong following a container spill in 1992. Ebbesmeyer's research showed that these toys had been in the sea for sixteen years, having been around the North Pacific Gyre[1] three times since the original spillage before finally being deposited and becoming frozen in ice on the shoreline of Alaska.

Following a similar principle of captioning my earlier work, each of the new composite images was given the main title of *SOUP*, with a sub-title that detailed the particular subject of the image, such as *Turtles* or *Fragmented Cups*. But this time, inspired by the 'plastic soup' description, I added a list of ingredients, which I felt was important in providing the viewer with the facts of what exists in the sea, and the disturbing reality that plastics can travel anywhere the current will take them.

The connections built up through my research led to an invitation by Dr Marcus Eriksen of the 5GYRES marine research organisation, and the Algalita Marine Research Foundation in the USA to join an expedition. These are two non-profit groups that campaign against plastic pollution and had organised an expedition to sail through the Japanese tsunami debris field. In March 2011 the most powerful earthquake to hit Japan triggered a major tsunami causing destruction along the Pacific coastline of Japan's northern islands. The month-long expedition from Japan to Hawaii was made possible for me through an environmental bursary from the Royal Photographic Society, which was a competitive process and I had written a proposal for consideration; it was a life-changing experience for me and a privilege to work alongside an international crew with different specialisms. But most importantly I was able to see firsthand exactly what plastics look like in the sea, and as a primary source of information this became significant to the way I responded creatively.

Being connected to the reality of the devastation that I witnessed firsthand in Japan before the voyage shifted my perspective. Staring down into the ocean and seeing unmistakable objects pass by such as a laced boot or a pair of children's shoes, cups, caps and a coat hanger, was a constant reminder of the lives lost to this natural disaster, and it changed the way I began to think about the kind of work I could make. I began to see similarities in the plastics collected;

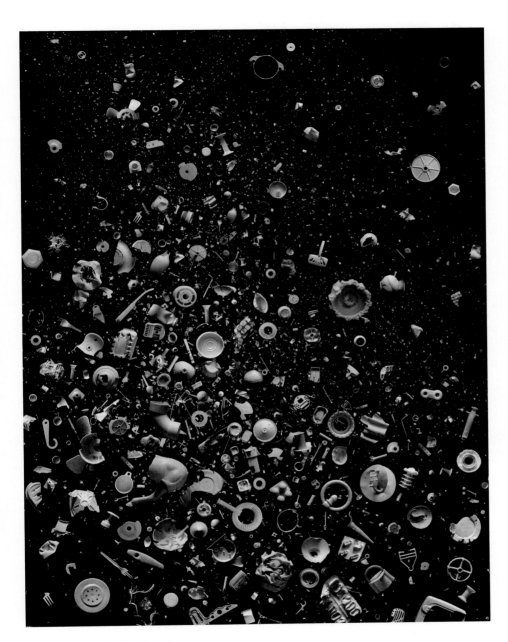

'EVERY . . . snowflake is different'

Ingredients: white marine plastic debris collected in two single visits to the shoreline at Spurn Point Nature Reserve England 2011. Includes added shards from other countries. (Snow flurry ingredients; draught piece, padlock, industrial mask, bread tie, cake decoration pillar, paracetamol packaging, plunger, fire alarm casing, aerosol nozzle, egg holder . . .
Photography by Mandy Barker, 2011.

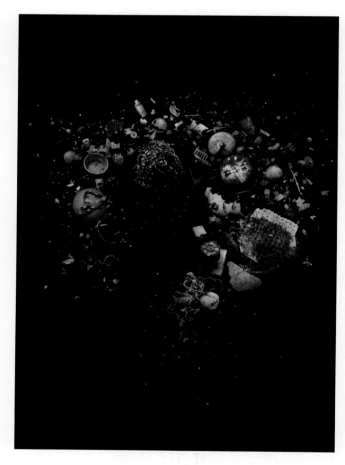

33.15N, 151.15E. From the series: *SHOAL*.

Included with trawl: tatami mat, part of the floor of a Japanese home, fishing related plastics; buoys, nylon rope, buckets, fish trays, polystyrene floats shampoo bottle, caps, balloon with holder and petrol container. Photography by Mandy Barker, 2012.

a shred of bag that looked like a face or a piece of Styrofoam that looked like a bone.

Because of the demands of their disciplines scientists have to remain detached and there is no room in scientific study for personal responses to the subject. I feel it's important for artists to be involved with issues such as this as art can connect with people in different ways and offer a new perspective. The series *SHOAL* was developed from trawls and net samples at various points on the voyage between Japan and Hawaii, and also from the tsunami-affected shoreline in Fukushima Prefecture. Each image included a different trawl sample and is captioned with the grid reference of where each sample was collected, a marker to pinpoint a specific location.

Recently, I visited Hong Kong to speak at the inaugural conference for a charity called Plastic Free Seas. I was shocked by the statistics and to discover that over 50 tonnes of polystyrene was going into landfill in Hong Kong everyday just from takeaway cartons, and the beaches are piled high with it. I visited some of the beaches and was taken to one of the islands that is particularly affected and I collected samples and photographed the debris. This led to the creation of a new project specifically about Hong Kong.

I wanted to create an opportunity to connect the people of Hong Kong with the problem of plastic pollution, and

therefore included elements in the design of the images that would be of specific cultural relevance. For example, in 2012 they had a container spill of plastic pellets or nurdles,[2] and that's one image. There are also plastic lotus flowers, which are linked to notions of beauty in Hong Kong. Tea packaging was another key element and a cigarette lighter with an image of a panda, the national animal of China, printed on the side. The final series *Hong Kong Soup* was nominated in the WYNG Masters Award[3] and was series winner in the Lens Culture EARTH Awards.[4] But I would never have thought about doing that if those links that my research had created hadn't added another dimension to my thinking about waste in different parts of the world.

Keeping my work fresh is something that I need to be aware of if I am to connect more people to the problems of marine pollution. This means that as part of my research process I have to think and plan ahead, so being alert to the possibilities and looking for potential new ideas is an essential activity. 2014 was the year of the football World Cup and this became the catalyst for the series *Penalty.* Rather than concentrating on different types of plastic I decided to focus attention on one single plastic object, the football, as a global symbol and one that would potentially reach a global audience. I put a call out via social media for people to collect and post footballs or pieces of footballs that had washed ashore on beaches around the world; and I have to say I was surprised by the response.

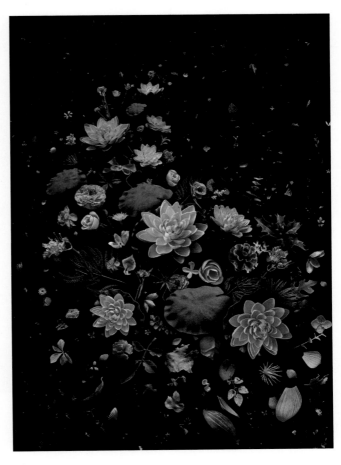

Lotus Garden. From the series: *Hong Kong Soup: 1826*.

A collection of different species of discarded artificial flowers (that would not exist at the same flowering time in nature) should not be found in the ocean. The flowers were recovered from various beaches in Hong Kong over the past three years (includes; lotus flowers, leaves and petals, peony, carnation, rose, blossom, holly, ferns, castor and ivy leaves). Photography by Mandy Barker, 2014.

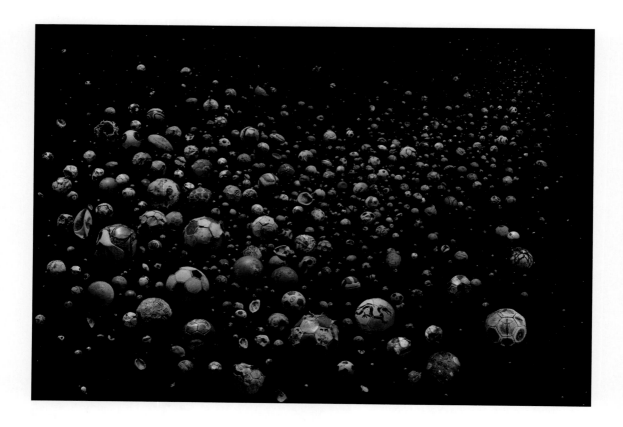

The World. From the series: *Penalty*. Photography by Mandy Barker, 2014.

In total, 89 members of the public collected 769 footballs and pieces of footballs, with the addition of more than 223 other types of balls from 41 different countries and islands and 144 different beaches in just 4 months. The recovered footballs were incorporated into a series of 4 images—*The World*, *Europe*, *United Kingdom* and *One Person*. *The Guardian* newspaper in the UK did a double page spread for their '*Eyewitness*' section and there were several other publications around the world that covered the story, along with interviews with CNN in the USA. So, the idea really took off and found the global audience I set out to reach.

The project that I am working on at the moment takes the idea of plastic pollution in the sea to a different level. I was Artist-in-Residence in Cork, Ireland recently and worked with a researcher from the University of Cork looking into micro-plastics. At the time laboratory studies at Plymouth University had found plastics in plankton and very recently new research was published[5] revealing that studies have found that plankton are ingesting plastic in the natural environment. Plankton represents the bottom of the food chain and ultimately this will have consequences for us all.

I see my role as an interpreter, to be aware of the facts about the harmful effects of marine plastics and to understand the science and to present it in an accessible way through my work and help to connect this global problem to a wider audience and hopefully in some way change things for the better.

Interview by Mike Simmons

Notes

1 The term gyre refers to a large system of rotating currents in the ocean and there are five major gyres across the globe. In the North Pacific, South Pacific, the South Atlantic, the North Atlantic and the Indian Ocean.

2 Nurdles is the term given to small (microplastic) resin pellets usually between 1 and 5 cm in diameter that form the raw manufacturing material for a range of plastic products.

3 The WYNG Masters is a non-profit photography initiative designed to stimulate the development of photography as an art form in Hong Kong and seeks to create awareness on different themes of social importance for Hong Kong. The award encourages proposals internationally and offers substantial cash prizes. More details can be found at: www.wyngmastersaward.hk/index.php/en/master-about-en/commission-en.

4 The LensCulture EARTH Award is an annual international photography competition whose theme is the natural world and how we live on our planet. More information can be found here: www.lensculture.com/earth-awards-2015.

5 The paper Ingestion of Microplastics by Zooplankton in the Northeast Pacific Ocean by Jean-Pierre W. Desforges, Moira Galbraith and Peter S. Ross is published in the *Archives of Environmental Contamination and Toxicology*, Volume 69: Issue 3. October 2015. Available from Springer Link: http://link.springer.com/article/10.1007%2Fs00244–015–0172–5#/page-2.

Martin Hartley

Martin Hartley is an expedition and adventure photographer who has worked extensively in polar regions. He works on and documents scientific expeditions as well as some of the world's most inaccessible places.

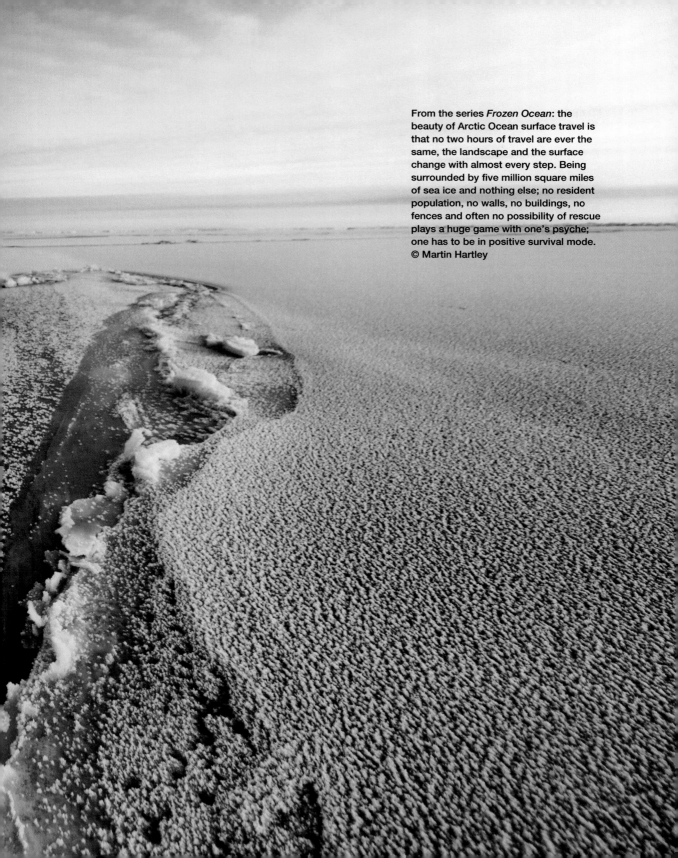

From the series *Frozen Ocean*: the beauty of Arctic Ocean surface travel is that no two hours of travel are ever the same, the landscape and the surface change with almost every step. Being surrounded by five million square miles of sea ice and nothing else; no resident population, no walls, no buildings, no fences and often no possibility of rescue plays a huge game with one's psyche; one has to be in positive survival mode.
© Martin Hartley

ALTHOUGH THE WORK I DO is most often about documenting expeditions, simply being in the right place at the right time is not enough when shooting in inhospitable environments and poor weather conditions. You have to become efficient at two main kinds of research—into locations and into equipment.

The only ways to do this are through acquiring experience and by talking to other expeditioners because the information you need is not to be found in books, magazines or on the Internet. The advent of the Internet has made looking for information the easiest job in the world, you just have to commit time to doing it, but you won't find very detailed and reliable information about things such as how to survive brutal weather on an extended Arctic Ocean expedition.

For me, the way to find people who have useful information about a remote place is through networking at the Royal Geographical Society. Photography in inaccessible places is unpredictable, generally speaking, because the environment dictates the work that you are able to do and you can't research everything before you go because the variables are too wide for that to be really useful. You can't pick up local knowledge till you are there so the key is researching a reliable on-the-ground fixer who literally knows the terrain, knows about things like translators and rescue services, and can also provide shortcuts to meeting people if you are intending to do interviews and/or portraits. You can only start

thinking about the work itself when you have sorted this out.

However, the most important research I do is about equipment. The equipment has to survive the shoot; it also has to be appropriate to the environment and the circumstances, which will determine how much you can carry. When you depart base camp you have to carry everything you need for the entire expedition and, as well as the food and fuel everyone has, I have all my photographic equipment and all my back-ups, including spare camera, lenses, flashcards, batteries and charging devices. I don't want anyone else carrying it, in case they lose or drop it, so I am carrying an extra 20 kilos of kit and have to make some compromises—the first things I don't take are a tripod and long lenses.

Photographing on expeditions is, more than anything else, about having the most reliable equipment and if any part of that equipment fails you need to have the right kind of back-ups to keep the system working. My first photography assignment in the High Arctic[1] was for *The Times* and I thought, not having done any research, that if I took a lot of equipment then, if one camera system failed, another would keep working. Because I had no experience of it I didn't anticipate a temperature of minus 48 degrees Celsius plus a 40-knot wind, which brought the temperature down to minus 71 degrees, and hadn't prepared for that kind of cold. My clothing was, I thought, OK but, in fact, it was inappropriate and I had to borrow

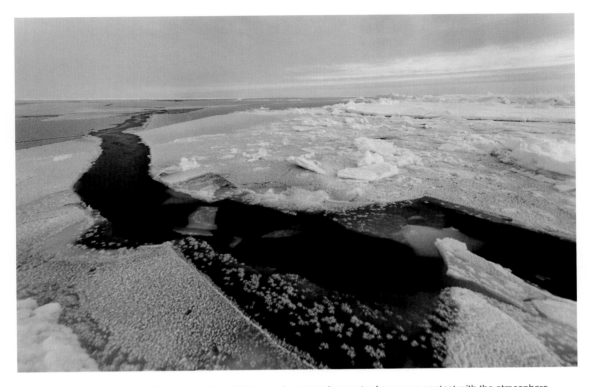

From the series *Frozen Ocean*: below minus four Celsius newly exposed seawater freezes on contact with the atmosphere. Unlike fresh water saltwater ice remains flexible, almost like a rubber sheet. As the newly open lead closes, squeezing the newly formed ice, the surface becomes more uneven and cracks again.
© Martin Hartley

thermals, gloves, hat and boots. And all the cameras I had, six in total, had exactly the same problem and they all became extremely stiff and unmanageable because of the cold so lenses wouldn't focus, film wouldn't wind on and the tiny batteries wouldn't stay at the right temperature for long enough.

But that was back in 2002 and now all modern cameras have lithium ion batteries and perform well in temperatures down to minus 30 degrees C. I also carry a brass body, fully manual Leica MP, which

doesn't seem to be affected by the cold. But film, and especially the sprockets, become brittle in the cold so I have to remember not to shoot the last frame because, if I do, the film will be so tight that it will snap when I try to rewind it. It's too difficult to change the film in these temperatures and on the move so I only use one film a day. But, because the Leica is all metal, I can hang it over the petrol stove in the tent in the evening and just give it a push from time to time and then change the film. Before I learned how to keep cameras warm I had an electrical

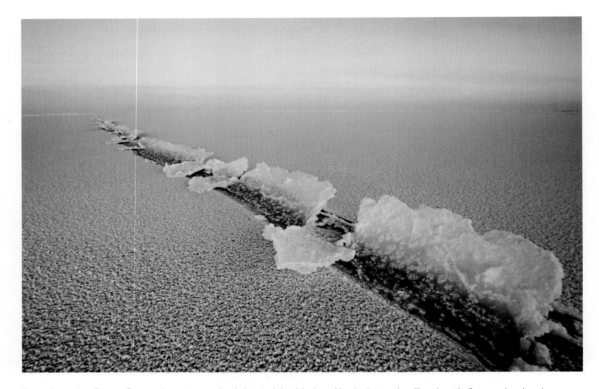

From the series *Frozen Ocean*: these two perfectly intertwining blades of ice lock together like gigantic fingers clasping, hence the name 'finger ice'. This ice forms when a crack has opened up and is then closed again before the ice has become solid. The ice then splits and grows like this while it is still malleable.
© Martin Hartley

engineer take a camera apart and add an internal heater and make the battery external but then it was heavy and clumsy and didn't keep the lens warm.

On that first Arctic trip I got lost and scared to such a point that I didn't want to take pictures and I didn't want to go back to the Arctic again afterwards—and that's what happens if you don't prepare mentally and physically. If you are not ready for worst-case scenarios that are not photographically related, i.e. if you are not comfortable in the environment you

are in, whether it's a mountain, desert or polar region, then you cannot access your photographic brain.

This sort of practical, physical research is always very important for me because if you end up in a country with the wrong skills to move around effectively and efficiently—mountaineering, skiing, dog sledding, yachting—then you are dead in the water.

I once had a phone call from a new client, Berghaus, who asked if I could ski

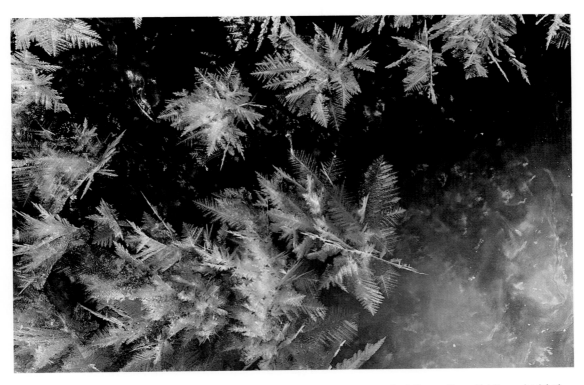

From the series *Frozen Ocean*: as soon as new ice begins to form the salt comes out of solution and beautiful 'flower beds' of tiny salt flowers begin to form. In order for these crystals to grow the temperature needs to be well below freezing and the wind to be zero. Once the wind picks up or the temperature rises these 'flowers' become rounded and lumpy and look like mini brussel sprouts.
© Martin Hartley

because they wanted photographs of a group climbing the highest active volcano in Russia and then skiing down. Their phone call came only five weeks prior to departure because the photographer they had originally commissioned had broken a rib in training. At that time I couldn't ski at all but said 'yes, I can' because my being a more than adequate skier was not in itself important. I took myself off to Chamonix for a week and my brief to the ski instructor was to teach me to get down anything—not with style but safely—in five days of instruction. It worked and I applied everything he taught me and that was far more important than getting stressed about the photography part of the brief. Because if you can't look after yourself, you can't think about taking pictures.

Part of my physical preparation is training and I go for long runs or bike rides in the cold not wearing quite enough clothing. I don't go running with anyone or take headphones because it's important to get used to the boredom of your own thoughts. You can also take a lactate curve test that tells you which heart rate to

From the series *Frozen Ocean*: the surface of the Arctic Ocean is a dynamic surface and in constant motion, either being blown by the wind or the undersea currents pushing the ice around. Cracks open and close frequently and always unpredictably. It's not unusual for a crack to appear suddenly under your tent and from that point rapid evacuation becomes a serious priority.
© Martin Hartley

train at to metabolise fat and knowing that means that when I am pulling a sledge my body is being as efficient as it can be in absorbing food and turning it into energy.

Quite often, once a team has been selected, we will go away together and purposely make our lives as uncomfortable as possible to test our ability to work together. This might mean walking for miles, swimming across a lake fully clothed or abseiling in the dark and being wet and cold and miserable all the time just to push the experience of working as a team.

Everyone will know basic first aid, from stitching up a wound to how to treat a burn or frostbite, and we always have a specialist doctor on call 24 hours a day. Nowadays you can also go on a course on expedition medicine at the Wilderness Medicine Society.

As part of my mental preparation when I am in bed at night I try to imagine I'm sleeping in a tent in the middle of nowhere because the transition from a heated house to an unheated tent with no water, no bed and not much space, which will all

From the series *Frozen Ocean*: the age of the ice can be determined by its depth; the average thickness of ice on the Arctic Ocean is 1.77m – less than half the average thickness when Peary was attempting the North Pole in the 1900s.
© Martin Hartley

have happened within about 12 hours, can be quite a headfuck. The knowledge that you can't just walk into a heated building when you are cold freaks some people out. It is quite hard to imagine that you are in the middle of five million square miles of ice and nothing else.

Another thing that is unique to my kind of work is that before each expedition I have to research the latest, fastest and cheapest way to send pictures back. In 1999 in Borneo we made the first live video transmission onto a server on a live expedition website, set up by Dan Haylock and a company called Live TX. Since then, the weight of the equipment has gone down from about four kilos to less than half a kilo. During 2014 I had to re-equip and I can now sit in a tent on the frozen Arctic Ocean and send photographs I've taken that day from my smartphone using a satellite transmitter the size of a cigarette packet.

Once you have become more experienced and capable in a particular environment you become familiar with evil things like

pain and learn how to manage yourself when things are difficult. It's a bit like learning to drive—when you first learn you can't think about anything else because you are far too concerned with the practical elements of keeping control of the car. Once you have been driving for a few years your subconscious takes over and frees you up to think creatively. It's exactly the same in extreme environments —once you can look after yourself naturally and subconsciously your creative thinking can come out. I am now much more experimental in my picture making and will try to think of the most difficult shot possible and chase after that rather than do the easy things you do at first. When you are cold and tired and uncomfortable your mind will only stretch to do the bare minimum photographically. The first time I was in the Arctic and got lost I stopped taking photographs even though it was absolutely beautiful.

Before I did anything on polar expeditions I had to know about Herbert Ponting[2] and Frank Hurley[3] who are the quintessential polar photographers. Ponting had the ability to turn quite a harsh environment into something beautiful and poetic. Hurley never ceases to amaze me because he always got his camera out in the most difficult of circumstances, for instance when they were marooned for 18 months he documented their survival to the very end. It's difficult not to compare what they've done with what I've done. I think about them all the time on expedition and whenever I'm feeling tired or lazy I think about them and get

my finger out. On the last two expeditions I did I researched both Ponting's and Hurley's photography before I went and tried to emulate it using an old camera and film to try and see how close a modern expedition would look to an early one—clothing has changed but the environment remains the same.

But their approach, which was that they were there to collect information, has also influenced my attitude to what I do. Because scientists don't have the skills to travel over the surface of the frozen Arctic Ocean I do data gathering on their behalf when I can. I think it's irresponsible to travel on an expedition today and not gather some sort of data—because unless that's what you're doing, it's a holiday and not an expedition.

Another key thing in all these long journeys is to have some degree of pre-visualisation of the kind of shots that you want to return with. I learned this from one of my photographic heroes, Galen Rowell,[4] who suggested building the idea of a picture in your head and then going to look for it. It's a technique you have to practise.

For example, I was commissioned to photograph Pen Hadow on his North Pole solo expedition in March 2002 so I had to come back with a picture that showed Pen on the day he arrived at the North Pole. Obviously, I wasn't going to be there with him because it was a solo journey but I had to take an image that could reflect his being at the Pole so I

From the series *Frozen Ocean*: the process involved in creating a litre of water from the ice is a protracted and labour intensive job. I have often thought, while watching a small block of ice as it slowly melts over the stove, that the energy required to change ice back into water seems entirely disproportionate. If you consider that the entire North Pole ice cap is thinning rapidly this gives some small insight into the amount of energy required to achieve this. Global warming is making it possible to melt five million square miles of ice when it takes me five hours to make just six litres of water using a very hot flame.
© Martin Hartley

looked through other adventure photographers' work to try and see how I could represent this—after all, the North Pole is just an imaginary point on the 'top' of the globe. Galen Rowell was a big inspiration and as a result I came up with the idea of photographing Pen as if he was actually at the top of the world. I decided to use a semi fisheye lens. I needed to find a small frozen lake and a stepladder. The only thing I couldn't organise was a bad weather day to hide the background—as it happened I found the right place and the stepladders in Resolute Bay in north-east Canada and had only to wait for the weather to be right.[5]

If I'm travelling with a writer on an assignment the writer will generally set out with a specific agenda, which we will usually have discussed. So, before we leave I have to think of what kinds of images will tell the story but the writer will

From the series *Frozen Ocean*: under a new full moon the tidal effect gets a grip on the Arctic Ocean in the same way it does everywhere else on earth as the gravitational effect of the moon temporarily changes the shape of the earth's surface enough to bend the ice. This causes widespread breakup three days before and after the new moon and it is a particularly awkward time to be on the ice.
© Martin Hartley

often come away with an entirely different story to the one s/he anticipated writing. You have to be experienced enough to be adaptable.

For example, in 2001 I went to photograph a small, remote community whose culture was under threat from a road being built to a town 180 miles away—that was the story we set out to tell and we wanted to document the village and the culture before the road reached it. I travelled with

a writer and an anthropologist who knew the culture and the people. What shaped the story was the anthropologist's research about the farming of the grain, tsampa, in the village so the story ended up being about food and the culture around the food more than about the road that was due to be built. An influencing factor in that was that my photographs around the food culture were rich in information and laden with storytelling possibilities.

I do have to have a very rounded view of the kind of pictures I can anticipate coming back with so I'm thinking about what kinds of image would tell or back up the story and I do that before we leave. A relatively new thing is if I am researching a job now I go online and research other photographers—this is a lot easier than it used to be because you don't have to go and find appropriate bookshops—and look at how they have dealt with the same subject and look at adopting and evolving some of their techniques and ideas. I try and see what's gone before and measure my work against theirs, usually from a technical point of view.

I don't keep records of each journey or a diary and I regret it. Captain Scott and Edward Wilson[6] both kept a diary and Wilson painted daily in his. There is no excuse not to except that Wilson was based in one place and so had time and I'm on the move and my spare time is taken up providing digital assets, usually a written document and an image, to the world outside my tent.

It's unusual for me to be able to look at one of my photographs and be happy with it. The only things I see are what can be improved. I'd go so far as to say that out of several million photographs I've only made a few I'm pleased with.

From a creative point of view I know if I'm happy with a project. I can measure this by the times when I've come back from an expedition with a different way of showing something I've photographed before. From a commercial point of view it's very measurable in terms of social media. If your number of followers on Twitter or image shares on Facebook, Pinterest, Behance and expedition website click-throughs isn't high the sponsors want to know where the problem is—immediately and during the expedition.

I evaluate my work when I get back by comparing it with my previous work and while on an expedition assess it on an ongoing daily basis, which you can do with digital and couldn't with film. I'm looking at how the story is evolving in terms of images; commercial pressure means I have to have a live daily presence by image sharing so I can tell by the response how successful they are. The interesting thing about social media, specifically Twitter and other image-sharing websites, is that you can actually measure the response from the audience. When I was away last year I took a picture of tiny salt crystals and that picture has been seen in 'impressions and engagement' 162,000 times.[7]

In addition, you get live feedback coming to the expedition when you make the daily phone call back to base to let them know how you are physically and what your intentions are for the next day. So, for example, on the last expedition I was taking photographs of epic landscapes and the occasional portrait and people were asking for images of life inside the tent and photographs of food and cooking. Even, for example, that on a polar expedition we have to collect and

From the series *Frozen Ocean*
© Martin Hartley

melt snow every day to drink and to rehydrate food with, which is a mundane, boring process to watch but people back home find it absolutely fascinating, so I photographed it, which I probably wouldn't have done before I got that audience feedback.

The pressure now on expeditions—even though every day is exactly the same—is that you have to show something new every day to keep hold of your audience. I try and make that part of it up as I go along and to remember what is normal and uninteresting to me is not necessarily normal or uninteresting to someone who has not been in that particular environment. It took contact with the audience to help me see that and start photographing our daily routines as modern day explorers.

So, I do now think about my audience a lot because the process has become quite interactive, whereas before there was only a post-expedition audience. Before, it was more or less the people who were in a dimly lit room with a slide projector—just

like Ponting and Hurley—whereas now it's a global and live audience who are looking at work on their mobile phones and laptops wherever they happen to be. On the last expedition I didn't post a picture on one particular day because I was simply exhausted and straight away the sponsor was demanding the pictures from that day.

My approach doesn't change much from project to project now; I know where to find the information I need. But there is never enough time—usually the funding comes in so late that I don't have time for all the research I would like to do and only

experience helps when you have to make it up as you go along.

One good thing about research is that it gives you a plan and the good thing about having a plan is that you can always change it.

Interview by Shirley Read

Note about the photographs: *Frozen Ocean* is personal work documenting changing ice formations in the Arctic and not part of Martin Hartley's commissioned editorial work.

Notes

1 The Arctic consists of the Low Arctic and the High Arctic, which are defined by different types of environment rather than their geographic location. The High Arctic is an area of polar barrens that are beyond the tree line, have sparse vegetation but are not areas of permanent ice and snow. The Low Arctic is characterised by tundra and more vegetation and is more habitable.

2 Herbert Ponting (1870–1935) was a professional photographer and cinematographer best known for his photographs from Scott's expedition to Antarctica in 1911–12. His archive is held by the Scott Polar Research Institute in Cambridge.

3 Frank Hurley (1885–1962) was an Australian photographer and cinematographer known both for his photographs of expeditions to Antarctica and for his images of two World Wars. Unlike documentary photographer Ponting, he constructed and posed his

photographs. His work is held in a number of collections in Australia and by the Scott Polar Research Institute in Cambridge.

4 Galen Rowell (1940–2002) was an American climber, writer and wilderness photographer. He was published in magazines including the *National Geographic* and *Life* and won the Ansel Adams award for Conservation Photography.

5 See: www.martinhartley.com for this photograph or Huw Lewis-Jones (2008). *Face to Face: Polar Portraits*. Cambridge, England: Scott Polar Research Institute. Photography by Martin Hartley (frontispiece).

6 Edward Wilson (1872–1912) was a doctor, naturalist, painter and ornithologist who travelled to Antarctica with Scott on the *Discovery* and the *Terra Nova* expeditions.

7 'Impressions and engagement' are social media definitions used to assess and denote popularity.

Deborah Bright

Deborah Bright is a photographer, scholar, art and visual culture historian, writer and Chair of the Fine Arts Department at the Pratt Institute in New York.

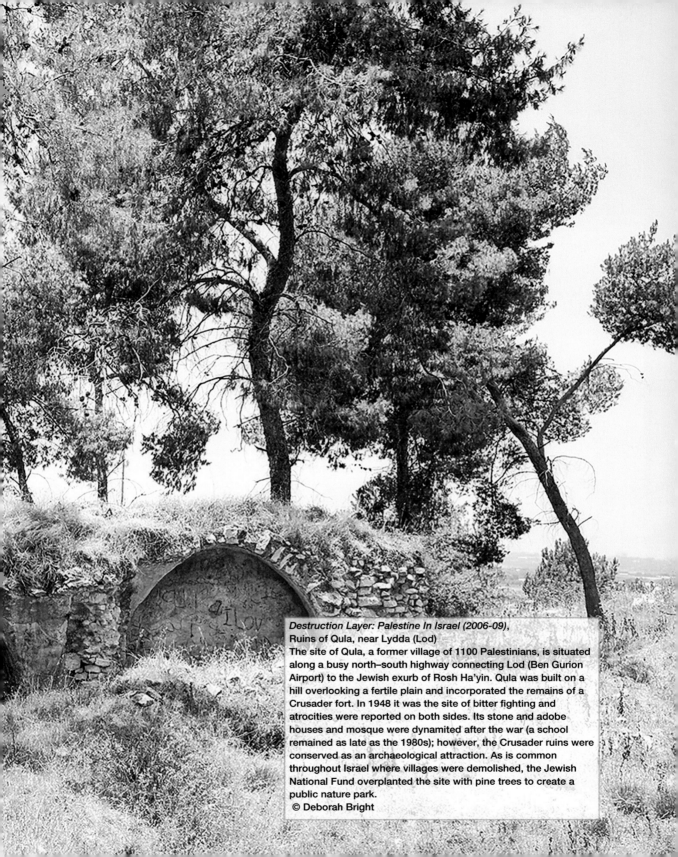

Destruction Layer: Palestine In Israel (2006-09),
Ruins of Qula, near Lydda (Lod)
The site of Qula, a former village of 1100 Palestinians, is situated along a busy north–south highway connecting Lod (Ben Gurion Airport) to the Jewish exurb of Rosh Ha'yin. Qula was built on a hill overlooking a fertile plain and incorporated the remains of a Crusader fort. In 1948 it was the site of bitter fighting and atrocities were reported on both sides. Its stone and adobe houses and mosque were dynamited after the war (a school remained as late as the 1980s); however, the Crusader ruins were conserved as an archaeological attraction. As is common throughout Israel where villages were demolished, the Jewish National Fund overplanted the site with pine trees to create a public nature park.
© Deborah Bright

RESEARCH, AS I UNDERSTAND IT, is all of the thinking, planning, investigating and information gathering required for a photographic project; labour that is immanent in the work itself. In my own landscape photography spanning 35 years, research is threaded throughout the process of bringing a given project to fruition. It is a matter of educating myself on my subject so that the story the images tell is as richly imagined as possible for a contemporary audience.

I don't have any set formulas for how I go about selecting and researching a subject though there is a fairly consistent path in how I proceed. I begin, as artists often do, with a hunch, an intuition. Of course, that intuition is not random but channelled by my individual sensibility, a way of thinking and seeing that has evolved over many years of working behind the camera and making and looking at photographs. Most of my landscape projects have to do with conquest and the obliteration of memory—who gets to tell the official story and whose stories are suppressed, though never completely destroyed. So, I see my research as a kind of excavation, doing the digging to find clues, to render visible what is neither seen on the topographical surface nor marked on maps or signage.

Once a particular landscape or type of landscape has captured my attention, I want to learn everything I can about it— its histories, its political and economic fortunes, who else has photographed it, what legends or stories have circulated

about it, its quirks and anomalies, its meaning (or lack thereof) for people today. It is only in this way that I can sort out the details that I want to look for when I'm back on the site, to see what visual signs will serve as my 'punctums' or have a synecdochical function where the photographed detail points to a larger concept or truth.[1] It is the relationship between my understanding gained through the research and the material presence of the site that is crystallised in the work. The research guides me as to where to look for what may be difficult to see after decades of neglect in what are often viewed locally as wastelands or latent sites for 'development'.

As a process research fosters deeper understanding by illuminating the historical record and previous documentation (visual and written) of the subject. This can help photographers sharpen their framing and point of view, to find the telling details that will make the subject come alive visually. It is often interesting to re-photograph a subject that has been documented in the past, to see how it has changed over time and what this tells us about changing politics and economic realities. The 'rephotographic surveys' of places photographed by nineteenth-century explorers in the American West, for example, tell us much about changes over time and how the land is, or is not, valued.[2]

As for how foregrounded a photographer's research needs to be in the final presentation of the work, this can be

'Ajami Quarter, Jaffa (Yaffa)

One of the most ancient cities in the world, Jaffa was a vibrant centre of affluent and middle-class Palestinian life before 1948. Terrorist attacks by Jewish nationalists (Irgun) precipitated the flight of 50,000 Palestinians, leaving behind around 5000 to guard family property and businesses. After the war, Israeli authorities forced this remnant into the 'Ajami quarter where they were densely crowded into available housing. Because of its seaside location and proximity to Tel Aviv, 'Ajami is undergoing intensive gentrification. Its Palestinian inhabitants have their homes demolished for the slightest infraction of building codes and the property is confiscated for Jewish development. This photograph shows a surviving Palestinian compound in northern 'Ajami, surrounded by new Jewish housing.
© Deborah Bright

evaluated through the choices the photographer makes about its destination—whether a commercial art gallery, community or educational exhibition space, published monograph, newspaper, *National Geographic,* or on Instagram. The only contexts where the outcomes of research carry considerable weight for viewers are traditional documentary or journalistic enterprises where the 'truth value' or believability of what is shown needs to be verifiable across multiple sources. These kinds of projects tend to feature situating texts and often take the form of the photo-essay published in a magazine or in book form (or on a blog or website that aggregates such projects).

Ruins in Bayyarat Hannun

Ruins of a large compound, village of Bayyarat Hannun, just south of the city of Netanya, along the main highway from Tel Aviv to Haifa. In 2006, the shell of this two-storey structure was still surrounded by acres of citrus orchards and cultivated fields. In 2007, construction began on a new soccer stadium and this view was made in July 2008. Rumor had it that the ruins are to be restored as a concession area for sports fans.
© Deborah Bright

Though research may play a key role in the formation of work shown in an art gallery or art market context, it is usually minimised in the presentation in favour of an emphasis on the artist's personal vision and the degree of formal innovation evident in the images themselves. At most, there will be a reductive Artist Statement at the reception desk (or on the museum wall) that frames the larger context for the work. In such contexts, the research is latent/implicit in the work rather than made obvious in the final presentation.

As I tend to work on photographic projects over several years, and because I am not meeting imposed deadlines, I have the luxury of integrating photography and research in a very organic way. Sometimes my projects will be triggered by something I've read or heard about that seizes my imagination, so then I try to find if that 'thing' can be seen and captured in the camera. Other times I will observe a phenomenon 'in the street', so to speak, make some preliminary photographs and then research the subject after the fact to enrich my understanding of it before I return to photograph it more consciously. As a landscape photographer, who is interested in histories of places over time, I work both ways. I find that this fluid interchange is important to my process and is the reason why my projects tend to unfold over years, rather than weeks or months.

This slow pace of working is also determined by my life as a full-time educator that limits me to summers or sabbaticals for any distant travel I need to do. But I keep the projects alive during the non-travel periods by researching and reviewing my documentation to see what I might have missed that I need to address on the next visit. In addition, I go to exhibitions and read reviews to see what other photographers are doing in terms of exhibition or publication strategies. This helps me think about possibilities for producing the final work and what formats would be most effective for reaching my intended audience(s).

The oscillation between research and production is a fluid one during the investigation phase and the photographing phase. There is both the visual investigation (locating the site, trying different camera angles, times of day, seasons of the year, choices of framing or sequencing), and text-based investigation (related historical, political, economic, folkloric or anecdotal materials). Such texts might include land ownership deeds, town records and microfilms of old newspapers, historical archives, blogs or websites devoted to the subject. In all cases I will read as deeply as I can about the histories of my subject (a particular place or landscape) while making repeated visits to the site(s) to photograph.

I will use art and photo history research to see how other artists or photographers with similar goals have approached their subjects. And if photographing in a challenging foreign environment I will do research specific to that location and

Al-Omri Mosque, Tiberias

Dome and minaret of the al-Omri Mosque in the old centre of Tiberias, viewed from the unfinished mezzanine balcony of an adjacent shopping mall. Tiberius was built by the Romans as an imperial city on the Sea of Galilee and its Arab and Jewish residents had coexisted peacefully for over a millennium. That ended in April 1948 when the city's 6000 Palestinians were encouraged by the retreating British army and Jordanians to evacuate their homes and were forbidden to return after the war. © Deborah Bright

culture so that the equipment and necessary preparations are made in advance for access to the intended subject and for visas, translators, fixers, transport, etc. Local historical societies are splendid resources for finding materials and people who have a relationship to the subject to interview—such as local residents of a place who know it well and can point out key details, or interviews with activists and planners who have information to contribute.

So, there is a constant reiterative process of looking, thinking and researching that bubbles along, much like a pot of soup on a stove. It has to cook for a time until the flavours mature. The assessment comes in the taste of the soup—is it delicious? What needs added to be the pot? Are the ingredients enhancing the flavour of the whole, or are some giving a bad taste? Should I bake a quiche instead? Should I toss the whole thing out and move on to something else?

Olive Grove and Garbage Dump, Lydda (Lod)

In 1948 there were 300,000 inhabitants of the city of Lydda, largely "Christian Arabs" who revered the birthplace of St. George whose medieval basilica still stands in the old center. Most of Lydda's population was expelled in July 1948 and forcibly exiled to what became the Jordanian-controlled West Bank. Renamed Lod, the city has been the site of violent unrest between its native inhabitants and encroaching Jewish high-rise developments. Palestinians are often prevented from harvesting olives, so the groves grow untended and neglected. This one has become part of a dump on the outskirts of town.
© Deborah Bright

The project featured here, *Destruction Layer: Palestine In Israel* (2006–09), began as an extended conversation with Linda Dittmar, a film and literature scholar and third-generation Israeli whose grandparents immigrated to Palestine in the decades before it was partitioned and Israel was recognised as a state in 1948. Over the many years of our relationship, I became increasingly aware of the complexities of Palestine/Israel's torturous historical trajectory in the twentieth, now twenty-first, century; of the political and religious allegiances within Israeli society and how these have changed and continue to change; of western colonialist adventures in the Middle East; of a century of diplomatic blunders, bad faith and missed opportunities on all sides; of the agendas that animate both Palestinian and Jewish extremists who would sabotage movement towards a negotiated compromise that might bring long-term stability and peace to both peoples.

I made my first trip to Israel with Linda in 2005, but as a tourist with little inkling of what I would find photographically, or whether it would even be possible for a non-Jewish American to undertake any politically charged project in that country and have credibility. Though she was an impeccable 'insider/informant' who spoke Hebrew and read Arabic, Linda was ambivalent as well about researching and photographing the remains of depopulated Palestinian villages inside Israel. It was not that she supported Jewish Israeli attitudes and policies toward the Palestinians—far from it—but the project was heart-wrenching because of her deep emotional ties to the country and her family's history there.

What we both knew was that a photographic project as potentially controversial as this one would have to be accurately researched and verifiable as to the 'facts on the ground', or it would be dismissed as anti-Israel propaganda. The degree and depth of research was undertaken with as much care and corroboration by multiple sources as possible. Fortunately, we were greatly aided in our research by Zochrot, a Tel Aviv-based organisation of Israeli peace activists committed to preserving the memory of the Nakba (Arabic for 'catastrophe'), the depopulation of approximately 400 Palestinian towns and hamlets seized by Israeli forces or temporarily evacuated during the hostilities of 1947–49. I was exceedingly pleased to contribute photographic images from my project that Zochrot

could use in their oral history work with displaced Palestinians, both within Israel and the Occupied Territories.[3]

Exhibition context will always be a critical matter as Destruction Layer is likely to be viewed with scepticism, even hostility, by those with a stake in the Israeli-Palestinian conflict. This is particularly true in the US with its large Jewish community that tends to close ranks where criticism of Israel is concerned. But the scepticism isn't just on one side. When we presented a slide talk to an audience that was sympathetic to the Palestinian cause, we were accused of minimising the Palestinians' plight in the present by focusing on events from the past.

Our feeling was that we would share the work with whoever would invite us to speak and this worked most successfully in university settings where controversial political material is more open to examination and discussion. As places to exhibit such work in the US, universities have been more open to taking risks and are best equipped to mediate conflicts through discourse (though self-censorship and caving in to vocal pressure groups can and does occur). Commercial galleries and art institutions that depend on the goodwill of private collectors and corporations will not host politically controversial work—that is a given. More discouragingly, the art world has spawned a potent critical apparatus that judges politically charged subject matter and artistic excellence as mutually

House in Sheikh Muwannis village

The village of Sheikh Muwannis was located just north of Tel Aviv. In March 1948, two months before the British ended their governance of Palestine and the State of Israel was declared, Jewish residents from Tel Aviv began taking over the houses in Sheikh Muwannis. A number of dwellings still remain, though most of the village was destroyed to make room for the campus of Tel Aviv University. The village head's palatial home now serves as the university's Faculty Club.
© Deborah Bright

exclusive categories. So, this effectively limits the venues for showing this kind of work, though it doesn't dampen my enthusiasm for making it.

The fluid relationship between research and production can take many different turns, depending on the subject and the conditions. In an early project, *How*

Village Mosque in Qesariya (Caesarea)

During the Ottoman era, a moslem diaspora from Bulgaria built its village on the site of ancient Caesarea, the Mediterranean port built by Herod the Great. Qesariya was the first Palestinian village whose inhabitants were methodically expelled in 1948 by Jewish forces and most of its houses were destroyed. The remaining buildings and shuttered mosque function as concession areas for a monumental archaeological park with many tourist attractions, including this "Artists Village."
© Deborah Bright

The West Was Won/Caution: Do Not Dig (1985–87), I began with a very local site known to few, a public forest preserve near Chicago where the world's first nuclear test reactor had been built as part of a top-secret installation during the Second World War. It was a fascinating place: a forested recreation area punctuated by detritus of ruined buildings and a few official markers. At first, I thought I'd make a series of composite panoramic photographs

of the site in the vein of my *Battlefield Panoramas* (1981–84). But as I read more deeply about the history of the Manhattan Project, I realised that there was another story to tell about the revived sense of 'manifest destiny' that military men like General Leslie Groves experienced; that the achievement of winning the war with the atomic bomb was akin to the glorious 'winning' of the American West in the previous century. So, the research led me to expand the

scope of the project and change its form. What began as a rather straightforward photographic document evolved into a time-based installation work, a format (pre-digital era programmed slide projection) better suited to the more complex story I wanted to tell.

From there I moved to creating a series of complex installation works before returning to more traditional photographic formats. The largest of these in scope and scale was the series of installations titled *All That Is Solid* (1992–2001). Rather than installing the same objects/images in different locations, I realised from my research and investigative photographs that the project needed to be shaped differently for each location (Chicago, Boston, Providence, Atlanta, Buffalo). The overarching concept of *All That Is Solid* (the effects of de-industrialisation and the redevelopment of former industrial districts) needed to be reflected through the peculiar local details of those places and so the final form and components of each installation differed from one location to another. So one might say I was testing my concept anew each time I changed the site of production and exhibition.

My other line of photographic work, having to do with more autobiographical material, is less research driven than my landscape work, though it is indirectly informed by the feminist and queer histories and literatures that I've absorbed over many years as an educator, writer and activist. But the starting point for these projects (*Dream Girls*, 1989–90, *Being and Riding*, 1996–99, *Fleurs du Mal*, 2007–) is my own experience growing up in the 1950s and 1960s. These projects are not driven by any external motive—beyond the relative historical paucity of images by lesbians of their emotional worlds—but by my own pleasure in realising them.

The arts give one great freedom to court chance and intuition in the making of the work; indeed, epiphanies and leaps of imagination are the artist's holy grail—the wilder the leap, the more potentially valuable the result. This is not the case with traditional scholarly research that is, by its nature, conservative. If an academic researcher has an intuitive grasp of a startling new idea or fresh approach, she will need to build her case carefully through argument and citation in peer-refereed journals and is likely to be met with vigorous resistance should her insight challenge more established views. Artists—in the west, at least—are encouraged by their teachers and peers to be unorthodox, to be disruptive. This thinking is intrinsic to modernist consciousness (though artists no longer make grandiose claims about being an avant-garde!) Another observation: Absurdity and playfulness are highly valued in the creative arts but would not have much purchase in the realm of academic research. It's not that scholarly approaches are in conflict with artistic approaches to knowledge creation, it is just that they operate at different speeds and play by different sets of rules. They

Pine Grove, Abu Kabir (Tel Aviv-Yafo)

The village of Abu Kabir was located southeast of Jaffa, the primary port of Palestine and at the heart of the flourishing citrus industry that made Jaffa oranges world famous. Where orange groves once flourished, pine groves have been planted which render the soil too acid for cultivation. A few scattered houses, commercial buildings, and a large vandalized cemetery remain from Abu Kabir which is gradually being swallowed by new road- building and high-rise development.
© Deborah Bright

can be in very productive tension with each other.

Research, chance and intuition are interrelated within my process and each is necessary to the outcome. Chance is key to any creative practice and every photographer and artist understands it, courts it and is grateful to it for its gifts. The lens 'sees' faster than the mind can absorb and we often find things in the images that we didn't notice when we were standing on the spot. I think of the exploratory phase of any photographic project as a crucial form of note-taking or sketching, though a few remarkable images may materialise early on. One is feeling one's way around the subject, observing what is present, what can be shaped in the viewfinder (and what cannot) and what might need supplementation (by archival material or text, etc.). A concept can feel quite inchoate and may take many months of looking and thinking to gel into a project, if it ever does. In my studio, there are boxes of unfinished projects where I did the preliminary photographic work and research, but the form of a finished project never crystallised, or I ran out of patience, or a more compelling project overtook me and I shelved the work. A later spark of chance or changing contexts might resuscitate these projects, or they may languish as vestiges of lively notions that lost their way.

It is also true that there are no certainties and rather little that we photographers/ artists can control. (Buddhists might say that any sense of control is an illusion and, as I get older, I increasingly think they're right.) The lessons of the creative process (staying engaged in the moment and being open to whatever happens) happen to be those that best sustain us in the larger project of living our lives.

Interview by Shirley Read by email

Notes

1 Writing in *Camera Lucida*, Roland Barthes put forward two discrete responses, which can connect the viewer to the image. One he described as the *studium*, something that is interesting and appeals to the intellect. The other was far more visceral and emotional, which Barthes termed the *punctum*. R. Barthes (2004). *Camera Lucida*. London: Vintage.

2 See, for example, Mark Klett and William L. Fox (2004). *Third Views, Second Sights: A Rephotographic Survey of the American West*. Albuquerque: Museum of New Mexico Press. Also www.thirdview.org/3v/home/index.html.

3 See www.zochrot.org/en.

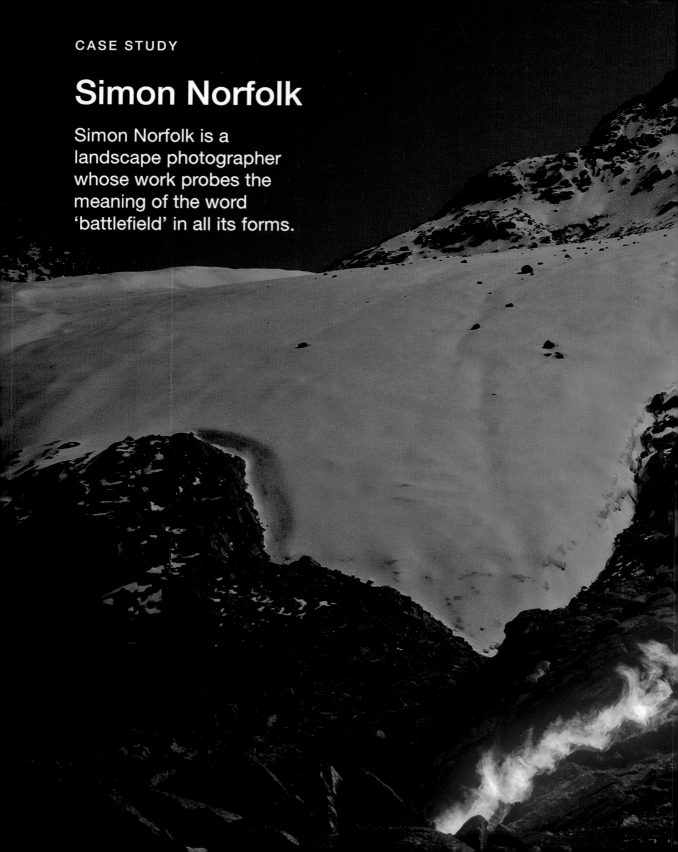

Simon Norfolk

Simon Norfolk is a landscape photographer whose work probes the meaning of the word 'battlefield' in all its forms.

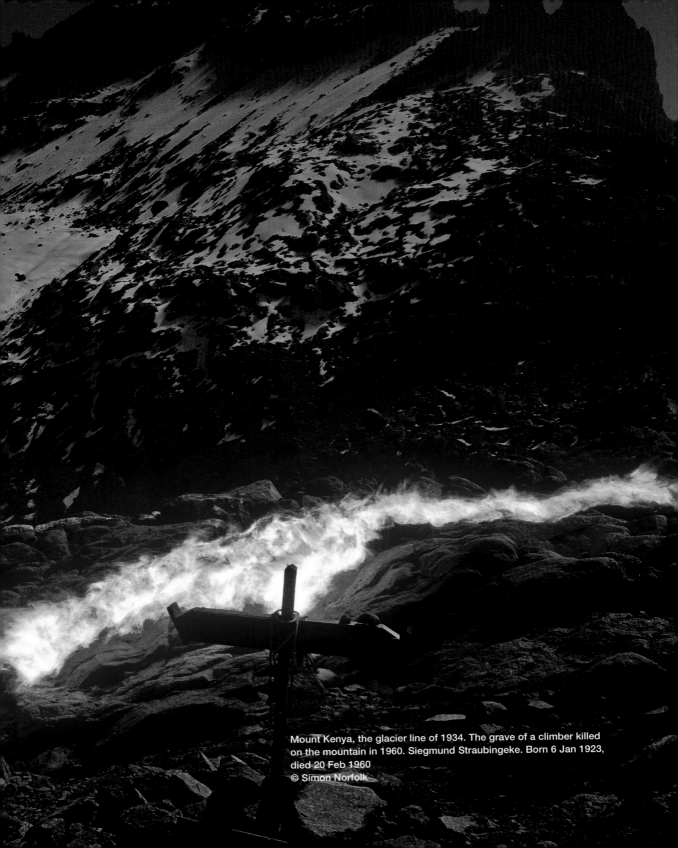

Mount Kenya, the glacier line of 1934. The grave of a climber killed on the mountain in 1960. Siegmund Straubingeke. Born 6 Jan 1923, died 20 Feb 1960
© Simon Norfolk

My RESEARCH IS PRIMARILY INFLUENCED by the conversation the media are having about the issues I'm interested in. I'm talking about photographing warfare and the things that interest me are those things that have been missed from the public narrative of, for instance, how we understand the war in Afghanistan. The first thing is to spot the shortfalls in the media approaches, the lacunae, the things that are not being discussed and the things that are being deliberately missed out.

Secondly, I look closely at what photographers, as one small subset of the media, are doing. Why are they not photographing the real way that modern warfare is being performed? I think that's because most war photographers are stuck, locked inside a work method that was defined by Robert Capa and which is: 35mm, close in, decisive moments. And what you might call 'bang-bang'. Quite honestly, the most significant events in the prosecution of war are not available to that mode of representation any more. Modern warfare consists of actions by special forces, actions by drones, satellite warfare and electronic surveillance. You can buy all the Leicas you want but you are not going to be able to photograph electronic surveillance or special forces' operations. And I defy anybody to photograph a satellite with a Leica. It's just the wrong approach.

I also look at the institutional pro-war, pro-British soldier bias that runs through everything published in Britain, helped along by the embedding process. Another thing for me is to create an antithesis to that kind of work by, for example, avoiding spending any time with British soldiers.

My interest is in the great waves of empire, of history repeating itself and, in particular, the British involvement with Afghanistan and the fact that the war that ended in 2013 is the fourth Afghan war. So, talking about the idea of empire was what I tried to do, for example, with the *Burke* project, which was about comparing my photography with the way that photography was used in the second Afghan war.[1] It was inextricably woven in with a way of talking about imperialism.

The necessity of working with good alternative partners who will facilitate my approach to the work is a crucial element of my research because I'm not taking the easy way, which is to embed with some British soldiers. It took me a very long time to build up a relationship with people in Afghanistan who I could trust as guides and who trusted me.

It wasn't till I met people in Afghanistan who I thought could help me and I could live with that I ever wanted to go back. They are my friends in Kabul, local photographers and people who live and work there so when I go there I stay with them. That's really important because it automatically gives me a completely different perspective on what's happening. In 2013, TV here was full of the soldiers bringing down the flag and flying home but

Mount Kenya, the glacier line of 1934. © Simon Norfolk

the Afghans barely noticed what the military were doing because what they are concerned with is rising crime rates, kidnap, embezzlement, bombs going off in the street, the return of the Taliban—none of which appears in the British press—and these are the things that interest me.

For the work on Mount Kenya's vanishing glaciers my partner is Project Pressure who came to me with the idea of photographing glacier retreat. I'd never really thought about environmental issues. It was only when I was provoked by Project Pressure into thinking about it that I realised that doing something about glaciers wasn't a diversion from my usual interest in warfare but was, in fact, taking the core of that work and applying it elsewhere. That core is about time, the strata of time, photography as archaeology and archaeology as photography and all those things which are the most distinct part of what I do. So, Project Pressure was very inspirational.

More specifically Project Pressure was really important in helping me with

Mount Kenya, the glacier line of 1963 seen from the surface of the glacier.
© Simon Norfolk

Project Pressure helped me get in touch with Prinz, with getting important academic papers and peer-review journals and getting very high-quality, accurate mapping of the glacier's retreat over the last 80 years onto a GPS. Once I had the GPS, all I had to do was walk across the mountain until the arrow was on the line where the glacier front used to be. When I'd established that I marked it, then I could connect my dots and it gave me an accurate map of where the glacier was in 1963 or 1981 and 2011.

So, one kind of research is about information and partnerships—the other part is about technique and approach. I think that some documentary approaches are now a bit tired. The idea of just taking a picture and writing a caption about what happened there 30 or 40 years ago, using very long captions to carry the weight of the pictures, seems really dull now. I did that 10 years ago and I'm not interested in doing it any more.

All these histories and archaeologies are buried in these landscapes and I want to try and make the landscapes sing—so how do you do this? How do you make landscapes tell their story themselves, expose themselves, disinter themselves? I try to find ways of embedding stories in the photograph—as if the landscapes were spewing up the evidence, as if they were just waiting for a camera to capture their hidden histories.

The fact that Mount Kenya is a long dead mega volcano is important and to

mapping and the objectivity of it because I wanted the work to be absolutely rooted in facts about where this glacier was and how it had moved. They put me in touch with Rainer Prinz, an academic at the Institute for Meteorology and Geophysics at the University of Innsbruck. The Austrians have done the most analysis of Mount Kenya's glaciers; they've been mapping them since 1934, and, in particular, the Lewis glacier, which is the biggest glacier on Mount Kenya.

reference this I invented the idea of painting with fire using very long exposures. When I did the test exposures in the square outside my house it looked like lava, as if the fiery heart was bursting out of a mountain. There's a brilliant metaphor there about fire versus ice. I love the idea that you are talking about ice but doing it with fire and that one degree of increased temperature brought about by climate change can be portrayed as flame. I think it is beautiful, one of those ideas that really engage the mind and make it swim.

Then the final idea was a little bit sly because Project Pressure is a non-affiliated, non-political organisation who say only 'the climate is changing and glaciers are melting'. But I believe that glaciers are retreating because of manmade global warming caused by the burning of hydro carbons so I very much liked the idea of painting my line using petroleum. I could have used wood or olive-oil but I like having petroleum embedded in the pictures, even though you can't actually tell that I have used petroleum.

On the mountain there were all these climbers who passed by and said they were there for the challenge of climbing Mount Kenya. They'd get there and face east and photograph the sunrise, although behind them was a melting glacier, which none of them knew anything about, nor did they photograph it. So there's also the whole idea of travel photography and zipping round the world portraying

climate collapse using a medium that burns a lot of hydro carbon and leaves it behind in the troposphere. I quite like that kind of conundrum—how do you get to Kenya without flying half way round the world? I suppose I could cycle to Kenya next time.

I made a film to go with the pictures to carry a few of these ideas but also because the pictures look as if I set fire to the mountain, which would be against the rules of the National Park. That could cause a lot of trouble for the guides and mountain porters who took me there and they could all lose their licences. So, the film was made to show that the fire was small, controllable and never dangerous; part of it was to explain the techniques, ideas and inspiration behind the work but part was to head off criticism. The film is a lot more than I expected it to be and a good half of what I did.

As research this was all very new for me—my previous project was about a whole series of Burke's pictures of Afghanistan and trying to find either the picture itself or a modern equivalent of it. But this project was very much about memorising a whole bunch of maps of a fairly small space. We had to work in a small area simply because we were working at 16,000 feet so the altitude made it completely exhausting—just walking up the slope to the loo left you breathless for 5 minutes—and we were doing very accurate mapping to place these lines on the ground, working at night.

It was very cold. It's pretty much as high as Everest base camp and a very tough environment to work in. I'd never spent time at that altitude and none of my guides had spent that long at that height. I have to say that, without a shadow of a doubt, this project was the toughest job I have ever done. I never cry but this one made me want to cry. Just for seven pictures, which took nearly three weeks to make. Just getting there was hard, it took four days to walk up the mountain and, of course, the logistical stuff was hard because we had to take everything with us. Then the equipment didn't work reliably, the batteries didn't want to work at that altitude or that temperature and there were electrical problems. Odd things happened like computers would switch off with 80 per cent power in them and new batteries would refuse to work. The brand new generator, which we carried up the mountain, worked then didn't work. Fortunately, one of the guides had the really smart idea of bringing a solar charger and we worked off that in the end.

So, having multiple back-ups is important but it's also about making sure that your back-ups will work in that environment. There's no point in having lots of fancy technology because it'll fall over; you have to have something you can repair with a penknife or with the materials you have around like bits of wire and sticks. We managed to rebuild the generator using a multi-tool. So, being able to think your way through those kinds of problems is crucial; the two mountain guides we had with us, Charles Kamau and Peter Mburu, were

very good, really great at that kind of improvisation.

I think I'm good at Third World three-dimensional photographic problem solving now. Every job I do, things fall apart and you have to improvise. Every time, cameras fail, tripods fall apart, hard drives explode and, if you don't have another idea about how you're going to do the work, then basically you're on the plane home. You've got to wiggle and twist and find your way out of these problems and that means being very on the ball.

I don't go anywhere until the research is finished and unless it all really stacks up. It has to be photographically interesting, something no one else is talking about and fit in with the rest of my work. Even financially, I've got to find a magazine or somebody to pay for it or commission it. I've got to make sure I don't come up with an idea that costs £3 million to do. All the ducks have got to be in a row before I even get the camera out. I'm a busy photographer but I must admit I don't take pictures more than about three times a year. Months can go by between my taking pictures, unless everything is really lined up I don't bother.

It's not worth my spending a lot of money going to shoot something that doesn't work so I don't commit to anything till I'm convinced it can work. For example, I couldn't risk going to Kenya and discovering that the flame was tiny because there's no air or petroleum doesn't burn very well at that height or

something like that. So I went up Mount Teide, the big volcano in Tenerife, and experimented with setting fire to carpet there to see if it would burn. I also experimented with different kinds of fuel and wick to see how they would work and if they made the right colour and size of flame and would be slow burning enough for a two-hour exposure.

I think my training as a photojournalist has really helped because when I started out you'd get an appointment with a picture editor and you'd be expected to pitch five stories at him. And if he was not interested in one you'd have to come up with others.

The actual research doesn't develop further once I've started the project. What does develop when I'm in situ is the dreaming. I find that the only way to think about work is by being there and doing it, which is why I'm a big fan of getting out of the door and getting on with it. I read a lot about glaciers but it wasn't till I stood in

Mount Kenya, the glacier line of 1963 seen from the surface of the glacier.
© Simon Norfolk

Mount Kenya, the glacier line of 1983. © Simon Norfolk

front of one and touched it that I felt their magnificence and power. That response can't be got from reading or from a GPS; the real emotional drive and passion for the project develops when I'm there. I find that this, rather than just wanting to make new work, is the thing that really drives me. Particularly with the Mount Kenya project where, after three or four days up the mountain, I was so unhappy because of the physical strain I was under I just wanted to leave, but that grab-you-by-the-heart thing is what pulls me in and makes me want to stay.

I found the same was true of Afghanistan. I think the feeling gives the pictures a three-dimensionality and a passionate bite that otherwise they wouldn't have and that without it they'd just be a recording. I have this argument with people all the time who think I research stuff so much that it doesn't allow for any serendipity. But if you don't do the research and the planning beforehand then there's no time for serendipity. You can't just go there with a knapsack like Coleridge or somebody.

Some things were driven by the look of the glacier. A lot of glaciers in Alaska and elsewhere are in valley bottoms and they freeze a lot of crap off the side of the mountain and carry a lot of rocks, rubble and sand on the surface and push a snout of rubble in front of them. So the problem with photographing them is that they don't look like glaciers; they look like big, dirty blocks of ice with lots of rocks on top. What this project needed was a glacier that really looked like a glacier—clean, white, crisp, and with a nice sharp front without a big mound of rubble in front of it. So, I was looking for glaciers on mountain peaks rather than in the valleys.

We originally thought about Mount Kilimanjaro but Project Pressure already had a project there. Then we talked about a place in Switzerland, which would have been quite nice because it had a cable car; I could have eaten fondue every night and slept in a nice hotel. But then we moved it to Mount Kenya because I liked the idea of working in a Third World country that has barely contributed to global warming but that will suffer first and most radically from its effects.

The biggest glacier on Mount Kenya is the Lewis glacier and it is doomed. It will have gone in about 10 years. A glacier is a moving, dynamic mechanism; it is fed by snow at the top, which pushes it down the hill. Last winter the Lewis split in two and now it's bisected by a kind of rocky headland, which means that the lower part will probably disappear very quickly.

So, there is that slightly tragic urgency about Mount Kenya.

There's one other thing about selecting Mount Kenya, which was that I had to have some transparency in the skies. It was important to me that the stars would move in the course of the exposure to indicate the passing of great geological time. One of the things I could guarantee about Mount Kenya was that it has a very regular weather regime—every morning is clear, every afternoon cloudy and the nights are clear. I couldn't guarantee that in Switzerland, for example, and there's no point in being at altitude if you can't see anything because of the cloud cover. So that's another thing in that list of everything that has got to be there. If any one thing in the chain is missing then don't even step out the door, instead get your head down, do more research and find a place where the ducks do all line up.

Working digitally means I can do some things that are more ambitious because I can see on screen whether or not I've managed to pull it off. These current projects are only visible by a camera sensor or a film sheet and not having digital would make them very tedious to do. I am not going to walk four days down a mountain to process a sheet of film. Also, all my work is abroad nowadays and carrying film abroad is just becoming impossible.

I don't write anything down. I don't keep logs. I don't do diary stuff. The truth is,

once I've taken the pictures I'm really bored with them. But the experience does stay with me. It's all in those things that make me—Rwanda, Afghanistan, problem solving and adventures and crazy techniques and mad professor stuff and even the frozen beard stuff.

I've always wanted to expunge myself from the work and for it to talk by itself. The issues I make work about are more important than me and my being cold or scared or missing my wife. Most of the places I go to are new to me and often quite fraught or tough so I never really get a chance to relax. Maybe that's one of the reasons why I'm so bored with the photographs after taking the picture. Once it's in the can I can relax but until it's in the can I can't.

I do test technical things like lighting techniques. Fashion and portrait photographers do it a lot but I don't think landscape photographers do. I do a lot of night stuff down here on the south coast where I have a favourite test place. It's on the beach, it's very dark and no one is bothered by my experiments.

The idea of audience means a great deal to me. It would be unconscionable to go to these places and use people's time and memories for vanity or just to win a prize or make money. So, if I am going to go to Afghanistan or Mount Kenya I should have something to say, and if I have something to say I have to have an audience to say it to. Getting it out there and getting it heard is crucial so that's why I've always run my

work in a kind of hierarchy where it exists as a set of only seven prints in a gallery but also as a book, a website—which gets thousands of hits—and in a magazine that gets seen by 1.7 million people. I always want to make sure I've got that breadth.

There's got to be something about my work that lifts it above the everyday; it's got to punch its weight. Is an audience going to look at it and think 'oooh'? If I were just going to photograph a glacier I could do a pretty good job—it'd be a beautiful picture of a glacier but a million photographers can do that. My work lives on an international stage and that is quite important. I can't just be a successful local photographer.

I don't believe that chance plays a part in my work. It's only by planning something really ruthlessly that I feel I can have validity when I'm in a place. So, I can be accused of over-planning and being over-methodical, but I think that's the only way to attain any kind of freedom. You can just get on a plane somewhere and take pictures if you are going to repeat the same motif time and time again.

What I like to see in the work of any photographer who has been around for more than a few years is some kind of connecting line through it. When I'm researching I'm still looking back 14 years and thinking about the line that runs

facing page:
Mount Kenya, the glacier line of 2004.
© Simon Norfolk

Mount Kenya, the
glacier line of 2013.
© Simon Norfolk

through and joins my work up. I wouldn't want to do a handbrake turn and go off and photograph something completely new. This is a really horrible word but I think a photographer is a brand and when somebody has spent £8,000 buying a print of mine I think they've made an investment and I have a duty to uphold the value of that. One of the dangers of shooting something else is that I could be devaluing that print and not upholding my part in a gentleman's agreement.

I think the thing that has helped me a great deal recently has been to autopsy old work that was successful and look for what was in the heart of it that really made it beat. The shell of the work in Afghanistan was the destruction of war and all those romantic paintings I was talking about but the heart of it was about time and time's directionality, time's

thickness. So, the new work will look radically different, it's not about destruction, it's not even about warfare but it's still got that thread. That interests me and it makes me realise that everything I've done is a kind of chapter in a bigger project.

I think you need to keep yourself in a position that's quite uncomfortable and keep yourself out there. I made a conscious attempt in 2010 to decide which direction to go in, I could have put my foot on the brake or dived in again. And the hardest thing is to dive in again but I went back to Afghanistan and it was good. While I can still get out there and do it I should do it because there are still things that make me angry when I watch the news on telly.

Interview by Shirley Read

Notes

1 Burke + Norfolk (Queens Palace, Baghe Babur Gardens, Kabul, March 2011 and Tate Modern, London, 6 May—10 July 2011) was a collaboration over time between Simon Norfolk and nineteenth-century photographer John Burke. Norfolk's photographs reimagined or responded to Burke's scenes from the second Afghan War in the context of the contemporary conflict.

Photographers and Research in Higher Education

Introduction

As a counterpoint to the reflections and work of the established photographers who have contributed to this book, we thought it would be useful to take a look at the role of research in a Higher Educational (HE) setting. The level of engagement in research and how this influences the creative process is illustrated through the following three case studies. Each provides an insider account of the personal experiences and arc of learning that different levels of study provide within the HE framework.

Many HE courses in the UK such as the undergraduate Bachelor of Arts (BA) and postgraduate Masters of Arts (MA) are modular in structure. The modules provide a mix of both practical and written work and the level of achievement in terms of knowledge and skill that students are expected to achieve is based on a credit system that relates to a set of assessment criteria known as Learning Outcomes.

For photography students in HE, in common with photographers in a professional context, 'research' is generally understood as the process of thinking, planning and information gathering that influences the decisions made in the creation of an art work. In other words a process that is for most practitioners, 'a necessary part of their everyday practice'.[1] Research in this sense is centred on the personal goals of the maker and 'any assertions embodied in [the art works] are rarely supported by empirical evidence'.[2]

So, for example, at BA level the core learning is concerned with the basics. This includes developing a portfolio of generic knowledge including research skills and critical awareness and understanding of historical and contemporary practices as well as extending the practical skills necessary to engage with photography at an advanced level. For example, Thu Thuy Pham describes the Final Major Project of her BA (Hons) Fashion Photography course as 'the consolidation of specific subject knowledge'. Rather than simply taking photographs students are

encouraged to use photography as a tool of investigation, which involves accurate interpretation or analysis of the information garnered through the research process and as Thu Thuy Pham highlights, 'synthesise the findings into final outcomes appropriate for your subject specialism'.

With the basics in place MA level, although still modular in structure, is geared much more to achieving a greater level of autonomy in the learning process. The Learning Outcomes are focused on increasing critical awareness and analytical thinking through the reshaping or considering of information and materials in other ways.

For example, Charlotte Fox explains how research at masters level has helped her discover her 'own creative voice' which has helped to '. . . shape me as an artist'.

Within a practice-based Doctoral Programme there is no modular structure or credit system and research is defined differently as 'a process of investigation leading to new insights, effectively

shared'.[3] PhD student Maria Paschalidou describes her experience as '. . . the way hybrid forms of knowledge create a dynamic context for theory and practice to collide and evolve in new ways,' and in this sense it is the process not the product that is important. An approach that Scrivener identifies as '. . . art making [that] is undertaken in order to create apprehensions (i.e., that is objects that must be grasped by the senses and the intellect)'.[4] The art work created cannot be understood without reference to an in-depth written critical thesis that supports it and vice-versa; art work and knowledge building are interdependent on one another.

So the meaning of research in HE is understood differently depending on the level of study being undertaken and to what end the outcomes of the research process are designed. But whatever the definition of research might be, research remains fundamental to the creation of artwork that has relevance and meaning for maker and audience for the work.

Notes

1 Linda Candy (2006). *Practice Based Research: A Guide*. Creativity & Cognition Studios. See: University of Technology, Sydney CCS Report: 2006–V1.0 November. See www.creativity andcognition.com.

2 See Órla Cronin (2006). Psychology and Photographic Theory. In Prosser, J. (ed).: *Image-based Research. A Sourcebook for Qualitative Researchers*. Oxon: Routledge.

3 See: Research Excellence Framework: Second consultation on the assessment and funding of

research, HEFCE, September 2009/38 at http://webarchive.nationalarchives.gov.uk/2010 0202100434/http://www.hefce.ac.uk/pubs/year /2009/200938/.

4 S. A. R. Scrivener (2002). The Art Object Does Not Embody a Form of Knowledge, Working Papers in Art and Design. See: www.herts. ac.uk/__data/assets/pdf_file/0008/12311/ WPIAAD_vol2_scrivener.pdf.

Thu Thuy Pham

Thu Thuy Pham is a fashion photographer working between London and Berlin. BA—London College of Fashion

I SEE RESEARCH AS A MEANS for exploration of new cultural territories and reflection on my existing perspectives as an image maker. I hope that the two develop in parallel and that, as I explore new social scenarios, my work will develop in range and technique.

Nine Women was the Final Major Project of the BA (Hons) Fashion Photography course at the London College of Fashion. The brief was to:

> create a substantial body of work that evidences the consolidation of specific subject knowledge of fashion image making. Moreover, the lens-based work should be informed by a rigorous process of research, indicating your ability to analyse and synthesise the findings into final outcomes appropriate for your subject specialism.

In the *Nine Women* project I question whether the subjects of a particular set of prevalent social opinions feel their portrayal is accurate and justified. Interviews with nine middle-aged immigrant Vietnamese women in Berlin explored their experiences of integrating into German society, and also high-lighted a fascinating similarity between political tensions along territorial lines in both Germany and Vietnam as a result of communism in both places. During the late 1980s, when Vietnamese immigrants moved to Germany, there was widespread unrest and readjustment on the part of both Germans and Vietnamese.

Nine Women seeks to portray aspirational women questioning their place in a foreign society, whose state of re-identification ran parallel to their own, as they embedded themselves in late twentieth-century Berlin society. The safest social position for these women has historically been one of anonymity yet, as German society has stabilised since reunification, these women have been able to step out of the shadows. By posing solitary Vietnamese women in contemporary western fashion against the backdrop of their adopted homeland, I wanted to remind the viewer of the tensions and alienation that affect the immigrant. This involved a very careful choice of locations to highlight the divide between the two cultures and place the Vietnamese woman in a very western context.

Nine Women was my first piece of staged documentary and a new way of working for me. Identifying myself with the subject's life experiences pre-shoot meant I could make informed styling and location choices, making the results less hit-and-miss than on other shoots. Getting to know models and subject matter pre-shoot also meant the models were involved in and contributed to the concept, which I think made the images stronger.

Research per se wasn't new to me when I started college, but my work had often felt quite 'light' in message. Adding a personal

From the series *Nine Women*
© Thu Thuy Pham

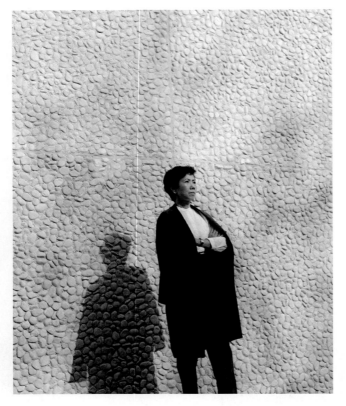

From the series
Nine Women
© Thu Thuy Pham

The research also provided a historical element, informing me of the models' pasts, and giving me the information to picture them in their present state, while questioning how they will be viewed in the future. I think that undertaking sustained research has taken my work beyond a simply visual approach, opened up new angles for questions and made it possible for me to construct a social message.

Nine Women is a project through which I brought together a community, and I think I have created a stable base for linked projects in future. Now that I have begun to understand the context and history of this social group I am better placed to chart its evolution. From a clarity of execution that comes from intricate pre-planning I hope I will be able to move into a position where I can shoot spontaneously in the present, but in an informed manner, because I understand the significance of what I am capturing and what I am attempting to show.

element through the juxtaposition of immigrant models and culturally significant German locations has given the work substantial exploratory purpose for me. Working commercially there is a predefined objective. In contrast, exploring elements of society and culture through personal researched projects gives my work and style an opportunity to evolve organically.

To achieve the clarity and honesty I wanted I had to develop different forms of research and production techniques, from brainstorms and bilingual interviews to the selection of camera format and film type.

A major element of *Nine Women* was to portray the women in a dignified manner and to attempt to outline an issue and open up space for contemplative conversation. I find many attempts at being controversial come across as banal and insincere, so it was important for my project to open up possibilities for a constructive dialogue. Researching how other photographers, such as Jean Mohr or Tobias Zielony working on issues around immigration, have explored peripheral social groups was of great importance to me. Often, I found that

photographers represent minority social groups with a rawness that does little to represent the diversity and intricacy of their experiences. I sought to achieve the visual message of repression and struggle through cropping, perspective and composition.

As an immigrant myself, I felt able to focus on highlighting the strength, humility and perseverance evident amongst immigrant groups. This was possible through my insider's perspective and interviews. Throughout the project I was always open to creative input, whether it was a visual suggestion or an avenue for social exploration. I systematically reviewed my progress to make sure that no aspect of my work misrepresented my subject.

I consistently log my project development in a folder that consists of potential locations, styling, interviews with models, mood boards, Polaroids of models and call-sheets, as well as elements of post-production such as potential book layouts.

After university I will undoubtedly continue to utilise research as a means of understanding both the subject and target audience. It only takes one element of a visual portrayal to be out of sync and an entire project can lose its credibility. In order to present both a historical portrayal and a picture of how a social group may evolve, I believe it is only through intricately crafted production techniques that a photographer can create a body of work that both documents and educates.

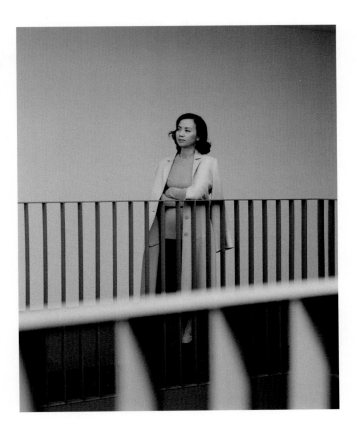

I believe it is important to consistently immerse oneself in personal projects that test visual and production techniques. As a photographer one should have the ability to adapt one's style to capture the diversity of scenarios that play out across the globe. There is no place for complacency within photography; it can only lead to doing an injustice to the subject matter. A poorly executed project may result in a significant message falling on deaf ears.

Interview by Shirley Read by email

From the series
Nine Women
© Thu Thuy Pham

CASE STUDY

Charlotte Fox

MA Photography—De Montfort
University, Leicester

From the series *Imaginary Time*
Charlotte Fox © 2014

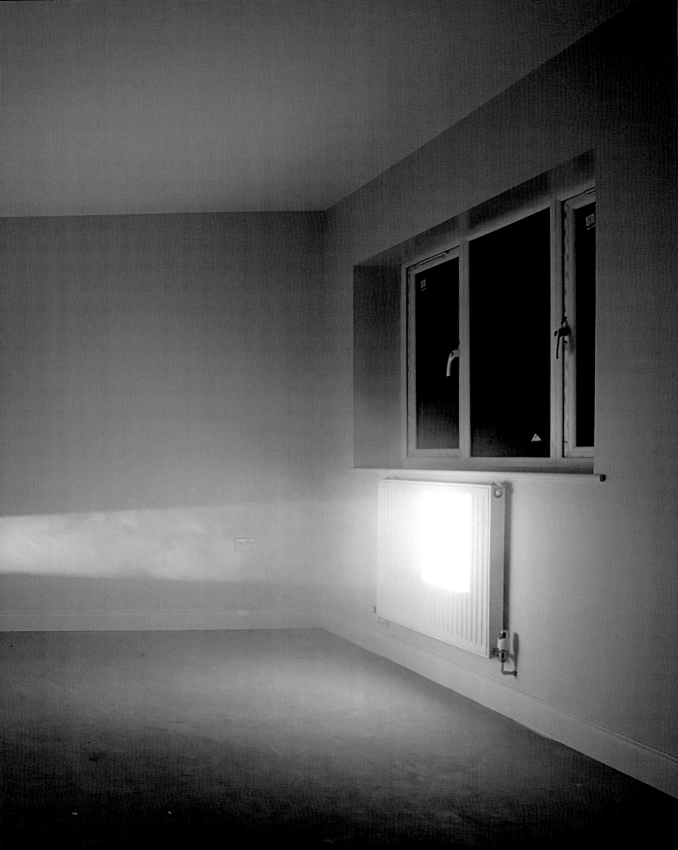

Research represents a crucial part of the intricate web of ideas and processes that build and create momentum whilst developing any new project, and it has taught me how to make the most of my ideas. I feel that research creates its own level of energy, which has led me to ask questions such as, 'What if I did this?' Research encourages me to continually challenge what I'm doing and establish new ways of thinking about my projects, which can be hard work. But, although it can be hard, it has made me more critical about myself, which is a crucial part of the research process for me. I have never felt, for example, that research got between me and being creative. Very early on I always understood that being able to take a step back from the work, to understand what I was achieving photographically, was equally important; to create some space to reflect on the project itself outside of the creative bubble.

For a number of years now I have been interested in space (height, width, depth), the 'thing' we are surrounded by or contained within, and how the transformative nature of photography can alter our perception of space. I have often been a fan of using photography as a form of early research; I think this

From the series: *Spatial Flux*. Photograph by Charlotte Fox, 2013.

stemmed from the artist Gordon Matta Clark where I always felt he used his camera as a form of investigation of the spaces he had worked with. I often photograph specific spaces or areas that I intend to work within. These initial photographs allow me not only to acquaint myself to the space, but to also pick up natural occurrences that I could then possibly exploit and harness in some form of critical investigation. This has happened twice during my Master's, which has fed into four individual projects.

Practical research, therefore, is crucial to my working methods in terms of using the right equipment to achieve the results I want, and if it doesn't exist I either make it from scratch or modify existing hardware. So, I experiment a huge amount to ensure my work is technically sound, and that the aesthetics I am searching for are relevant to what I'm trying to achieve; there is no room for compromise. However, the biggest trap that I think most people fall into is being consumed by technique at the expense of developing the idea. I have gone through a project where the technical side took over and I lost what I was trying to say with my photographs. But then, having said that, I have also weakened an idea by not executing the technical side well enough.

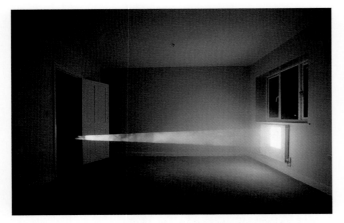

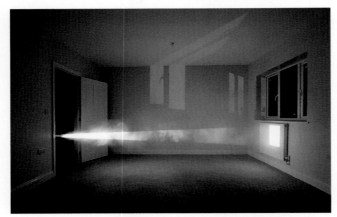

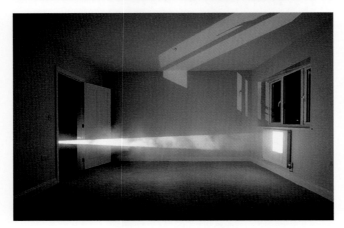

From the series: *Imaginary Time*.
Photograph by Charlotte Fox, 2014.

I felt that the *Imaginary Time* series struck a good balance between the technical and conceptual strands of the work, and that was down to the research. *Imaginary Time* is a photographic series and video work developed from an earlier project, *Spatial Flux*, which I feel also demonstrates the importance of research in the evolution of one project and its influence and inspiration for a new work. The initial steps I took with *Imaginary Time* were to re-visit my earlier research in order to see if any avenues of thought were worth exploring that I had previously dismissed or put aside.

Spatial Flux employed what I have termed 'light performances', namely the control of artificial light using the unique character of the architecture within a specific space; in this case the doorways leading off a corridor in a domestic building, which were used to restrict the light allowed to enter that space. Whenever I came across an artist who used artificial light I also questioned why they used this light form and how that related to my work. This creates a critical dialogue between the research and my own work. Sometimes, how much they differ is just as important as the similarities and teaches you what you don't want.

It was through this that the idea of performance was revisited from several articles already found, which opened up some defining aspects of *Imaginary Time*, especially when discovering installation light artist Anthony McCall, who in these early stages demonstrated

to me that light could be a physical object too—as a light beam. This physicality became an obsessive idea for me, as I could use it to interact with the space compared with the previous light experimentations. Although shadows had been extremely prominent in the earlier work, I had focused on light as the tool, allowing shadowing to be a by-product of this. By reversing this and considering shadow as a tool instead, I hoped to generate a different mind-set for the new project.

The series used two independent light sources to explore the defining constraints of architectural space. These combined lights capture the movement of time through a photographic sequence, as though a performance occurred for the viewer with the space providing the auditorium, and articulates to me the fragility of light and space, and their dependency upon one another. Creating the light beams was one of the challenging aspects of *Imaginary Time*, and I took two avenues of research at this time. I prolifically researched artists who use light, so not only could I gain technical information but also on what the light connotes in its application. I also consulted with several technicians over this period in order to create a physical beam of light and this was achieved by an extended period of practical trial and error. Aside from this specific research, I also looked into artists and theorists within a range of different creative disciplines, including sound art, chronophotography, sculpture, architecture, installations and site-specific art, performance art, and virtual reality, all of which allowed me to expand upon the idea of light, time and space, which helped in the development of *Imaginary Time*.

I document everything I do thoroughly in order to keep track of things. I find the easiest method for me is to use a loose-leaf folder. This is mostly because, although I still work chronologically, my research is continually expanding and I need to regularly update or extend the information I record. I keep two types of record; one logs all of the practical experimentation and the other all of my contextual research. Adding notations to both helps me to maintain continuity between my practice and the various forms of information that inform my thinking. Another key thing is that over time my logs have developed into a substantial archive that I can refer to again and again.

I feel that now I have established a way of working that suits my personality and works for me. I am acutely aware of the importance of research to my development as an artist, as it provides stimulation and credibility for my work. And I feel that the whole point of research, finding and interpreting different forms of information feeds the creative process and has enabled me to gain confidence and insight that together have helped shape me as an artist, and through this I have begun to develop my own creative voice.

Interview by Mike Simmons

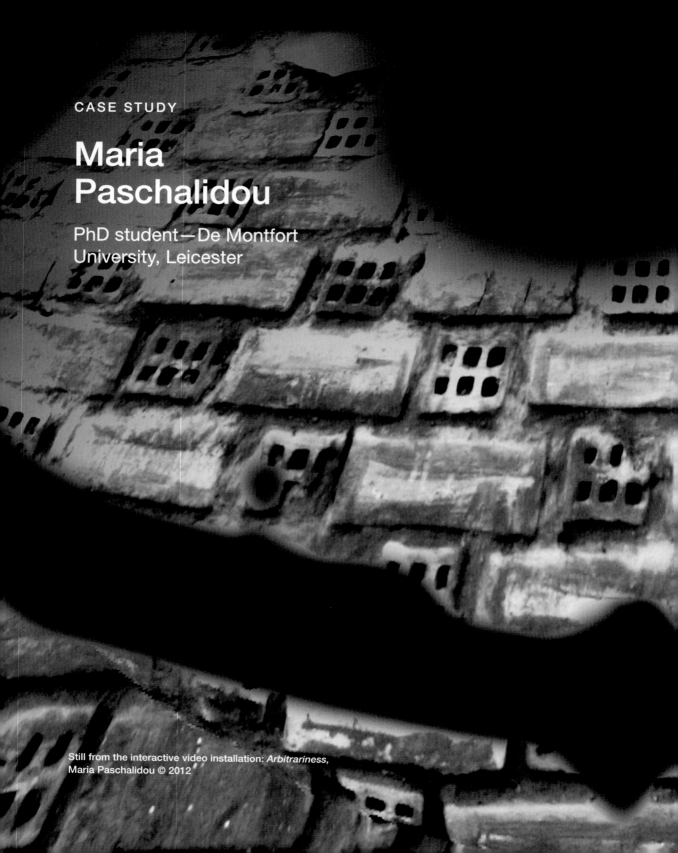

Maria Paschalidou

PhD student—De Montfort
University, Leicester

Still from the interactive video installation: *Arbitrariness*,
Maria Paschalidou © 2012

Having completed an undergraduate programme in photography at the Focus School of Art and Photography in Athens in the mid-90s, I gained an MFA in photography from Columbia College Chicago some 12 years later. After more than 20 years developing my practice as a performance and installation artist, I'm now in the final phase of studying for a practice-based PhD at De Montfort University in the UK. So, my understanding of research has developed considerably over–long period of time, and I now see research very much as a creative process that exposes multiple possibilities; a process that requires openness to new pathways that may not be visible at the beginning of a project. I have learned to work on and to overcome many preconceptions about my subjects, and I have become familiar with the way hybrid forms of knowledge create a dynamic context for theory and practice to collide and evolve in new ways.

Believing that photography is not an objective medium, fiction has always been at the core of my practice. I consider myself a visual *storyteller* who uses photography and other lens-based media as tools for recording staged realities to question, critique, comment, rearrange or reconstruct the boundaries between fact and fiction and employ visual metaphors, fabricated environments, ephemeral constructions and participatory installations as a theatrical stage and a performative act.

I see art as a process of knowledge building and communication and through my work I explore issues of power and control where the body is a site of both socio-political and emotional conflict; the power agents that mediate in the construction of identity.

For example, notions of visibility and invisibility became central concerns in my work *Bodies Under Investigation,* a photographic installation of digital archival inkjet prints, accompanied by a short looped digital video of 3 minutes' duration that explored how certain aspects of the inner self become visible through medical technology. This work refers to a hypothetical medical examination and uses specific types of numbering, text and diagrams used in medical imaging projected on the surface of the body to convey a certain viewing of the body.

My current research is built around the idea of 'phantasmagoria', a word used to describe the eighteenth- and nineteenth-century travelling theatrical extravaganzas that drew their themes from storytelling and narratives reflecting the era's 'visible' concerns about death and the afterlife. A magic lantern as well as rear projections and theatrical effects were utilised to project depictions of ghosts and macabre dancing shows.

Initially my work concentrated on the production of a single visual spectacle adopting the practices and techniques of the old phantasmagoria shows in

combination with contemporary visual technologies. However, during my research I realised that there were many different connotations of the word phantasmagoria and by examining the semantics of the word a definition

emerged that the philosopher and cultural critic Walter Benjamin described as a 'commodity culture' implying a socio-political perspective, and I have used this interpretation to explore the current economic crisis in Greece.

Detail from: *Bodies Under Investigation.* Photograph by Maria Paschalidou, 2003.

I am particularly interested in investigating ways in which images, created using still photography and moving image, can be combined as a mechanism in the performance of personal narratives, to develop the dynamics in the trichotomy of artist—art work—audience. Over the years I have developed different art practices to explore ways of actively involving audiences in various stages of the art production. In retrospect, I would say that these practices generated outcomes that were evident on multiple levels. For example, they signified an embodied mobility; I as an *artist-body* left my studio and moved into the world. They signified the emergence of words and texts into the images, a fact that brought challenging tensions to the surface of the art. They signified certain displacements that led to the emergence of 'unknown' vocal audiences. I as an artist was no longer at the centre of my artwork. Finally, these art practices have signified movements in time and space and have transformed the audience into an artist and the audiences' product into works of art that are contextual and situational. In *Biography of the Bread*, for example, the installation exposes the obsession with bread imposed by its fundamentality to the necessity of living, and the political games of lacking or being granted the right to it. The sounds of the installation mingle fragments of Byzantine ecclesiastic hymns with violent protest slogans in which the word 'bread' is being repeated.

Within the installation space, I suggest various ways of viewing and displaying static and moving images as well as encourage audience participation and immediate response to the works of art. The outcome has become a systematic production of visual statements that combine aesthetics and fiction with issues of power and control. Fiction is the tool with which I develop my concepts and my view of reality as a performative and transformative process. Fiction constitutes the library of my various translations of 'reality' and contains my artist's perceptions of history, culture, memory and geography.

I have created a theoretical framework to investigate the implication of public speech as fiction and public space as performative and from this perspective the phantasmagoric becomes highly politicised and multi-vocal, as well as controversial, where the relations of power and aesthetics continuously pose questions of what is seen and what remains unseen, which voice is listened to and which is not.

My research is focused on various orchestrated participatory conditions where personal and public narratives can be visually exposed in performative and interactive ways. For example, *Semiotics of the Phantasma* was realised as a public performance at Eressos on the Greek island of Lesbos, in July 2014.

facing page:
From: *Biography of the Bread*. Photography and video performance.
Photography by Maria Paschalidou, 2014.

Still from the performance: *Semiotics of the Phantasma.*
Maria Paschalidou, 2014.

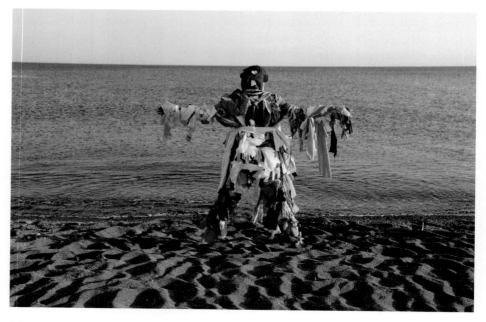

Still from the performance: *Semiotics of the Phantasma.*
Maria Paschalidou, 2014.

The performance draws on the local ritual of hanging personal items of clothing on the branches of wild olive trees, as a wish for healing from illness or injury. As the items weather and eventually fall to the ground the magical power of transfer is completed and the healing becomes validated. In this way personal anguish and fear are exposed to the public view creating a visual spectacle of multi-coloured old and new clothing on the branches of the trees. Participants in *Semiotics of the Phantasma* contributed both at the preparation stages (cutting clothing into small pieces) and throughout the act of tying pieces of clothing over my body until I was fully covered by them. Creating staged conditions of visual imagery and audience participation in this way can yield different kinds of knowledge. In re-creating this particular ritual I was able to discern the nuanced ways in which the participants tied the pieces of clothing to my body; some were gentle while others were much more aggressive.

The performance in Eressos represented a collective simulation of a ritual that contemplates multiplicity and vanity or futility. *Semiotics of the Phantasma* explored performativity in photography while attempting to alternate between cultural custom and the dynamics of a collective experience expressed through the medium of the performance. This model of working is grounded in the creation of staged conditions and audiences' direct involvement in different ways such as performing, writing, speaking, searching, listening or seeing, and in this way the artwork is constantly evolving and changing.

Interview by Mike Simmons

Patricia Townsend: Between Inner and Outer Worlds

The making of a new body of photographic work involves far more than the act of taking pictures. It is likely to include stages of preparation and research before any photographs are taken (although this is not always the case) and a process of editing afterwards; but these are much deeper and more complex tasks than one might at first imagine.

In creating a new body of work, photographers not only relate to elements of the outside world (the subject of the photographs, the camera, the prints and so on), but they also embark on a personal journey, which in turn will reflect some aspect of their inner world.

In this essay, I explore the question of how a new photographic artwork comes into being. In my discussion, I draw from my own experience as a photographer, and from a series of 30 interviews with professional artists (conducted between 2011 and 2013), six of whom use photography as the central medium in their practice. The essay situates these personal accounts within a framework of psychoanalytical thinking. But to begin I will describe my own practice, and the making of *Under the Skin*,[1] a photographic artwork which is an animation of still photographs.

The Making of *Under the Skin*

Some time before I began work on this particular project I was staying in the Lake District in the North West of England, in a valley halfway between the mountains and Morecambe Bay, a vast expanse of quicksands, channels and intertidal mudflats. After a while I noticed that I would rarely travel to the coastline. There was something troubling about this landscape for me. It seemed too open, too flat and too vast. Looking out over the great expanse of the Bay at low tide, I imagined myself walking out alone towards the horizon until I could see no land, and wondered what it might feel like to be out in this wet desert, alone and far from help.

I knew that many lives have been lost there, sucked down by quicksand or swept away, engulfed by the incoming tide, which is said to be as fast as a galloping horse. But I sensed

that there was more to my emotionally charged feelings about the Bay. It was as if my responses were the tip of an iceberg and that below the surface were unconscious echoes resonating within me, which I could not yet understand. It was this feeling that propelled me to make a series of artworks related to the Bay. Through making the work I hoped to discover what it was about the Bay that made me feel like this.

Initially, I did not know how to approach the subject beyond the fact that my usual media are video, photography and installation. I spent long periods of time walking the coastline and finding vantage points that seemed 'right'. One favourite area at the mouth of an estuary had a small pier from which I could film the incoming tide. Another spot had deep channels in the sand that altered with every tide. I took many photographs and shot many hours of video footage in an attempt to clarify what it was that I wanted to make.

This stage of the process can be seen as preparation involving practical experimentation and contextual research. I questioned whether I should use still or moving image, decided on both and began shooting in different locations, from different viewpoints, in different weather conditions and states of the tide. Alongside my trial photographs and video, I looked into the history and geography of the Bay, to try to get to 'know' the landscape as deeply as I could.

This period of research and experimentation was guided by an intuitive sense of what elements might carry the work forward. The notion of intuition, described by the philosopher Michael

Polányi[2] as 'know[ing] more than we can tell' is often seen as a fundamental principle within the creative process, but it is difficult to define. It is a process that can contribute to the emergence of insight or knowledge in new or unexpected ways; something that can have significant impact on the development and conclusion of any given body of work.

The psychoanalyst Christopher Bollas[3] sees intuition as an unconscious skill that allows the creative person to know where to look in the outside world to find those elements that will help to develop his or her work. In addition to the conscious research of facts and the production of trial images, intuition allowed me to search at an unconscious level too. So, the stage of preparation and research included a gathering of unconscious data. Bollas points out that this has an advantage in that 'the intuiting person is unconsciously able to explore lines of investigation that would meet with incredulous disapproval if he were fully conscious of what was being considered'.[4] That is, at an unconscious level the artist is free to make connections between different things in ways that would be censored or ridiculed in their conscious thought. The data gathered through intuition is processed and integrated unconsciously until it is ready to emerge into consciousness as an idea or image for a new work or a new direction in the making of a work.

Returning to my own process, through my experimentation with taking photographs and videos, I decided that I wanted to make a work related to the way in which the channels in the sand change with every tide. Also, I had discovered that the original meaning of 'quicksand' is 'living sand'. Then the idea came to me of making an artwork that would bring the sands to life and I realised that I could do this by animating a series of still photographs of the channels. The animation would enliven the still images and convey the idea of a movement over time. I was quite elated by this idea. The moment when an idea or image comes suddenly into consciousness is often exciting for an artist. Grayson Perry speaks of the 'golden glow' of the initial idea for an artwork 'and it's beautiful and it's fuzzy and everything is right and it only has the good sparkly bits'.[5] The idea seems perfect because it is still not fully defined and it is not limited by practical considerations.

My excitement began to dissipate when I tried to put the idea into practice and I came up against the practical problems and limitations that are inevitable at this stage of an artist's process. At this point the idea no longer seemed to be so perfect. My next task was to find the images that seemed to 'fit', but I did not yet know what that 'fitting' might be. That is, I did not have a clear sense of what images I needed but I knew that if I began to make and look at photographs of the sands they would start to visually articulate my ideas in a way that simply trying to think through alternative approaches would not do. By returning to the same position on the shoreline after each successive tide, I began to collect a series of preliminary images. However, I found that the changes I recorded were too great. The channels in the sands were completely transformed by every tide so that when I tried to juxtapose the images and to use an animation programme to create a smooth movement from one image to the next, the result was disjointed and lacked the continuity I felt I needed. After several attempts, I realised that I would need to find an alternative approach.

I had somehow to manipulate time in a way that would create a more coherent and fluid *Under the Skin 1, 2 and 3 © Patricia Townsend* expression. After a period of feeling stuck and unable to move forward, I had the idea that I could simulate a time change through a location change. That is, I could shoot the images at the same time but at different points on the same stretch of the shoreline. In this way, I could build up an impression of time that was more closely related to what I was trying to achieve. Bearing in mind that this work was to be shown as a moving image piece, I found that the landscape or horizontal format no longer felt 'right'. I realised that I wanted to create the sense of a wall or mountain of sand, which related more to how the landscape made me feel, and for this I switched to a portrait or vertical format; and further experimentation followed.

At this point there began a subtle shift away from my original idea to something that incorporated additional layers of meaning as I began to discover more about what felt 'right'. I had no clear sense of exactly what I was trying to do, but I continued to shoot, edit the images and experiment with different animation techniques. At each stage I evaluated the outcome to find a tangible link between my inner sense of what felt 'right' and the actual work I was making.

What emerged from this process was the idea that the animated images should move in such a way as to suggest that the surface of the sand resembled the skin of a living being. I realised that this atavistic sense of the land itself being a living and possibly hostile creature had been part of my initial response to the Bay and the animation technique would help me to articulate that. This realisation went hand in hand with the discovery of a particular animation

technique that resulted in just the effect I wanted. However, it is hard to say whether the discovery of the technique led to the recognition that this was what I was looking for, or whether my growing awareness of what I desired to achieve visually and emotionally led to the discovery of the technique.

When the work was eventually completed, decisions about the way in which it should be exhibited initiated a further series of experiments, as I wanted to create a specific effect for the viewer—a sense of tension and apprehension. I realised that this called for a large-scale image that would tower over the viewer and I decided to show the work as a rear projection in a doorway. My intention was to create the illusion that the room beyond the doorway was filled with unstable sand that might flood out at any moment to engulf the viewer.

My description of the stages I went through in the creation of *Under the Skin* raises a series of issues related to the question of how a new artwork comes into being. I have said that I was looking for images that felt 'right' or that 'fitted' but what does this mean? How did I judge whether a new idea for how to proceed was on the right track? What states of mind did I go through on the way? What was the nature of my relationship to my medium?

The Hunch

It becomes clear from my narrative of *Under the Skin* that my response to Morecambe Bay was a very personal one. From the beginning it became a space of imagination for me. The

psychoanalyst Donald Winnicott[6] was interested in the relationship between the inner world of our subjective experience and the outer world that is available to us all. Sigmund Freud[7] had stressed the division between 'phantasy' and 'reality' (roughly corresponding to inner and outer worlds), but Winnicott's great contribution to psychoanalytic thought was that he proposed the existence of an intermediate area of experiencing where inner and outer worlds co-exist. He observed young children with teddy bears or pieces of blanket that had a special significance for them and he coined the term 'transitional object' for these playthings. The child invests the object with something of his or her own inner experience so that it is *both* an object in the outer world *and* part of his or her inner personal world at the same time. Winnicott thought that we all need this intermediate area of experiencing which he called potential or transitional space.[8] Older children access it through play, and as adults we can find it in a number of experiences including religion and the arts.

We can also access it through our response to landscape. I had invested the landscape of Morecambe Bay with aspects of my own inner experience, so that there was an overlap between the external reality of the Bay and my inner world. Morecambe Bay became a transitional space for me. But, beyond this, I also had an intimation that the Bay might provide the means to find a form (in the shape of a new artwork) to correspond with what I was feeling. I will use the term 'hunch' for this. If we think of an 'idea' as a specific sense of direction (possibly in the form of a mental image) then the hunch is something less clear. I define it as a sense that an interaction between inner and outer worlds is taking place and the accompanying intimation that this could lead to a new artwork. As one of the interviewees put it:

> I knew there was something I wanted to do but I couldn't really say what it was until I'd got to that point where I did it right.

> (Sarah Pickering)

The making of a new artwork is an attempt to find a form that 'fits' the hunch.[9] In the search for this form the hunch will gradually become clearer and may develop into an idea, a more specific picture of the possible artwork the photographer wants to make. In the making of *Under the Skin*, my hunch developed into the idea of making an animation that would bring the sands to life. In my subsequent process, each stage of experimentation can be seen in terms of an attempt to find a form to fit my hunch.

As the work progresses, the artist may find that one idea must be abandoned in favour of another idea that corresponds with their hunch more closely. It is this willingness to explore the possibilities that keeps things fluid. Sticking rigidly to one idea may limit the potential for the work, a notion echoed by one of the interviewees:

> I plan stuff out, but it's not a rigid plan because I know it is going to change, it always does through the doing.

> (Sian Bonnell)

In my own process, the idea of bringing the sands to life by animating still photographs seemed to fit, but as the work progressed and the hunch became a little clearer, the landscape format no longer felt 'right' and a switch to portrait format was necessary. The animation editing technique that I had just discovered felt 'right' because it created an effect that fitted the hunch. At every stage it was essential to be open to the unexpected. If I came across something surprising as I was taking my photographs, it might point to a new possibility. If my editing programme behaved in an unexpected way that seemed at first to be a problem, it might turn out—as in practice it did—to be the very effect I needed.

The Photographer and the Medium

The photographer has to find a way of working with the medium, to follow the hunch towards a form that will eventually return to the outside world as the completed artwork. This medium may include the camera, processing of film, darkroom equipment, means of digital processing and printing, test prints and so on. All these pieces of equipment and processes have their own characteristics that can both limit or open up new possibilities for the photographer, as the photographer enters into a dialogue with the medium. The medium responds to the actions of the photographer and the photographer in turn responds to the results the medium produces.

I have found Adrian Stokes' thinking about the relationship of artist to medium useful here. Stokes was an art critic, initially writing in the 1930s, who wrote about his own experience as a viewer of art and architecture. He also wrote about the ways in which artists engage with their materials, differentiating between two modes of working that he called 'carving' and 'modelling'.[10] For Stokes, these are not merely techniques; they also reflect the artist's attitudes towards, and responses to, the medium.

According to Stokes, modellers use their medium in a 'plastic' way to mould it into a preconceived form. They impose their own vision onto their material. Carvers, on the other hand, have regard for the intrinsic properties of the medium and enter into a struggle with it, taking away from it to reveal the form within, allowing it to take on a life of its own. Carving establishes the artist's medium as 'out there', as possessing its own characteristics separate from those of the artist.

In his early writing Stokes thought that artists were either carvers or modellers and at that stage he valued carvers more than modellers. However, he gradually came to realise that he could not maintain this clear-cut division. Eventually he concluded that all artists must to some extent try to impose their ideas onto the medium and are also affected by the behaviour of the medium in response to their actions.

One of the artists I interviewed describes his dialogue with his camera in terms that fit with Stokes' thinking:

> There's something about the positive feedback you get from putting a pencil on a page. For me that relates to how I want to use the camera. And you know, I suppose

there is a kind of relationship between the sort of touching with the eye or touching with the lens . . . there's a nervousness . . . will you be able to find a way of holding that within the limitations of what the camera can do? But then pushing what the camera can do.

(Dryden Goodwin)

Goodwin looks for 'feedback' from his camera. What does it have to say to him? He knows that the camera has its own characteristics that will impose certain boundaries on what he can do and this gives rise to some anxiety. If the camera refuses to give him the effect he wants, will he be able to push it beyond its normal capabilities? Following Stokes' model, he employs both 'carving' and 'modelling' modes as he enters into a struggle with the medium, pushing it to its limits to achieve whatever he has in mind (modelling) whilst also respecting and responding to its behaviour and feedback (carving).

Play and Playing

The photographer, then, listens to what the medium has to 'say' to him or her. Sometimes it responds to the photographer's actions in predictable ways and sometimes it asserts its own properties and does something unforeseen:

The Quick and the Dead
© Patricia
Townsend

It's about the happy accident but it's also about recognizing something when it's coming towards the surface where you can catch it if you're aware enough of how crucial it can be to what you're going to make.

(Liz Rideal)

If the photographer has a fixed idea of what he or she wants to do, the unpredictability of the medium may be frustrating but if they are open to new possibilities it may be the happy accident that makes the work. This openness or flexibility is described by another photographer in terms of play:

> I am very interested in playing. Right at the beginning of a piece of work I might have a very vague idea of what I might be interested in . . . My camera is my tool and I will have made a decision before I begin about whether the piece (if it is eventually going to be a piece) is going to be done with a certain piece of equipment to begin with. I often use a pinhole camera . . . but even before that there's a sort of play action whereby I'm not sure what equipment I might be using Although I go at the start of the residency with some particular idea to get me startedthroughout my time I would be playing so there would be a whole lot of photographs that I just take with no idea if they are ever going to go anywhereI am always collecting images that at some point I may pull out and it may become a piece of work. . . . I know what I'm looking for but I know it's going to shift.

(Gina Glover)

The initial 'idea' is 'very vague', perhaps more a hunch than a specific image. It gives the photographer a sense of knowing what to look for but any more specific idea that arises from it is provisional and Glover understands that 'it's going to shift'. The vague idea or hunch initiates a series of experiments, both in the imagination and in the outside world.

To begin with there is the 'play' of the decision about which equipment to use. Imagination encourages playing with the idea of using a pinhole camera. Would this produce the desired effect? If not, should a digital or a large format camera be used? This may lead to trying out different equipment and a comparison of the results before making a decision, or choices may be made on the basis of experience and imaginative 'playing' with likely effects. That is, the artist may imagine possible effects and mentally 'play' with them to explore different possible outcomes.

Having chosen the equipment, the project then moves on to a different sort of experimentation, this time with taking the photographs themselves, 'playing' not only with the subject matter of the images but also with angle, lighting, framing and so on:

> There's a whole lot of processes I give myself. Have I looked at this building from the other side? It's a really good discipline to do. . . . It's this whole business of trying to make work with fresh eyes . . . by either calming the brain and letting the

brain become empty and therefore the eyes see something differently or you're just allowing the eyes to see what you're trying to make by a different light, by different locations.

(Gina Glover)

Here Glover is entering into a dialogue with the medium following a 'vague idea' or hunch but also alert for any new direction that might emerge from experimentation with the camera. In looking through the viewfinder from a particular angle, does something unexpected appear and if so, does it fit her hunch? She knows that it fits when she sees the image in the viewfinder and feels that this is what she was looking for all along but she could only recognise it once she saw it.

Having taken the photographs, yet another period of 'play' follows in the editing process as the photographer experiments with the images and decides which work together, which combination fits the hunch:

[It's] kind of like a muddy vision—not super clarity. It also exists as single images or combinations of images and that's kind of fun as well, that it has got these different lives, these different potential ways of being resolved.

(Sarah Pickering)

Although Pickering says that this stage can be 'fun', this 'playing' is not carefree. It is a serious business involving a great deal of hard work. It may also involve periods of boredom and frustration and call for painful decisions, such as the decision to abandon a direction that is not working:

I've learned you've got to get rid of your favorites quite often. In fact you have to get rid of them . . . You have to realize that they don't work . . . I suppose it's like a pruning. You've got a bush that you like and you have got to chop off a bit that's not working, even if it's a lovely bush.

(Sian Bonnell)

A Certain Sort of Concentration

The word 'playing' implies a particular state of mind. When children play, they are lost in a world of their own. They are in a state of total absorption in which their toys are both part of their inner drama and remain objects in the outside world. They are in the transitional space described by Winnicott. The photographer, too, is in a state of absorption while working with his or her medium. When I was on the shores of Morecambe Bay taking photographs and, again, when I was absorbed in editing my images, I felt myself to be in a bubble of time, separate from my everyday life. One interviewee describes her state of mind while working:

The whole point is that you don't force the concentration. You let that happen . . . It's about a certain sort of concentration. I think when we say the word concentration we think about this forced thing that's really directional and really trying to understand . . . whereas it's much more like looking at a Poussin painting and letting it just come into your eyes and understanding. That is deep concentration and it's quiet and it's very personal and it's very private.

(Liz Rideal)

This is reminiscent of the educationalist Anton Ehrenzweig's[11] description of a particular state of mind that he sees as integral to the process of art making. This state involves a 'flexible scattering of attention' and 'unconscious scanning' that he describes as 'dedifferentiation'. In this unfocused state the artist is able to hold all the diverse elements of the work in mind at once. According to Ehrenzweig, artists fluctuate between focused and unfocused states of mind as they work. Both states are necessary as the artist needs to experience the work as a whole but also be able to focus in on a detail.

Another way of thinking about the unfocused state of dedifferentiation is to see it as an opening up to the overlap between inner and outer worlds. The psychoanalyst Marion Milner,[12] who examined her own efforts to draw and paint, describes a state of 'illusion' or oneness between her and the painting. Milner is not talking about illusion as a mistaking of fantasy for reality but rather of a state of mind in which such distinctions do not apply. Moments of illusion are 'moments when the me and the not-me do not have to be distinguished. Moments when the inner and outer seem to coincide.'[13] These moments can occur at any time during the process of making the work. Dryden Goodwin, who draws on photographic portraits, describes this experience both in his studio and whilst on location:

So it was about the drag of the drawing device on the surface that actually set up a particular physical sensation that put me in a certain state, or whether I would wear a magnifying visor in my studio to look at a photograph and draw on the photograph . . . so my sense of my body behind my eyes would then dissolve similarly when photographing on Oxford Street there was a sense that I was hovering in space. Again a sense of the body dissolving behind the camera this time.

(Dryden Goodwin)

This is a graphic description of moments of 'oneness' as a sense of the artist's body 'dissolving'. According to Milner, experiences of 'oneness' or fusion are an essential stage on the way to 'twoness'. In other words, it is the experience of 'illusion' or oneness that allows the artist's process to progress so that artist and artwork can arrive at 'twoness' and the finished work can stand on its own, separate from the artist.

There is a parallel between Milner's concept of illusion and Winnicott's idea of transitional space. Winnicott's concept of transitional space contains within its name the idea that it is

associated with movement, with transition. For the baby this transition is from a sense of oneness with the mother towards a sense of twoness. So, the photographer's 'play' can be thought of as a movement from a sense of oneness between photographer and medium or developing artwork towards a state in which the artwork is finished and separate. As the process progresses the artist experiences the artwork as more and more separate from the maker. Finally, it takes on a life of its own and is ready to be launched into the outside world. At that point yet another phase of playing is necessary as the photographer chooses the way in which he or she wants to show the work.

Some Final Thoughts

I have tried to show how the journey of making a new photographic artwork involves a movement between the outer world of shared experience and the photographer's inner world that depends upon an interweaving of the two in the transitional space described by Donald Winnicott. The photographer starts by feeling drawn to some aspect of the outer world. This

On the Shores
© Patricia
Townsend

signals that there is an overlap with something in his or her inner experience and gives rise to the sense that this particular aspect of the outside world will provide a route towards a new artwork. I have called this the 'hunch' and have suggested that the process of creating the artwork can be seen as the search for a form that will fit the hunch. The artist translates the hunch into the artwork through the dialogue with his or her medium and so puts it back into the outside world.

Once the artist has separated from the artwork sufficiently to let it go out into the world we might think that this is the end of the artist's process. We might suppose that the artist can now leave this work and move on. Indeed, this may be the case but sometimes the artwork raises further questions for the artist and these questions call for another work in order to explore them fully. Occasionally a particular artwork seems to have a special significance for the artist. If the artist uses a medium such as painting or sculpture, where each work is unique, these may be works that are not sold but are retained by the artist him or herself. The artist wants to refer back to this particular work because it seems to have further potential.

Here I am talking about a situation that is different from that in which an artist creates a body of work that is intended from the outset to give different perspectives on the same subject. It is also different from the situation in which artists may have a single central theme in all their work and spend their life exploring different aspects of the same subject. In these cases, each artwork is a separate exploration of the central theme. For example, my piece *Under the Skin* is one of several different works I have made that relate to Morecambe Bay.

But if the finished artwork not only provides a form corresponding to the artist's hunch but also touches on further areas of the artist's inner world, the artist may feel the need to start again from what they might expect to be their finishing point. The creation of the artwork began when the artist was drawn to an element of the outside world. Now, it seems that the new artwork itself acts as an element of the outside world that resonates with the artist's inner experience. This leads towards a new hunch and a new process can begin.

Notes

1 *Under the Skin* was shown as an installation at the Blue Gallery, Brantwood, the former home of the English writer, artist and social reformer John Ruskin (September to October 2013). It can be viewed here: www.patriciatownsend.net/patricia_townsend_portfolio.html.

2 Michael Polányi. 2009 (1967). *The Tacit Dimension.* (Re-issue edition). Chicago and London: University of Chicago Press, p. 4.

3 Christopher Bollas is a psychoanalyst and writer. His writing on intuition appears in Bollas, C. (2011). Psychic genera. *The Bollas Reader*. London: Routledge.

4 Ibid., p. 73.

5 Grayson Perry, Talk at Conference 'Making Space: Psychoanalysis and artistic process', University College, London. 25 February 2012.

6 Donald Winnicott was a psychoanalyst and a paediatrician. Work referred to—D. W. Winnicott (1953, 1986). Transitional objects and transitional phenomena; a study of the first not-me possession. *Playing and Reality*. Harmondsworth: Penguin.

7 Freud used the term 'phantasy' to denote unconscious fantasy. See, for example: S. Freud (1908). Creative Writers and Day-Dreaming. *The Standard Edition of the Complete Psychological Works of Sigmund Freud*, Volume IX (1906–1908) *Jensens's 'Gradiva' and Other Works*. London: Hogarth Press (published 1953–74), pp. 141–154.

8 Donald Winnicott referred to 'transitional objects', 'transitional phenomena' and 'potential space'. Later commentators have ascribed the term 'transitional space' to him and now 'transitional space' and 'potential space' are used interchangeably.

9 Strictly speaking, the developing artwork is not an embodiment of the 'hunch' itself but, rather, of an aspect of the artist's inner world together with the corresponding element of the outer world that gave rise to the hunch.

10 *See: A. S. Stokes (1934). The Stones of Rimini. The Critical Writing of Adrian Stokes* Vol. I (1930–1937). London: Thames and Hudson.

11 See: A. Ehrenzweig (1967). *The Hidden Order of Art: A study in the psychology of artistic imagination*. London: University of California Press.

12 See: M. Milner (1969). *The Hands of the Living God*. London: Hogarth Press, p. 416.

13 Ibid., p. 416.

Shirley Read: Finding and Knowing—Thinking about Ideas

How important is it for an artist or photographer to find a subject matter that is particular to them? And what do we mean when we talk about the central concerns of a photographer's work? What Simon Norfolk, in his interview for this book, describes in this way: 'when I'm researching I'm still looking back fourteen years and thinking about the line that runs through and joins my work up'? Or in the same vein when Georgia O'Keefe in an interview, very many years ago now, said that looking back she could recognise that she had the same concerns in her nineties as she did when she was eighteen and just starting out?

As a curator I am looking for what is at the core of any work, whether it is the work of a student or an established exhibitor. What I am looking for will carry with it the sense that the work is powered by the authentic concerns of the photographer, that it is in some way heartfelt and has an integrity to its approach and treatment of its subject. For me, the presence of that authentic voice is what lifts a body of work above the everyday.

I once went to a photographers' party where identifying the photographers from a set of anonymous images was a quiz set us for the evening. What helped us do this was not simply the photographers' stylistic choices and habits—the use of particular framing, camera format, colour range, lighting or focal distance for instance—but the fact that, consciously or unconsciously, a photographer will usually have long-term preoccupations. These preoccupations may be in either abstract or quite material ideas or subject matter, an approach to the world or to making work.

So, for example, since the 1970s Peter Kennard has talked about war, armaments and poverty—and used a range of media including photomontage, painting, collage and sculptural installation to do so. In their interviews for this book Tom Hunter talks of his work as collecting and reinterpreting stories; Mandy Barker that 'the motivation for my work is to raise awareness of plastic pollution in the world's oceans and the harmful effect this has on marine life'; Ingrid Pollard of different projects being linked through 'ideas of migrancy, home and belonging'; and Deborah Bright that 'most of my landscape projects have to do with conquest and the obliteration of memory'.

 The artist may, or may not, recognise their own motivation when they start out or may come to recognise it over time and across bodies of work: Simon Norfolk is known for his work on the landscapes of war and comments that

> doing something about glaciers wasn't a diversion from my usual interest in warfare but was, in fact, taking the core of that work and applying it elsewhere. That core is about time, the strata of time, photography as archaeology and archaeology as photography.

Sian Bonnell also recognises how her interest has remained consistent while developing over time:

> I realised recently that my central concern has remained the same since my earliest days as an art student. I was studying sculpture and I refused to make anything until I knew what space it was going to inhabit. I began making spaces that sculptures might occupy and it is only now I see that my work has revolved around defining

The Mariabad area, Pakistan
© Asef Ali Mohammad

The parents of Nazir Hussain, a Hazara police officer, who was killed in a bomb blast in January 2013, holding his portrait. © Asef Ali Mohammad

a sense of (often interior) space and then working out what the limits of this space might be through the placing of objects within it. The objects were often re-used and I came to see them as props. Only lately have I begun to enter the space myself—perhaps to find out what it feels like to inhabit it but this is an ongoing concern, yet to be resolved.

In some cases a subject matter is quite clearly a given, the result of background and circumstances. For example, Asef Ali Mohammad is a British-based Hazara, who was born in Afghanistan, grew up in Quetta, Pakistan and recently completed his MA in photography at Middlesex University in London. He is quite decided that his future lies in documenting the lives and struggle of his people. The Hazara are discriminated against as a religiously Shia and ethnically Turku-Mongol minority in Pakistan and elsewhere and as he says

> I grew up with my parents talking about the Hazara's struggle and so it was a natural subject for me when I started to train as a photographer. Whatever happens in my life I imagine that it will remain something I'll always work on—because people still need to know about the lives and struggles of others. The Hazara are sometimes in the news when there's a terrorist attack but I want to fill in the gaps in this picture.

A subject matter may also come from a particular experience or time in the artist's life. Georgina McNamara describes her interest in 'the gulf between who we are and how we want to be perceived by others' as stemming from the fact that:

Bay
© Georgina McNamara

Unicorn
© Georgina McNamara

Pile
© Georgina McNamara

As a child, I was uncomfortably shy. In my teens, I overcame my inhibitions by armouring myself with a bolder persona which in time became second nature. In earlier work, I focused on self-consciousness in self-portraiture, covering my face with a variety of props to enable myself to pose for the camera more comfortably. It can be hard to pinpoint why we are drawn to certain themes. For me, it was only when other students pointed out that all my work had a theme of hiding or disclosing that I was able to make the link between my teenage self and my ongoing photographic interests.

My current work revolves around ideas of revealing or concealment to explore how the mood of a person can be physically or metaphorically masked. Although I occasionally deviate from this theme, it repeatedly grabs my attention and pulls me back.

A particular approach to their subject matter may be the underlying concern that links different bodies of work from a photographer. So, for example, expedition photographer Martin Hartley acknowledges the influence of the early polar photographers on his work and says, 'I think it's irresponsible to travel on an expedition today and not gather some sort of data—because unless that's what you're doing it's a holiday and not an expedition'.

A completely different approach is shared by Sian Bonnell and Grace Lau who both enjoy playing with aspects of image-making. Sian Bonnell remarks that she frequently explores

what a tool or implement will do or what it's not supposed to do by putting it to a different usage or context. Grace Lau says:

> Issues about race and gender motivate my work because they are personal. Being Chinese I'm always aware of how people expect me to behave and speak. My instinct is to confuse their expectations so I make photographs which subvert rather than confront. But it was meeting and photographing people in the fetish and S&M sub culture, who played with socially accepted roles and encouraged me to document their role-playing, which led me to questioning cultural stereotypes in my own work. And this has remained a constant theme over the years.

So, finding one's subject matter may take input or feedback from others and may also necessitate feeling one's way through the process of making work. As writer and critic Geoff Dyer[1] has pointed out, 'You don't have to know what kind of book you are writing till you have written a good deal of it, maybe not until you've finished it—maybe not even then. All that matters is that at some point the book generates a form and style uniquely appropriate to its own needs.' I believe that this comment about writing holds good for photography.

The 'not knowing' can become knowing as we see from the intertwined processes of research and making work as described by Ingrid Pollard, Susan Derges and Hannah Collins, for example. The work may start from a few words, a feeling or question and be a process of discovery, a working towards something which feels right, true or authentic.

Deborah Bright adds to this sense that the interaction between knowledge and instinct cannot always be untangled but points out that the continued process of making work strengthens the artist's ability to find their way: 'Intuition is not random but channelled by my individual sensibility, a way of thinking and seeing that has evolved over many years of working behind the camera and making and looking at photographs.' Or, as Edmund Clark says, when describing the moment of making a photograph, 'the decision is related to all that research I've done before. Because you are having to work quickly you are so completely focused on what you are doing that you trust yourself to make the aesthetic judgement but also to make decisions based on what your brain is telling you is interesting.'

I do think that the recognition of their particular subject matter is crucial to the long-term progression of the work of any artist or photographer. That this recognition may take time and the accumulation of work. And that looking back at the concerns that form the backbone of the work and the interests which fuel it, with or without input from others, will serve to provide evidence of where they have been and point the direction for the future.

Note

1 The Write Way. *The Guardian*, 2011, www.theguardian.com/uk. Geoff Dyer is a writer, critic and journalist. He has written a number of novels as well as critical books including *The Ongoing Moment* (2005, New York: Random House inc).

Janina Struk:
A Photographer in
the Archive

As a professional documentary photographer and writer with a zeal for critical investigation, research informs my photography, and my photography informs my research.

When I began to work as a photographer I didn't consider myself a researcher, but I *was* aware that subject knowledge was imperative if I was to make informed choices about the kind of photographs I needed to take to communicate a particular message.

A photograph is a two-dimensional object; a fraction of a second frozen in time and evidence that the moment existed. In that sense a photograph is objective, but it is also subjective, influenced by the intention of the photographer who makes a series of technical, aesthetic and ethical choices each time the shutter is released, for example which part of the scene to photograph, how best to compose it, then how to achieve the required result – the use of lenses, the angle, distance, the type of lighting and focus. These factors determine how we 'read' or understand the moment captured by the camera. But in order to 'interpret' a photograph, we must look beyond its lines and tones to what lies outside the frame of the image. The phrases 'a picture is worth a thousand words' or 'every picture tells a story' are only applicable if we already know what the story is by other means. As Susan Sontag has written, 'photographs do not explain, they acknowledge'.[1]

My first solo photography exhibition, *Washington in a word . . .*,[2] was produced as a result of six months of research as photographer-in-residence at Washington New Town in the North East of England.

The brief from my commissioners and funders, the Artist's Agency and Washington Development Corporation, was to photograph 'The people of Washington' and the end product would be an exhibition.

As I had never been to Washington, nor did I know much about the North East of England or new towns, I moved from London into a studio apartment on one of Washington's award-winning estates, or 'villages' as they were called in the town's glossy public relations brochures. I decided that to get to know the people of Washington I needed to live there.

*Washington New
Town*, landscape,
1984
© Janina Struk

For the first month I took few pictures as I made notes on my impressions and what I learned about the town. I used my camera as a kind of sketchbook, a way of creating a link with the people I met and exploring the visual possibilities of the area. I spent time speaking to residents in working men's clubs, cafes and in the community school that had offered me workspace. I also began to familiarise myself with the history of the town.

In 1964 Washington—then largely a coal mining area—had been designated as a new town under the New Towns' Act 1946. A Development Corporation was put in place headed by officers appointed by central government. The last remaining coalmine had been closed down, apparently on the premise that the coal supply had run out, although former miners would tell me otherwise. Perhaps a colliery did not fit with an image of a new town?

But what is a new town? I discovered that the concept originated in the work of the late nineteenth-century writer Ebenezer Howard, whose book entitled: *Garden Cities of To-morrow*, published in 1902, formed the basis of this modern movement. In Howard's utopian vision, a garden city would be the result of the marriage between country and town. It would be a new kind of environment in which people would escape the harsh realities of urban capitalism and live in well-designed homes amidst parks and gardens.

In Thatcher's Britain[3] Washington New Town was far from utopia. The complex roadways constructed for a society in which the majority would have cars seemed virtually empty. Its copious industrial estates built to cater for a socio-economic boom lay in waiting, and its

Chief Architect, Washington New Town, 1984
© Janina Struk

working class population with little disposable income were confined to the 'villages' that had little to offer in terms of transport or leisure facilities.

The history of the new town movement and the socio-economic conditions directly informed the type of photographs I decided to take, as well as the structure of the final exhibition. As the research influenced the photographs, so the photographs gave a modern interpretation to the theories of the garden city. In order to emphasise the design and structure of the town I photographed the roadways and villages just after dawn to avoid people or cars. I took portraits of the corporation's chief officers in their offices in order to give a face to the town's leading bureaucrats—largely unknown to the population.

I photographed industrial estates and took posed portraits of its workers. I also photographed its young people and to accompany their portraits gave them the opportunity to write their opinions about the town. I was aware that how I chose to photograph my subjects would play a vital role in how an audience would understand or relate to those subjects.

The exhibition consisted of more than 50 black and white photographs. Each image was framed with a relevant quotation taken from Howard or other new town theorists, and the opinions collected from the town's youth. This structure was based on the idea that since the combination of two elements—country and city—would create a garden city, the combination of image and text would work in a similar way and encourage the viewer to synthesise a meaning from these paired elements.

The response to my work was mixed: some positive, some critical. The school incorporated the exhibition into geography and history classes to inspire discussion among its pupils about the town—its history, structure, design, past and future.

My critics posed questions: where were the pictures of the town's working class population in their homes? Why had I photographed the chief officers in poses that made them seem remote? How had I managed to take pictures of empty roadways and why? Why had I exhibited photographs of punk rockers (considered anarchic at the time) with their unedited opinions about the town?

But it seemed that the most disconcerting and perhaps controversial part of the exhibition was the way in which I used the research—or perhaps that I had carried out research at all. Why were quotations taken from the theories of new towns in the exhibition? It wasn't what had been expected of a documentary photographer.

The corporation responded by pulling down the shutters on other 'arts' projects intended for the town. In an attempt to counterbalance my critical work a photographic competition ran in a local newspaper asking the people of Washington to submit their own view of the town. I seem to remember the winning picture that adorned the corporation's headquarters was a large colour print that featured ducks on a lake taken during a glorious sunset.

I regarded the corporation's viewpoint as much to do with their perceived idea of what documentary photography should look like rather than anything else. At the time, the supposed realism of black and white photographs that gave a glimpse into the 'reality' of working class lives was a popular subject for the concerned documentary photographer. This was particularly the case at Side Gallery, in nearby Newcastle upon Tyne. At the time, Side was influential in promoting this genre of photography and was renowned for its bleak portrayal of working class life in the North East region of England.[4]

I doubt that the corporation wanted the gritty realism that adorned the walls of Side Gallery, but there seemed to have been an expectation from my commissioners that I would work in the spirit of the documentary tradition and take pictures of its population at work and play—perhaps also with a public relations gloss. But if photographs are about imparting information, then I decided my exhibition would have to incorporate text about new town theories. I also decided that the precise and systematic construction of the town would be best represented by images that were also constructed and systematically presented. I had also chosen to work in this way to avoid the potential pitfalls of the liberal documentary tradition and what I saw as its voyeuristic nature.

The story of the Washington exhibition highlights the influence that research had on my approach to photography. The photographic assignments and the writing that followed have been a development of that approach. And, as my practical understanding and enthusiasm for photography, representation and history has grown, research has become an increasingly important part of my work.

One of my primary concerns is the influence photographs have on our perception and understanding of history. I began a study into a specific collection of images that analyses how visual representation contributes to how we understand—or misunderstand—a particular

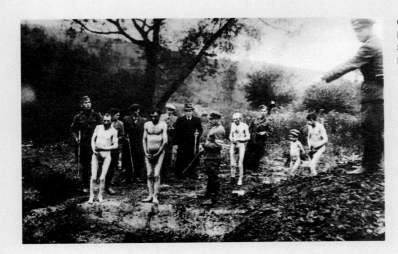

subject. My experience as a photographer gave me the practical and analytical skills to begin the research and provided a framework within which to work with historical images that can become separated from the original context thereby affecting the way in which they are interpreted and used.

That study into photographs taken during the Holocaust began in the early 1990s when I started to pursue an inquiry into photographs taken during the Second World War, with a particular interest in Poland. At the time, no significant research had been carried out into images taken during the Holocaust, especially those taken in Nazi-occupied Poland and Ukraine. In the early days of my research I came across images that seemed to cut across the boundaries of what I perceived war photographs to be about; they did not show the dead strewn on battlefields nor the devastating effects of war on civilians, but a type of photograph I was not familiar with at the time.

One image I came across in an archive in London shows four naked men and a boy standing on the edge of a pit apparently passively awaiting their execution. Surrounding them are seven perpetrators, some armed, some in uniform, some not. A man in uniform on the right-hand side is looking to the camera, seemingly directing proceedings.

I felt ashamed for examining such a barbaric scene, voyeuristic for witnessing their nakedness and vulnerability, and disturbed because the act of looking put me in the position of the possible assassin, but I was also compelled to find out more. Where was the picture taken? Why had it been taken, and by who? Who are the people in the picture? Are they Jews, Poles, Gypsies or communists?

As with many images taken during the Holocaust, this photograph was without provenance, so I asked the archivist *who* she thought had taken the picture and *why*? My questions were regarded as surprising and my curiosity somewhat morbid. The sheer barbarity of the scene seemed to prevent any rational thought. Isn't the fact the photograph exists enough evidence of Nazi crimes? But it could have been an official photograph for the files of the Reich,

or a memento for a Nazi or sympathiser. In order to begin to understand what the image showed, I had to find out where and in what circumstances this type of execution could have taken place.

In spite of the lack of information, this photograph has been widely used in books, exhibitions and films about the Holocaust and attributed to many different locations and many different dates. It has become an all-purpose illustration—an icon to the barbarism of the Nazi regime—used as evidence, but by different people towards very different objectives.[5]

The research into this photograph and hundreds more Holocaust images led me to public and private archives in Britain, Poland, Ukraine, Israel and the USA over a span of almost ten years. The research culminated in my book *Photographing the Holocaust: Interpretations of the Evidence* (I.B. Tauris, 2004), which explores various questions including who took the pictures and why they took them. It analyses how the pictures are archived, and who uses them, how and why. These questions, which traditionally been disregarded, are fundamental to begin to understand how to interpret these photographs.

I began to research and write *Private Picture: Soldiers' inside View of War* (I.B. Tauris, 2011) partly as a result of unearthing a large number of personal snapshots taken by German soldiers while researching *Photographing the Holocaust*. The main question these snapshots posed was the following: If German soldiers had taken pictures of their crimes, then other soldiers must also have taken pictures in other wars. My research in public and private archives, as well as interviews with soldiers, showed this indeed was the case in almost all wars. During the Boer War (1899–1902) and the First World War (1914–1918) soldiers used cameras to record their personal memories of conflict; as did more recently the Israeli Defence Forces in Palestine and at the time of writing the book the story about the pictures taken by American soldiers at Abu Ghraib prison in Iraq filled the press. This investigation led me to ask a further question: what effect could a wider appreciation of these soldiers' pictures have on the popular perception of the genre of war photography?

The thoroughness and doggedness of my research relies in part on asking questions of a photograph. I use primary sources and do not rely on published work either in print or on the Internet. Not asking the correct questions of photographs can lead to false conclusions or to reading them in incorrect or inappropriate ways. This continues to be the case with Holocaust images. They are sometimes accredited with incorrect captions, no captions at all, or are put to multifarious uses including for propaganda purposes.

Traditionally, photographs have not been subjected to such scrutiny. Historians have rather tended to regard them simply as evidence, an illustration to support a text. The idea that photographs can be considered as a text, as well as a rich source of information that adds to our knowledge of history, is not a widely held viewpoint.

When I was invited to speak about *Photographing the Holocaust* at a conference of historians at East Anglia University some years ago, my participation was considered as innovative by participants. To an historian a photograph is considered of secondary importance to written documentation and photography not a subject for investigation.

This point is illustrated by an exhibition first displayed in Hamburg in 1995 entitled *War of Extermination: Crimes of the Wehrmacht 1941–44*. As its title suggests it took as its subject the crimes committed by German soldiers during the Second World War in Eastern Europe and the Soviet Union. It included more than 1000 photographs, some taken by soldiers.

For more than two years it travelled through Germany and Austria until a historian alleged that some of the pictures did not show what the curators had assumed they did: people shown as corpses in photographs taken in Western Ukraine had been murdered by German soldiers. The historian alleged that they were already dead when the Germans arrived, and that Russians had murdered them. A moratorium into the authenticity of the photographs began. After almost a year of rigorous research by a panel of eminent historians a report concluded that only a few of the images had questionable or inaccurate captions, yet the exhibition was discredited and subsequently closed down.

During my research into this exhibition and in order to get to the root of this complex story I travelled to Hamburg to interview historian Hannes Heer. He admitted that they (the historians) had sometimes used photographs on the basis of what they *assumed* they showed. He said: '[As historians] we had no knowledge, nor had we thought about what a photograph is, how dangerous it is, how ambiguous it is and how it can be used in different ways. For historians a photograph is simply evidence.'[6]

I am sometimes asked whether I consider myself as a historian, a photographer, a photo-historian, a researcher or a journalist. The answer is that there is something of all these disciplines in my work. The practice of documentary photography is an interdisciplinary practice that, in order to understand the subject and take well-informed pictures requires background research and good communication skills as well as technical ability. As a writer my study into photographs is enriched by this knowledge and fuelled by an insatiable curiosity about photographs, their history and provenance, how they are interpreted and used, and what we can learn from these fragments of the past.

© Copyright: Janina Struk, January 2016

Notes

1 Susan Sontag quoted in Janina Struk (2004). *Photographing the Holocaust: Interpretations of the Evidence*. London: I.B. Tauris, p. 4.

2 *Creative Camera*, no. 229, January 1984, pp. 1218–1219.

3 Under Prime Minister Margaret Thatcher (1979–1990) Britain witnessed two major recessions, a rapid programme of privatisation, a sharp decline of industry—particularly in the North of England—and a dramatic increase in poverty, inequality and the number of unemployed.

4 Janina Struk (1987). 'Northern Mythologies', *Creative Camera* 6, pp. 30–31.

5 'A Photograph from the Archives', pp. 2–15 in Struk, *Photographing the Holocaust*; see also *The Guardian*, 'The Death Pit': www.theguardian.com/artanddesign/2004/jan/27/photography.museums.

6 For a detailed account of this exhibition see: 'How Pictures Can Haunt a Nation', pp. 89–108, Janina Struk (2011). *Private Pictures: Soldiers' Inside View of War*. London: I.B. Tauris.

Conohar Scott:
Collaborative Working

Environmental Resistance:
Art for change

The Rationale Behind Collaboration

My interest in the photographic documentation of industrial pollution first emerged almost by accident over a decade ago when I visited Eden, a small hamlet in Vermont, USA. My stay resulted in the documentation of Eden's most notorious feature—the town's abandoned asbestos mine. Once the largest of its kind in the USA, it was forced to close following a change in federal law in the late 1990s, which made it illegal to mine asbestos. However, no funds were allocated to cleaning up the site and the owner of the land was not obliged to take any action. As a result the mine remained as it was on the last day of production, with loading buckets laden with refined asbestos suspended in mid-air. I photographed the mine at Eden without having a clearly defined ethical stance towards the subject matter, and was simply photographing the mine as I discovered it. In doing so I conducted no protest, I appealed to no one and I maintained only a flawed objectivity without a coherent understanding as to what I was doing.

Following this realisation I undertook a project in collaboration with Greenpeace in Hungary. At the time Greenpeace were pursuing legal action with the EU's European Commission. The action was against the Hungarian government for issuing a rather dubious licence to the waste disposal company TATAI. The licence allowed the processing of toxic waste from the production of aluminium at a plant in Almásfüzitö on the banks of the Danube. The highly caustic waste was stored in unsealed red mud ponds close to the river, which were susceptible to seismic fluctuations and represented a substantive environmental threat.

Behind the scenes Greenpeace supplied me with scientific data, maps, advice on how to enter the compound, and most importantly the contents of the licence. This formed the basis for the textual information that accompanied the photographs that I took at the Almásfüzitö site. The final project is composed of ten diptychs in which the photographs are juxtaposed

with text panels that detail the entirety of the TATAI licence, which is breathtaking in its scope and permitted TATAI to dump any kind of industrial waste into the unsealed basin of the Almásfüzitö red mud ponds.

Asbestos Loading Bucket. From the series *The Edge of Eden*. Photography by Conohar Scott, 2006.

The final outcome—*Almásfüzitö: An Index*—was disseminated in the form of a photo book delivered to 20 individuals across the EU, who had some professional interest in the case. Some of the recipients represented the Hungarian government and others were EU ministers in neighbouring countries or environmental scientists who might be sympathetic to the protest. In such cases it was hoped that the publication would stimulate debate across a number of diverse professional communities around Europe.

Although the book format was a successful means of highlighting the environmental problems ongoing in this location, certain difficulties arose due to my informal partnership with Greenpeace, which had a clearly defined operational structure and my position as an independent artist unaffiliated to the organisation. When it came to disseminating the photo book the campaign managers at Greenpeace were unable to back my project publically because Greenpeace were operating their own PR strategy. As a result, it would have been easier to sell Greenpeace photographs of the TATAI plant as a photojournalist might do rather than to provide the organisation with a conceptualised artwork.

10 11 16 solid wastes from flue-gas treatment other than those mentioned in 10 11 15. 10 11 17* sludges and filter cakes from flue-gas treatment containing dangerous substances 10 11 18 sludges and filter cakes from flue-gas treatment other than those mentioned in 10 11 17. 10 11 19* solid wastes from on-site effluent treatment containing dangerous substances 10 11 20 solid wastes from on-site effluent treatment other than those mentioned in 10 11 19. 10 11 99 wastes not otherwise specified 10 12 WASTES FROM MANUFACTURE OF CERAMIC GOODS, BRICKS, TILES AND CONSTRUCTION PRODUCTS 10 12 11* wastes from glazing containing heavy metals 10 12 12 wastes from glazing other than those mentioned in 10 12 11. 10 12 13 sludge from on-site effluent treatment 10 12 99 wastes not otherwise specified 11 WASTES FROM CHEMICAL SURFACE TREATMENT AND COATING OF METALS AND OTHER MATERIALS; NON-FERROUS HYDRO-METALLURGY 11 01 WASTES FROM CHEMICAL SURFACE TREATMENT AND COATING OF METALS AND OTHER MATERIALS (FOR EXAMPLE GALVANIC PROCESSES, ZINC COATING PROCESSES, PICKLING PROCESSES, ETCHING, PHOSPHATING, ALKALINE DEGREASING, ANODISING) 11 01 08* phosphatising sludges 11 01 09* sludges and filter cakes containing dangerous substances 11 01 10 sludges and filter cakes other than those mentioned in 11 01 09. 11 01 13* degreasing wastes containing dangerous substances 11 01 14 degreasing wastes other than those mentioned in 11 01 13. 12 WASTES FROM SHAPING AND PHYSICAL AND MECHANICAL SURFACE TREATMENT OF METALS AND PLASTICS 12 01 WASTES FROM SHAPING AND PHYSICAL AND MECHANICAL SURFACE TREATMENT OF METALS AND PLASTICS 12 01 02 ferrous metal dust and particles 12 01 07* mineral-based machining oils free of halogens (except emulsions and solutions) 12 01 09* machining emulsions and solutions free of halogens 12 01 12* spent waxes and fats 12 01 14* machining sludges containing dangerous substances 12 01 15 machining sludges other than those mentioned in 12 01 14. 12 01 16* waste blasting material containing dangerous substances 12 01 17 waste blasting material other than those mentioned in 12 01 16. 12 01 18* metal sludge (grinding, honing and lapping sludge) 12 01 19* readily biodegradable machining oil 12 01 99 wastes not otherwise specified 12 03 WASTES FROM WATER AND STEAM DEGREASING PROCESSES (EXCEPT 11) 12 03 02* steam degreasing wastes 13 OIL WASTES AND WASTES OF LIQUID FUELS (except edible oils, and those in chapters 05, 12 and 19) 13 01 WASTE HYDRAULIC OILS 13 01 04* chlorinated emulsions 13 01 05* non-chlorinated emulsions 13 01 09* mineral-based chlorinated hydraulic oils 13 01 10* mineral-based non-chlorinated hydraulic oils 13 01 12* readily biodegradable hydraulic oils 13 01 13* other hydraulic oils 13 02 WASTE ENGINE, GEAR AND LUBRICATING OILS 13 02 07* readily biodegradable engine, gear and lubricating oils 13 02 08* other engine, gear and lubricating oils

Untitled Diptych. From: *Almásfüzitö: An Index.* Conohar Scott/Environmental Resistance, 2012.

Designing for Advocacy

As a photographer interested in documenting industrial pollution, I had to develop a method of working in order to situate my photographs into a cultural context where the photographs could contribute to an advocacy process, and be instrumental in instigating environmental remediation alongside the environmental science community or activist groups. It was from this aspiration that Environmental Resistance was born, which can be described as an artist-led group that benefits from the diverse skills of its members. So far, it has comprised a photographer, an environmental scientist, a graphic designer and a translator/interpreter.

Importantly, working within the collaborative structure had the advantage of helping to constitute a group identity, which in turn led to the development of a mission statement in which a series of ethical and political objectives could be clearly defined.[1]

The process of designing for visual information advocacy—a term that sums up how Non-governmental organisations employ imagery in order to garner public support—involves situating the photograph within a multimodal context, whereby additional information such as infographs, maps, QR codes linking to scientific data or activist web content, etc. can be displayed alongside or in combination with the photograph. The inclusion of additional modes has the function of anchoring meaning into the photograph by providing the audience with an awareness of the environmental or social problems relevant to a given location.

The importance that captions or additional modal forms play in connoting political meaning to the photograph is demonstrated in the most recent Environmental Resistance publication, *No Al Carbone*, Brindisi. The project was conducted in partnership with the Italian activist group No Al Carbone (NAC), which means 'No to Coal'. The group has been active in their hometown of Brindisi, Southern Italy, for a number of years, and can muster a membership in the low hundreds for significant events such as large street protests. The organisation very

successfully raises local awareness of the health problems associated with the four coal-fired power stations and various petrochemical works, which constitute the nearby Brindisi Industrial Zone. Our collaboration was intended to provide the NAC activists with a physical photo book, a digital file and website content, which could be used as a 'toolkit' for engaging in advocacy debates with public or state officials in the Brindisi region.

In the *No Al Carbone, Brindisi* publication, meaning in the images is anchored to a series of captions alluding to various scientific studies, which point towards Brindisi having elevated rates of cancer, chronic obstructive pulmonary disease and congenital birth defects, when compared with other regions in Italy and beyond. Importantly, the project was designed to be an interactive publication, wherein the scientific claims stated in the captions are affirmed by the use of QR codes at the bottom of the page, which point the reader to a URL, allowing the audience to access the articles in full. This feature of the artwork was instrumental in altering the status of the reader from an initial position of passivity to that of an active researcher. In the context of the ongoing political situation in Brindisi, one of the aims behind the publication was to raise awareness concerning the existence of scientific texts, in order to widen participation in environmentalist discourse throughout the region and beyond.

Mindful of the need to communicate with the inhabitants of Brindisi, whilst simultaneously raising the profile of a localised environmental struggle to non-Italian speakers further afield, it was important that *No Al Carbone, Brindisi* was written bilingually in English and Italian. Here, the contribution of a translator was critical. Our commitment to situating the photographs alongside a series of bilingual captions, detailing the substantive environmental health threat offered by the Brindisi industrial zone, is indicative of an overriding ethical obligation to communicate from a position of universal intellectual equality, as existent between all political subjects. For this reason, there is no 'dumbing down' of the content of the accompanying

Untitled Diptych. From the series: *No Al Carbone, Brindisi*. Conohar Scott/Environmental Resistance, 2014.

captions. Instead, there is an expectation that scientific knowledge pertaining to the sites of pollution should not be restricted to individuals who claim to have representative governance, or privileged professional access to information, at the advantage of the populace in general.

Future Directions

No Al Carbone, Brindisi provides a model of how collaborative working practices can provide a 'service' for localised activist struggles, by synthesising an indexical description of the Brindisi Industrial Zone with an overview of the environmental health implications, which have been suggested by a variety of scientific studies. In this way, an imaginative combination of art and scholarly research can be of benefit to activists who are intimate with the environmental problems that are impacting upon their community.

At the core of Environmental Resistance is the belief that situating the photograph in a multi-modal context can provide the public with new forms of knowledge and new ways of seeing and understanding a given locality. The individual can undergo a shift from a position of hitherto unknowing and invisibility to a form of citizenship that announces the visibility of the individual as an active democratic subject. It is art's capacity to act as a framing tool for the dissemination of knowledge, which is capable of altering individual subjectivity and reconfiguring the social at a micro level, which represents art's potential to act as a potent tool in the battle for political emancipatory struggles.

Note

1 For further details on the Environment Resistance mission statement and other works please visit the project website at: environmentalresistance.org

Mike Simmons:
Documenting the Process

A Framework for Reflection

> The scientific worker operates with symbols, words, and mathematical signs. The artist does his thinking in the very qualitative media he works in, and the terms lie so close to the object that he is producing that they merge directly into it. [1]

In contrasting the 'two cultures'[2] of science and art John Dewey highlights the unique and intimate relationship that develops between artist and subject through the creative process, where the reciprocal action of research and practice fold into one another. As a polar opposite to the scientific approach, Dewey's observation also draws attention to the problematic nature of this symbiosis, as it can often be difficult to separate, value and exploit the things that emerge from within creative practices. In other words, when you focus closely on a project it can sometimes be difficult to 'see the wood for the trees'.

Part of my role as an educator is to encourage students to step back from their work and to think critically about the relationship between their research and practice.

Central to this process is an objective examination of how the knowledge and understanding that emerges from the research process informs their practice and the key to this is reflection. This essay provides some theoretical and practical perspectives to help you develop your reflective skills and critical awareness.

The Project Narrative

Photography first and foremost is not concerned with the concrete but feeds on the uncertainty inherent within the shifting borders of personal experience. Creativity is action orientated and driven by 'doing', a complex process that includes a range of research activities centred on information gathering. Doing can shift and change ideas through the development of knowledge,

PROACTIVE
Motivated change oriented behaviour

RECURSIVE
Analytical and evaluative thinking

INNOVATIVE
Brining together of ideas

TRANSFORMATIVE
Creative problem solving

Developed by Gilles Deleuze and Félix Guattari, respectively a philosopher and psychiatrist. The concept of the rhizome is concerned with multiplicity and non–linearity.

which as a photographer you will express through the 'making' of original artwork. As a method, each element seeps into the other to shape a personal journey of discovery that is proactive, recursive, innovative and transformative, and which provides an infrastructure that is bounded by context but remains open-ended and responsive to tacit knowing and intuition. It encourages rigour but embraces the notion of possibility where ambiguity and difference are familiar bedfellows. In this schematic representation the creative process is outlined as a fluid system of exchange, a holistic chain of events that crisscross and connect equally through and across multiple gateways to reveal opportunities and expose potential. This phenomenon has been described philosophically as 'rhizomatic', referencing the botanical term for plant growth with multiple connections and points for growth where 'any point of a rhizome can be connected to anything other, and must be'.[3]

However, to make personal visual statements relevant and to give them credibility, you need to take into account and question your own subjectivity and its relationship to knowledge and the potential for innovation. In order to survey the contextual landscape and navigate your way through the practical possibilities and keep sight of your purpose, the chart to steer by will be the detailed information recorded and reflected upon in your project narrative. Like the rhizome, which is a 'map and not a tracing',[4] it will connect your research and practice in a

In this detail from the research log Shiam Wilcox, the project narrative combines contextual and practical research elements with reflective questioning and demonstrates the principle characteristics of the rhizome in action.

number of ways. By engaging in a close examination of your 'work in progress' you will begin to question and test your ideas through the development of 'critical distance', a term used to describe the triangulation of ideas, research and practical experimentation. Being critical gives rise to an understanding of the connections, contradictions and challenges that you will encounter, and how this can change your perception through 'the transformation of experience'.[5]

The key to reflection is the identification, analysis and evaluation of the implicit relationships embedded within your research and creative practice and making this tangible by documenting your processes and recording your responses in order to understand and exploit the things that emerge through doing and making.

Traditionally, in arts practice education this has been achieved through a research log of some kind. This can be a physical or digital notebook such as a diary or a blog, and can contain anything that is relevant to your creative work. Developing a project narrative is something that should form an integral part of your practice.

The scientific approach begins with a clear plan, question or design, but arts-based practice cannot have such a defined starting point. By engaging in the creative process you will begin to think and respond to the topic or situation of interest in the light of your developing understanding, which will change and evolve through the organic process of 'doing' and 'making' as you come to 'see and understand in a different way',[6] questioning the what, why and how of your practice, you will begin to engage with the creative process on your own terms and in a way that is relevant to your own aims.

There are a number of established models for reflection that can be explored[7] but a useful and straightforward approach for photographers (and adapted here) is the 'What?' framework for structured reflection.[8] This model has three core questions that act as prompts for additional questioning. It builds logically, and if applied to each phase of a project, will inform each subsequent phase of work.

Core question	Process	Characteristics	Additional questions
What?	Describing the situation to establish perspective	Re-visiting the experience	What did you set out to do?
			What did you do?
			What were the outcomes?
So What?	Analysing the situation to understand context	Theory and knowledge building linking practice with research	What worked well?
			What didn't work?
			What influenced my decisions?
Now What?	Evaluating the situation to modify future outcomes	Action orientated	What might I do differently?
			What other things do you need to consider?
			What might the consequences be?

Adapted from Driscoll 1994 and Rolfe et al. 2001.

Reflection prompts interpretation and understanding in a number of ways and not only stimulates critical distance from your own practice, but it can also be applied to the work of others to examine a range of approaches, theories and contexts. Within photography there are many things that can happen in the process of developing a piece of work. For example, research materials are not fixed to one meaning and thus are open to interpretation, which can lead to unexpected discoveries. Photographers use a range of mechanical devices and

In this detail from the research log of Charlotte Fox, a review of a practical phase of work reveals a number of areas for further technical development.

processes that can at times have 'a mind of their own'. Things can emerge thorough your practice that were not planned for and these chance encounters may be pivotal in shifting the direction of your work, which may become hidden or lost if not documented in some way, and an opportunity for development will be missed.

Scholarly studies across different disciplines have acknowledged the existence and influences of intuition and chance, and there are many examples within the pages of this book that

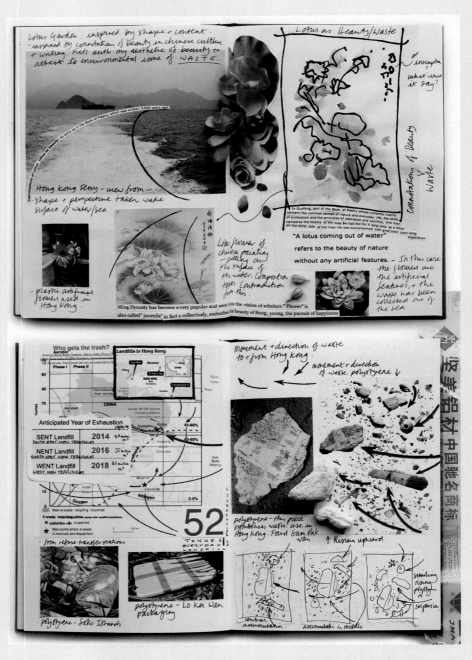

In this detail from the research log of Mandy Barker, the recording of practical and contextual information reveals the story behind the work. The information you record also becomes an archive and may take on new meanings through reflection to stimulate subsequent projects.

exemplify such events. But the literature has also identified that 'an open and questioning mind'[9] is required to identify and acknowledge such opportunities, which can be made explicit through the recording, reflection and evaluation of your activities.

You may become unrealistically attached to certain aspects in your work, which is another pitfall that documentation and reflection can identify and overcome. The questioning developed through your analysis and evaluation will allow you to make informed choices and keep focused on the purpose of our work. In any given project there are often challenges that may halt progress. The temptation is to alter your goals aims to fit the changing circumstances. But rather than simply sidestepping the problem, finding creative solutions is a far better approach and maintains the integrity in your work. Through your research log you can locate when the problem began, identify where things may have gone astray and why, and work through the problem and progress your work in a forward direction and improve your personal and creative performance.

Of all the research and practical experimentation you undertake, you will probably set aside more than half in the resolution of your work. But the choices of what to take forward and what to leave behind can only be made effectively if you know and are familiar with what you are dealing with, which can only be achieved through documentation and reflection.

Notes

1 See John Dewey's *Art as Experience*. Originally published in 1934 but re-issued in 2009 by Perigee Books: New York.

2 C. P. Snow's *The Two Cultures* was originally published in the *New Statesman* in 1956, and by Cambridge University Press in 1959. It is now in its eighteenth reprint.

3 For further discussion on the rhizome theory see: Gilles Deleuze and Felix Guattari (2005). *A Thousand Plateaus: Capitalism and Schizophrenia*.Translation by Brian Massumi. Minneapolis and London: University of Minnesota Press.

4 See Gilles Deleuze and Felix Guattari as above.

5 David Kolb is an educational theorist whose book *Experiential Learning: Experience as the Source of Learning and Development*, from 1983, is available from Prentice-Hall: Englewood Cliffs, NJ.

6 Clark Moustakas published *Heuristic Research, Design, Methodology and Application* in 1990, which is available from Sage Publications: London.

7 See Kolb's Experiential Leaning Cycle, 1976. Also Graham Gibbs (1998). *Learning by Doing: A Guide to Teaching and Learning Methods;* Christopher Johns (2006). *Engaging Reflection in Practice—A Narrative Approach*. Oxford: Blackwell Publishing.

8 Originally suggested by Terry Borton in his book *Reach Touch and Teach: Student Concerns and Process Education*, published in 1970 by McGraw-Hill: New York, and subsequently developed by Driscoll (1994), *Reflective Practice for Practice. Senior Nurse*, Vol.13 Jan/Feb. 47–50, and in *Critical Reflection for Nursing and the Helping Professions: A User's Guide*, by Gary Rolfe, Dawn Freshwater, Melanie Jasper, published by Palgrave Macmillan, London in 2001.

9 See Pek Van Angle (1994) Anatomy of the Unsought Finding. Serendipity: Origin, History, Domains, Traditions, Appearances, Patterns and Programmability. In *The British Journal for the Philosophy of Science*, Vol. 45, No. 2 (Jun., 1994), pp. 631–648.

Sian Bonnell: Lessons from the Audience

The responses of audiences over the years have had quite a profound impact on how I have developed my work and on at least two occasions this response has led to a major re-think on my part. Despite the knowledge that a viewer may be triggered into a different reading of the image than was intended, I had not been prepared for these readings to affect some form of change in my own interpretation and communication of the work.

My photographs have the appearance of absurdity and are conjured from the most banal of experiences and objects. The methodology that I have developed over 30 years is one that is open-ended, experimental and exploratory. I will work with whatever is there to hand and wherever I am—I do not need a studio in order to make my work. I tend also not to follow technical prescriptions—not because the proper tool or implement is unavailable, but because I want to see what it will do in a different usage or context or what it's not supposed to do. My approach to my work revolves around lived experience and stems from my education, studying the art movements that influenced me most, Dada and Arte Povera; and this approach is woven through my everyday life—I will make a piece of work just out of my lunch.

My early work centred on landscape and object; I used juxtaposition as a method to explore the flora and fauna of the local land and noticed that in re-placing disparate objects, toys and food into alien territory the objects began interrogating themselves and their dislocations, producing a variety of atmospheres that were sinister and frightening. I was examining every facet of the landscape genre with particular emphasis on politics; land use, territory, ecology, sustainability and gender. I was utterly earnest in my approach but although the methods I used to make these images were quite absurd (running up and down hills with set jellies in moulds, slapping these down on the land and photographing them) it never occurred to me that the humour might leach into the images themselves.

I was deadly serious. The photographs were hysterically funny. In exhibitions people were laughing uncontrollably. I was mortified and deeply upset; I interpreted this as a huge failure. It took a little while but through a reflective process I realised that this reaction could be turned on its head and be used positively. After all, humour can be seen as a gift and one

From the series
Groundings.
© Sian Bonnell

that can be used to hold an audience's attention as well as to draw them in. This was when I realised that listening to the audience's response, though perhaps bruising, can have the power to affect change.

The audience for that early work gave me permission to be myself as a maker. Since then I have not been ashamed of my methods and ideas. I realise that perhaps looking stupid or absurd in the making of an image is a small price to pay for communicating complex ideas. I realise, too, that audiences are far more intelligent and intrepid than we presume and are prepared to go a very long way with what is being asked of them, if it is done with evident integrity.

The second time that audiences profoundly affected my work was in 2011 when I was showing a preview of some of the work I had made on a three-month fellowship in Rome. *Camera: How to be Holy* featured self-images enacting religious gestures and *Camera: Stigmata* depicted the re-enactment of five versions of St Catherine of Sienna receiving the stigmata. I was concerned with notions of superstition and religion and how these still might have relevance today. This stemmed from my mother's desire for my sister and me to be indoctrinated into the Roman Catholic faith as small children, despite our being a Protestant family. As a child I had become obsessed with the idea of holiness and, for a seven-year-old, this involved the acquisition of a halo.

Being a grown-up meant that I could revisit this early fascination and this led me to fashion rough halos out of domestic disposable plates and party servers. I also acquired three housecoats

From the series
*Camera I: How to
be Holy*, 2011
© Sian Bonnell

from a street market. These were unflattering, highly patterned garments, the kind worn by older ladies to do their housework. I began making self-images wearing this clothing and the halos. This led to my researching the gestures found in religious iconography of all kinds; not just in High Renaissance painting but in the cheap tat sold at the Vatican. I made a series of images reiterating these gestures under the title *How to be Holy*. The concept was one of instruction, like a manual or like a TV programme that shows you how to do something: 'Here's one I made earlier.'

I used available light in the studio, I sourced a costume that alluded to the housewife or a cleaning lady—but of course she would not be doing what I was doing whilst wearing it. My halos were made from picnic ware. Sometimes I was the Virgin, sometimes a priest, sometimes an angel; I was being both male and female.

I introduced my dressing gown (a hooded grey velour robe zipped up the front), with a selection of homemade paper and card halos for *Camera: Stigmata*. As in the previous set of pictures, I made no attempt to hide my status as a twenty-first-century woman.

At the exhibition when they were shown I was shocked by the reaction of the audience. Men and women were affected equally; they would start with laughter and then suddenly they would be overcome emotionally, many cried. I had not expected this and it gave me a jolt, in that I had underestimated the power that photographs can have to play with a spectator's emotion. This intense reaction of the viewers threw me. I put the work aside for two years, which allowed a retrospective view of my practice over a 30-year period. I was unable to let the work go until I had undergone this review.

Normally, once my work has been exhibited, I must let it go. It no longer belongs to me—it is out in the world and has to fend for itself. I continue to learn a great deal from the reactions and views of audiences and from the different readings the work provokes for them, especially if new contexts for the work are evoked in that process. I find this intensely exciting and rewarding; I respect completely what audiences have to teach me.

From the series *Camera II: Stigmata*, 2011. © Sian Bonnell

Camilla Brown: In the Public Domain—A Curator's Perspective

The term curator is currently used for a variety of different roles and approaches, so for clarity it seems worthwhile setting it in some form of context. My background has been working as a curator in the UK public gallery sector, with 10 years spent in a curatorial role at The Photographers' Gallery in London. Referring mainly to examples of my work during this time the text seeks to outline, and hopefully reveal, how public gallery curators work. The text has been written whilst considering the photographer's perspective and is structured as a journey from research; to audience; to the display of work and the reception of a show.

Research

Research is embedded in a curator's role and they will be on a constant learning curve discovering new artists and keeping up to date with current themes and issues. Research on individual artists will often start at a nascent stage when curators visit undergraduate students for portfolio reviews, or when they see postgraduate degree shows. Those artists not in higher education may be picked up on through festival portfolio reviews, through work published in magazines or seen in other shows. Curators will often sit on juries, increasingly for online awards, and will be constantly sifting through and looking out for interesting work and sharing this information with their network of peers.

It can be hard to know how to initiate contact with a curator especially now that most venues no longer have an open application process for applying for exhibitions. Getting a chance to meet a curator can often take time, research, persistence and requires networking. However, a curator's work is in the public domain and most will give talks and be part of public events so with tenacity a way can often be found. Should an opportunity arise to show a curator your work, it is well worth making the most of it by rehearsing what you will present and what you will say about your work. Equally, spending some time finding out more about the curator's work and looking at some of their shows will help to break the ice on a first meeting.

Once an artist's work sparks interest then curators will keep an eye on shows and publications and make studio visits. This is likely to be over many years. Temporary exhibition spaces like The Photographers' Gallery, unlike commercial spaces, will only show an artist's work once. This means that there is a lot of emphasis on picking the right moment or series of work to show. When an artist or show is at the point of being actively discussed in a programming team, a priority for most venues will be to have some form of angle or unique aspect to their exhibition.

To give an indication of how long things can take, an exhibition with the UK-based artist Dryden Goodwin took eight years to develop. The conversation began in very early 2000 when Goodwin expressed an interest in exploring the role of photography in his practice. It was not until 2008 that the project happened and was in the end the last exhibition held at the Gallery's Great Newport Street site. The fact that Goodwin was keen to make new work in and around the Gallery location became a key factor, alongside his own trajectory as an established UK and international artist. The project was in collaboration with the commissioning agency Photoworks. They had secured significant funding to produce a new series of work

Installation views of work *Caul, Dryden Goodwin: Cast*, exhibition held at The Photographers' Gallery, 26 Sept.–16 Nov. 2008. © Dryden Goodwin.
Jason Welling. Courtesy of the Photographers' Gallery, London.

Installation views of work *Cradle*, *Dryden Goodwin: Cast*, exhibition held at The Photographers' Gallery, 26 Sept.–16 Nov. 2008.
© Dryden Goodwin.
Jason Welling. Courtesy of the Photographers' Gallery, London.

with Goodwin. They also had a partnership with the international publisher Steidl to develop a monograph alongside the show. The Photographers' Gallery would not have had the budget to produce a large book and new work without external financial support. Through working together we were also able to find an international touring venue—the Hasselblad centre in Sweden—to take the show after it was seen in London. This was to add income to the project but also offered international profile for the show and the artist. Often, it is the artists who broker such collaborations by mentioning to curators other people and organisations that have expressed interest in their work. Increasingly, with budgets getting smaller, collaborations such as this are becoming more key in curatorial discussions.

Audience

Curators in publicly funded galleries will have a keen sense of who their audiences are and which audiences they are trying to reach. Galleries will have information from marketing departments on the demographic profile of their audiences, which may also indicate the types of shows that may appeal to different groups. This will impact on the work they show and there are trends and fashions within this. A curator may develop a show with a particular audience in mind, for which they could have attained designated funding.

For example, the exhibition *Brixton Studio* held at The Photographers' Gallery in 2002, included the archive of a Brixton-based studio portrait photographer Harry Jacobs, alongside a series of new commissioned works by four artists working in Brixton. A local photographer Paul Ellis, saved Jacobs' work as it was about to be thrown into a skip after he retired. Ellis could see that what he had produced from the 1950s to the 1990s was a rare and valuable community and photography archive. Across the work, the Afro-Caribbean Windrush-year migrants who moved to Brixton from the 1950s were seen, as were their families and future generations. Funding was received to digitise the collection and an artist was employed to work in the community in Brixton to find people who appeared in the photographs and to arrange community-focused events during the show. This was a very specific example of audience-focused programming and reach. More often, such community work will happen through the education programme alongside a show.

In terms of audience, it is not only the general public that a curator will be thinking about, there are a range of other key groups and opinion formers such as the press, funders, patrons and other artists and curators. Getting press coverage for exhibitions can be challenging for venues in London where there is a lot of competition, but equally outside of London it can be difficult simply to get critics to visit shows. A gallery's press team will have a range of ongoing contacts with reviewers and publishers and this key group will be in their minds when planning and developing a show. The gallery will be in constant contact with funders and individual patrons and donors, and will often hold specific events for those people which artists will be asked to attend. These groups will also strongly impact on how the work and show is positioned and described.

The Language of the Show

The different types of audiences will impact on the language that a curator will use about an exhibition. Often it is one paragraph of 100 to 150 words that will be used repeatedly in marketing material and on websites, in the press release and sent to potential funders. Surprisingly, this can then be literally copied in articles and listings in the papers and online. It will also be used as the basis for interpretative material in the show and on the gallery walls. It will have an institutional, rather than an individual voice and tone. It should use

straightforward but informed language, and is likely to be originated by the curator but then go through various internal rounds of editing and input.

It is worth setting your terms with a curator in advance. Are there pieces already written about your work that you particularly like or do you have a way you like your work to be described? Are there terms you would rather avoid, for example the term documentary can be quite contested? Equally, do you want to be called a photographer or an artist? Trusting the curator is part of this process; not only will they be experienced writers and experienced in positioning and describing work, but they will also be the final editors of the text before it goes out into the world.

Outside of this type of writing a curator may also develop a longer piece of text on your work in an essay for a catalogue or online publication. Equally, they may do this for a show they are not working on with you, and most curators will write both for their role and outside of this context. Developing a relationship with them as a writer can be helpful and be a way to nurture a longer-term relationship with them.

Text will also accompany the work itself, the title of the work and the caption for an image. Traditional editorial photography depended on the written word alongside photographs in shows. Often, long captions were needed to contextualise images. Over time the connection between titles and works has shifted and the way that text appears alongside images has also altered. Card-mounted captions are becoming a thing of the past as text is now more often directly adhered to the wall using dry transfer or vinyl lettering. This allows for the use of colour, a play with scale and to experiments with fonts.

Thinking about the Space

In an age when so much photography is consumed online and in books it is worth reflecting on what it might mean to show your work in a gallery space. It is a very different encounter with the work. In preparation for this it is literally well worth living with your work, trying out different print sizes, groupings and sequencing. How many works are needed to convey the meaning of the series? Should all the images be the same size or would it work to make some larger? How might you place them on a wall in a line? As a grid?

Photographers who have studied in fine art schools will often make presentation decisions very early on in their working process. Traditional photographers are unlikely to consider this aspect until much later on in the process. Of course, the type of space you are working with—the height of the walls and the width of the space—will also make a difference to how you might present the work. The gallery space is an installation and a curator from a particular venue will know the space well and should acknowledge both its limitations and strengths. The planning process for a show will often begin with floor plans of the gallery space, which for a new building may be detailed and sophisticated but in an older space are more likely to be basic and rudimentary. However, they are key in the development of the installation and will be used to decide where temporary walls might be built and to estimate how many

works will fit into the space. A curator will always pace out such plans in the space with the technical crew and attempt to measure out potential temporary walls. If it is possible to attend these meetings it is well worth it. If that is not possible then detailed conversations and taking advice from the curator will help.

Realistically pre-visualising the space your show will occupy is an important task, but some people find this easier to do than others. It may aid you to work on a scaled plan or you may prefer to be more instinctive. However, turning up two days before a show opens and expecting a complete rebuild of the space will simply not be possible, nor create a good working dynamic. Venues are under immense pressure to be closed for as short a time as possible between exhibitions to prevent a drop in footfall, and the usual loss of income this entails. This means there is usually a specific window to build and install work. Also, for budget management good estimations are needed, especially when working with artists who are overseas. Being clear about the number of works that need to be printed and framed is important, as transport costs are usually very large. Equally, storage space is at a premium in most gallery spaces and the cost of secure offsite storage and insurance can be high.

Ultimately, the exciting time for a curator and artist will be in these tense days whilst work goes up on the wall and the sculptural presence of the show takes shape. Inevitably, things don't always go to plan, so being responsive to last-minute tweaks can in the end lead to a better realisation of the show. Making it look as good as it can in the space is key, and that requires teamwork with all those at the space, the installation crew and curatorial staff, but often the interns and volunteers as well.

Exhibition Design

Curators and the in-house installation crew face the challenge of having to keep a space looking fresh, by regularly changing its configuration. Thinking of innovative ways to design the space and to brand the show using graphic design and colour is part of enhancing the visitor experience. Audiences are expecting an ever-increasing quality of display that they are used to seeing in museum and gallery spaces internationally. Major museums will employ exhibition designers and can spend a significant amount of their budget on this aspect of a show. Smaller venues have to try and achieve the same effect with less money and using the in-house team.

Spaces can be transformed by simple and cost-effective means and attention to detail. For the Dryden Goodwin installation of the work *Caul* (see photo), a number of things were done to change the look and feel of the space, including painting all the gallery walls a uniform grey. This changed the lighting level for the show, made what was quite a busy series of spaces feel more coherent and unified, and overall made the space feel much more like a traditional museum. It can take quite a lot of persuasion to get galleries to be willing to paint their white walls a different colour, not least as it takes time after a show to get the walls back to white. But there are times when it can work very well in particular contexts. Sometimes, painting just one wall a different colour can make all the difference.

Presentation of Work

How works are framed and displayed can be one of the biggest costs for a show but will also make a huge difference to the impact of the work on the wall. As with other things there are trends; there was a time when all photographs seemed to be mounted with white card and placed in black-rimmed frames, and other moments when everyone seemed to mount their prints on aluminium with batons on the back that were attached to the wall. Exhibiting work is a chance to try out new print sizes and to play with presentation. Go large and perhaps a frame will not be needed at all and the work can sit pinned on the wall, or if you want to go very big the work might need to be stuck onto the wall—the devil will be in the detail. If you are trying anything new it is well worth factoring in the time to do some tests and trial runs ahead of the show. Again, this is something to discuss with the curator who may have relationships with a particular printer or experience of trying out different sizes in the past.

Installation views, *Once More with Feeling: Recent Photography from Colombia,* exhibition held at The Photographers' Gallery, 18 April–15 June 2008.
© Oscar Munoz, Mauricio Prieto.
Jason Welling. Courtesy of The Photographers' Gallery, London.

It is not always necessary or possible for expensive solutions to be found for exhibiting work. With budgets tight often the production costs for a show need to be kept down. With Colombian artist Oscar Munoz's *Archivo porcontacto* (2004–2008) this involved developing an installation that needed to combine an archive of small black and white prints with large colour works. On an early site visit we decided to work in a gallery space that was also a café. Several ideas were floated including placing the smaller prints onto the tables in the space with glass on top of them. However, in the end one of the installation crew suggested a simply constructed angled shelf with a plexi-glass insert that could be built in several units along the wall of the space. Above it the large colour prints were simply pinned to the wall. With their white surround and scale this worked well in the space.

An increasing trend in contemporary photography is for artists to work with archives of either their own images or with other people's photographs. Being creative about how these works are installed is a very important part of the work. A good example of this type of practice is the work of Marjolaine Ryley. I have included two examples of shows she has

Installation views, *Once More with Feeling: Recent Photography from Colombia*, exhibition held at the Photographers' Gallery, 18 April–15 June 2008.
© Oscar Munoz, Mauricio Prieto.
Jason Welling. Courtesy of The Photographers' Gallery, London.

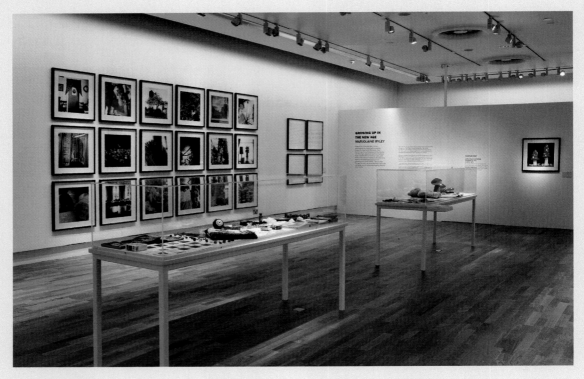

Installation views of Marjolaine Ryley *Growing Up in the New Age*, exhibition held at the Wolverhampton Art Gallery,
23 June–8 Sept. 2012.
© Marjolaine Ryley.

worked on in venues where I have not been involved as a curator, but which demonstrate
how different spaces offer alternative ways to exhibit the same work. This series of work
Growing up in the New Age comprised a series of colour photographs, some text works and
a collection of objects. Two installations are shown here, one at Wolverhampton Art Gallery
and the other at Street Level in Glasgow. In Wolverhampton the objects are placed in glass
vitrines in the centre of the space. You will see on that on this occasion photographs have
been interspersed with text works, which are similarly framed. At Street Level the configura-
tion of works alters as the text work appears on its own in a group and the images are laid
out differently. These alterations allow the work to shine in each space and venue but, equally
important, provide the viewer with a unique exhibition experience each time the work is
shown.

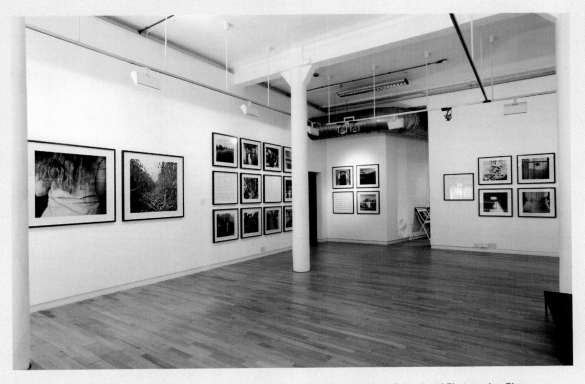

Installation views of Marjolaine Ryley *Growing Up in the New Age*, exhibition held at the Street Level Photoworks, Glasgow, 20 April–3 June 2012.
© Marjolaine Ryley.

Budgets

A lot of such decisions will inevitably come down to money and a curator will be the gateway between you and the budget. Ultimately their priority is to ensure that the money is spent where the public will see it. It may not seem best value for money to buy one very expensive frame if a series of large prints could be produced for the same budget. Value for money is key but equally artistic integrity and quality is also important. Curators are often adept fundraisers who can work to apply pressure to get more money in at the right time for projects. Equally, when finances are short they will need to find cost-effective yet creative solutions to working with limited funds. Ultimately, they will be responsible for balancing budgets and ensuring they come in on target. So, working with, rather than against them, is key.

During the Show and Beyond

The exhibition will of course be a rare public outing of an artist's work and will give unique opportunities to get public views on your practice. You will also get some critical assessment of the show. It is well worth listening and documenting this. Taking your own installation shots is a good idea as a venue may do this for their own archives but not in the way that is most helpful for you. Giving talks about your work and meeting the audience can also be very rewarding and helpful. Keeping press cuttings and copies of marketing and printed material is worthwhile for future use in funding applications and as a record of your work. It is worth asking for audience feedback from venues that will most likely over time collate all the print and press material and audience statistics for a show. Often, however, simply spending time in the space—incognito if necessary—and listening to people's responses can be the best way to gauge reaction to the work.

In conclusion, exhibiting your work should take you as well as the visitor on a journey. It will develop new professional relationships, which may over time lead to other projects and opportunities. It will also introduce an audience to your work and increase your profile as an artist. To develop your reputation you need to have your work shown. Art historians and future generations of researchers and art enthusiasts use these public manifestations as signals of your works significance. Over time they cumulatively lead to museum and collector interest in your work. The creative arts are as much an industry as any other form of business or enterprise, and in some ways exhibiting your work is your way of entering that market. It is time consuming and at times exhausting working on shows but it can equally be enriching and rewarding.

First steps to exhibiting your work may well start with self-initiated projects, group shows, or degree/postgraduate shows. These entry-level opportunities give you valuable experience and insights into how to handle the exhibiting process and what is involved. There are many new ways to develop a public platform for exhibiting work perhaps for an event or at a screening, or through online competitions and websites. However, the social space of the gallery will continue to remain an important arena in which to encounter photography and associated media. There is work and content that is just more fulfilling and meaningful to experience firsthand and to contemplate in a social space with others. What is interesting for a curator is that an exhibition can transform or alter the way a work is seen or understood, which can be a revelation. If you are aspiring to show your work in a gallery context then hopefully this essay will have provided some tips to enable you to start that journey.

Contributors' Biographies

Subhankar Banerjee's photography and writing explore eco-cultural relationships between human and nonhuman biotic communities and varieties of anthropogenic environmental violence, including climate change, and have engaged with three geographies so far: the Arctic; desert of the southwestern United States; and the coastal temperate old-growth rainforests of the Pacific Northwest. His photographs have been exhibited widely, including in the *Rights of Nature: Art in Ecology in the Americas* exhibition at the Nottingham Contemporary and *All Our Relations* of the 18th Biennale of Sydney. His most recent book is an anthology he edited, *Arctic Voices: Resistance at the Tipping Point* (2013). He has received several awards, including a Cultural Freedom Award from the Lannan Foundation and a Greenleaf Artist Award from the United Nations Environment Programme. In 2016, Banerjee was a Visiting Fellow at Clare Hall, University of Cambridge. Further details can be found at: www.subhankarbanerjee.org.

Mandy Barker has exhibited internationally including The Photographers' Gallery, Somerset House, The Mall and Cork Street Galleries, London, The Aperture Foundation, New York, and The Science and Technology Park in Hong Kong. Her work is currently touring the United States as part of the exhibition, *Gyre: The Plastic Ocean* that began at The Anchorage Museum in Alaska. Mandy Barker has been nominated twice for the prestigious Prix Pictet award and won other awards including the LensCulture Earth Award 2015, IPA 2014 and The Royal Photographic Society's Environmental Bursary 2012. She was interviewed live for *Connect the World*—CNN News, United States, for her series PENALTY during the time of the FIFA World Cup 2014, and contributed to *CNN International, Time Magazines Lightbox for Earth Day 2012*. Her series SOUP has been published in over 20 countries including *Time Magazine, The Guardian, the Financial Times, Smithsonian, GEO* and *The Explorers Journal*. Further details can be found at: www.mandy-barker.com.

Sian Bonnell is a UK-based artist and curator. Educated at Chelsea School of Art and Northumbria University, her images have been exhibited and published widely, most recently at the Victoria & Albert Museum in London throughout 2015. In addition to her own practice, she has continued to mentor emerging photographers and artists as well as curating numerous exhibitions in London and abroad; since 2014 she has selected and curated tertiary-level UK student photography for a series of exhibitions at Pingyao International Festival of Photography in China each September. She is regularly invited to review portfolios at prestigious events and has judged major competitions including the Jerwood Photography Prize in 2006 and the Taylor Wessing Portrait Award at the National Portrait Gallery in 2009. Further details can be found at: www.sianbonnell.com.

Deborah Bright is a Brooklyn-based photographer, writer and educator. Prior to becoming Chair of Fine Art at Pratt Institute, she held a joint appointment as Professor of Photography and History of Art/Visual Culture at the Rhode Island School of Design where she served as Dean of Fine Arts from 2009 to 2011. Her photographic projects have been exhibited internationally, including at the Victoria & Albert Museum; the Museet for Fotokunst, Copenhagen; Nederlands Foto Instituut, Rotterdam; Museum Folkwang, Essen; Canadian Museum of Contemporary Photography, Ottawa; Cambridge Darkroom; and Vancouver Art Gallery. Her photographs are included in the collections of the Whitney Museum; National Museum of American Art, Smithsonian; Addison Gallery of American Art; Fogg Art Museum; Boston Athenaeum; Rose Art Museum; Binghamton University Art Museum; California Museum of Photography; and the RISD Museum of Art. She has received numerous grants and awards for her photography and critical writing. Bright edited *The Passionate Camera: photography and bodies of desire*, a groundbreaking collection of images and writings on photography and queer politics. Further details can be found at: www.deborahbright.net.

Camilla Brown trained as an art historian and is a curator, writer and lecturer at Middlesex University and a Visiting Fellow in Photography at the University of Derby. She regularly writes for artists' monographs and for publication on the history of photography. Her curatorial practice has also been featured in a number of books and her series of essays about contemporary women photographers are available at: www.photomonitor.co.uk/reviewed_by/camilla-brown-2/. Also, for further information see: www.camillaebrown.co.uk.

Edmund Clark is an artist whose work links history, politics and representation and traces ideas of shared humanity, otherness and unseen experience through landscape, architecture and the documents, possessions and environments of subjects of political tension. Recent works *The Mountains of Majeed, Guantanamo: If the Light Goes Out* and *Control Order House* engage with state censorship to explore the hidden experiences and spaces of control and incarceration in the 'Global War on Terror'. Clark's work has been acquired for collections including the National Portrait Gallery, the Imperial War Museum and the National Media Museum in Britain, and internationally the George Eastman House Museum, USA,

the Museum of Fine Arts Houston, USA, and The Fotomuseum, Winterthur, Switzerland. He was awarded the Royal Photographic Society Hood Medal for outstanding photography for public service in 2011 and shortlisted for the Prix Pictet in 2012. He is represented by Flowers Gallery (London and New York), Parrotta Contemporary Art (Stuttgart and Berlin) and East Wing (Dubai). Further details can be found at: www.edmundclark.com.

Hannah Collins is an artist and filmmaker who has lived and worked in Barcelona and California and is currently living in London. Her work has been shown internationally most recently at the Caixa Forum, Madrid; Camden Arts Centre, London; and the Sprengel Museum, Hannover. Her films include *La Mina*, *A Current History*, *Parallel*, and *Solitude and Company*. Her work is featured in many collections including V&A, Arts Council, British Council and Tate in London; the Maison Européene de la Photographie in Paris; the European Parliament in Strasbourg, MUDAM in Luxembourg, and the Walker Art Museum and Dallas Museum in the USA. Her books and writing include, most recently, *Hannah Collins* (Sprengel Museum, Hannover 2015); the *Fragile Feast* (Hatje Cantz 2011), and *Finding, Transmitting, Receiving* (Black Dog 2007). Further details can be found at: www.hannahcollins.net.

John Darwell has exhibited widely including the UK, the Netherlands, Italy, the USA, Mexico, South America and the Canary Islands. His work is featured in a number of collections including the National Museum of Media/Sun Life Collection, Bradford, the Victoria & Albert Museum, London, and the Metropolitan Museum of Art, New York. John has published 17 books to date, the most recent being: *Sheffield: In Transition* (Cafe Royal Books); *Chernobyl volumes 1 and 2* (Velvet Cell, 2014); *Things Seen Whilst Wandering Around Attercliffe* (Cafe Royal Books, 2014); *'Desert States': Images from the South West United States* (Velvet Cell, 2014); and *Grangemouth and the Forth Estuary* (Cafe Royal Books, 2014). Further details can be found at: http://johndarwell.com.

Susan Derges began her career as a painter working in London and Berlin in the 1970s and moved to Japan in 1980 where she developed the camera-less approach to photography for which she has become internationally renowned. Cycles of life, death and change, and their relationship to physical experience are explored through visual metaphors that borrow from science, nature, psychology and art. She is currently working on a series titled *Tide Pools*, which has been developed with assistance from the department of Marine Biology at the University of Plymouth, where she is also Visiting Professor of Photography. Her publications include *Liquid Form* (Michael Hue Williams, London); *Woma Thinking River* (Fraenkel Gallery, San Francisco); *Elemental* (Steidl, Gottingen); *Shadow Catchers: Camera-less Photography* (V&A/Merrell, London).

Andrew Dewdney is a research professor, PhD supervisor and lecturer at London South Bank University. He is a co-director of the newly formed Centre for the Study of the Networked

Image, which is a collaboration with The Photographers' Gallery, London, as part of their ongoing Digital Programme. He is an editorial advisory member for the Routledge journal *Photographies* and the Intellect journal *Philosophy of Photography* and a Board Member of Culture24. Between 2007 and 2010 he was the Principal Investigator and Director of an AHRC major national collaborative research project between Tate Britain, University of the Arts London and LSBU. In 2014, he was a Co-Investigator on Cultural Value and the Digital, a further collaboration with Tate and the Royal College of Art. He has worked professionally in the cultural industries and voluntary arts sector as well as academia and through his research promotes the need for greater collaborative approaches between theorists and practitioners working in the public realm. Further details can be found at: www.lsbu.ac.uk/ about-us/people-finder/prof-andrew-dewdney.

Charlotte Fox is an English artist and photographer. She graduated from the University of Lincoln (UK) with a BA (Hons) in Fine Art where her key interest was the manipulation of space photographically within an architectural context. Fox undertook a Master's in Photography at De Montfort University (Leicester) to pursue her ambitions further by introducing sequenc ing to include the notion of time within her work.

Judy Harrison is a photographer, artist, writer, curator and lecturer. She was the Founder and Director of the Mount Pleasant Photography Workshop from 1977 to 1992, and in 2014 she was awarded a Lifetime Achievement Award by the Asian and Sikh Community of Southampton for her contribution to photography. Her documentary and editorial photography have been published widely and she has exhibited nationally in the UK. Her work is held in numerous collections including the Victoria & Albert Museum, London. She is currently a member of Photofusion Picture Library, London, and was a member of the FORMAT Picture Agency, London from 1986 to 2003. She is Principal Lecturer of Photography and Course Leader for MA Photography at the University of Portsmouth.

Martin Hartley has over a decade of travel on journeys to the North and South Poles and is one of the only photographers in the world with the skills to cross the frozen Arctic Ocean on foot and with dogs. He was nominated by *Time* magazine as one of their Heroes of the Environment in 2009 for his work with the Catlin Arctic Survey in documenting sea ice cover and ocean acidification. His work has been published internationally by: *National Geographic*, *The Times*, *The Guardian*, *Independent*, *Telegraph* and the *New York Times*; *Hotshoe*, *British Journal of Photography*, *Practical Photography* and *Digital Photography*. He is Director of Photography for *Sidetracked* magazine. His first book was *Face to Face: Polar Portraits*, published by the Scott Polar Research Institute. He has exhibited at venues including the Royal Geographical Society in London, the Scott Polar Research Institute in Cambridge and Iniziative Culturali in Trieste, Italy. Further details can be found at: www. martinhartley.com.

Tom Hunter is an artist and film-maker living and working in East London. He is Professor of Photography Research at the London College of Communication, University of the Arts, London, Honorary Fellow of the Royal Photographic Society and of the University College, Falmouth, and has an Honorary Doctorate from the University of East London. His work has been exhibited nationally and internationally, including the National Gallery and the Serpentine Gallery in London, the Modernamuseet, Stockholm, National Gallery, Poland and Prado, Madrid. His work is in collections which include MOMA in New York; the V&A and National Gallery, London; the Modernamuseet, Stockholm; the Smithsonian, Washington; and the Los Angeles County Museum of Art. His graduation work, *The Ghetto*, is on permanent display at the Museum of London. He has published six monographs about his work: *Le Crowbar* (2014); *The Way Home* (2012); *Tom Hunter—Living in Hell and Other Stories* (2005); *Tom Hunter* (2004 and 2003); *Factory Built Homes* (1998). Further details can be found at: www.tomhunter.org.

Jennifer Hurstfield is a London-based freelance writer and researcher. Her expertise is in public policy research and she has directed research for a wide range of organisations using a variety of research methods. For several years she was a co-editor of the *London Independent Photography* magazine. She is now involved in projects in the London region of the Royal Photographic Society.

Grace Lau is a photographer, lecturer and writer. She was born in London of Chinese parentage. In the 1980s, she explored the subculture of fetish and S/M bondage clubs in London and published *Adults in Wonderland* (Serpent's Tail, UK, 1997). In the course of writing *Picturing the Chinese* (Joint Pub, Hong Kong, 2005) addressing western perceptions of the Chinese during the nineteenth century she recreated a nineteenth-century Chinese portrait studio in Hastings, in which she invited residents and visitors to sit for their portrait. The result was an archive of *21st Century Types* in an echo of early western photographs of the Chinese as portrayed in her book. These portraits were shown at Tate Britain in *How We Are* and have toured across the UK. She has exhibited widely and her work is in the collections of the National Portrait Gallery, Michael Wilson Centre and David and Sarah Kowitz.

Simon Norfolk is a landscape photographer whose exploration of the idea of the battlefield has led him to work in some of the world's worst war zones and refugee crises as well as photographing supercomputers used to design military systems and test launches of nuclear missiles. He won a major commission from Le Prix Pictet in 2013; Le Prix Dialogue at Les Rencontres d'Arles in 2005; The Infinity Prize from the International Center of Photography in 2004; the Foreign Press Club of America Award in 2003: and the European Publishing Award, 2002. He has produced four monographs of his work including *Burke+Norfolk: Photographs from the War in Afghanistan* (2011); *Bleed* (2005) about the war in Bosnia; *Afghanistan: Chronotopia* (2002) (in five languages); and *For Most of It I Have No Words*

(1998) about the landscapes of genocide. His work is in major collections including The Museum of Fine Arts, Houston; the Getty, Los Angeles; and the Tate, London. Further details can be found at: www.simonnorfolk.com.

Deborah Padfield is currently Research Associate at the Slade School of Fine Art, University College London (UCL) where she also received her PhD. She has collaborated extensively with clinicians and patients exploring the value of visual images to clinician–patient interactions and the communication of pain. Her collaboration with Dr Charles Pither at St Thomas' Hospital, led to a touring exhibition, pilot study and book, *Perceptions of Pain* (2003). Her recent collaboration with Professor Joanna Zakrzewska and facial pain clinicians and patients from University College London Hospitals (UCLH) led to several exhibitions, symposia and the current UCL Centre for Humanities Interdisciplinary Research Projects funded project *Pain: Speaking The Threshold*. She lectures and exhibits nationally and internationally. She is the recipient of a number of awards including Sciart Research Award, UCL Arts in Health Award, the UCL Provosts Award for Public Engagement 2012, British Pain Society Artist of the Year 2012 and a UCL Public Engagement Beacon Bursary 2015.

Maria Paschalidou works with photography and video performance. Her work seeks to blur the boundaries between the 'real' and 'imagined', through visual metaphors, fabricated environments, ephemeral constructions and participatory installations. Her research interests include initiatives for collaborative projects as well as activities that challenge dichotomies such as artist and audience, image and language and theory-praxis. Maria has participated in exhibitions, festivals and art projects in Europe, the US, Canada, Russia, Australia, China and South East Asia.

Thu Thuy Pham is a photographer working between London and Berlin. Further details can be found at: www.thuthuypham.com.

Ingrid Pollard is a photographer, media artist and researcher currently undertaking a PhD at the University of Westminster, London. She lives and works in London. She has developed a social practice with representation of history and landscape with reference to race, difference and the materiality of lens-based media. She has exhibited extensively in Britain, including exhibitions at Tate Britain and the Hayward Gallery, London and internationally including Barbados; Martinique; Houston, Texas; Emden, Germany; and Rotterdam, the Netherlands. Monographs include *Hidden in a Public Place* (IMP Press, London) and *Postcards Home* (Chris Boot, London). Her work is in collections which include the V&A and Arts Council Collections in London. Further details can be found at: www.ingridpollard.com.

Conohar Scott is a photographic artist and lecturer at the University of Lincoln. Prior to taking up this post Conohar was the Leverhulme Artist in Residence at Centre for Environmental and Marine Science at the University of Hull. He completed his PhD by practice at

Loughborough University and founded the artist-led collaborative initiative Environmental Resistance as part of his research practice. Conohar's interest is in exploring how art can contribute to informal science learning and public engagement as a form of activism with science and technology.

Nigel Shafran was born in England in 1964. His work has been included in exhibitions such as *Observers, Photographers of the British Scene from the 1930s to Now*, Galeria de Arte SESI Sao Paulo, Brazil; *How We Are; Photographing Britain*, Tate Britain; *Island Stories: Fifty Years of Photography in Britain*, Victoria & Albert Museum; *Reality Check*, Photographer's Gallery/British Council; *Theatres of the Real*, FotoMuseum Provincie, Antwerp and also at the Contemporary Art Society and at Fig -1, both in London. Previous publications include *Ruthbook* (1995), *Dad's Office* (1999), *Edited Photographs 1992–2004* (2004), *Flower's for ___* (2008), *Ruth on the phone* (2012), *Teenage Precinct Shoppers* (2013) and *Visitor Figures*. His work is held in several public collections, including Simmonds and Simmonds, British land, Museum for Moderne Kunst, Frankfurt, Arts Council Collection and the Victoria & Albert Museum. His new book, *Dark Rooms*, was published by Mack Books in February 2016. Further details can be found at: www.nigelshafran.com.

Janina Struk is a documentary photographer, writer and lecturer. Her articles, essays and photographs have been published in a wide range of journals, magazines and newspapers, including the *Guardian*, *British Journal of Photography* and *Feminist Review*. She is the author of two books, *Photographing the Holocaust: Interpretation of the Evidence* (I.B. Tauris, 2004), and *Private Pictures: Soldiers' Inside View of War* (I.B. Tauris, 2011). She has taken part in discussions on British and Irish national radio and featured in documentary films, including *History Detectives* for PBS television in the USA, *Engineering Evil* for the History Channel and most recently *The Secret of the Auschwitz Albums* for ZDF, German television. She is regularly invited to lecture and take part in national and international seminars and conferences, and continues to research and write on the subject of photographs as evidence and the representation of war. Further details can be found at: www.janinastruk.com.

Patricia Townsend is an artist, a psychoanalytic psychotherapist and a writer on the interface between the artist's process and psychoanalysis. She is a PhD candidate at the Slade School of Fine Art where her project is to study the creative process of visual artists. As an artist she works with photography, video and installation and shows her work in gallery exhibitions and film screenings. Recent shows include the solo exhibition *Under the Skin* at the Blue Gallery, Brantwood, Coniston, 2013, supported by an Arts Council award. Recent publications include: catalogue essay for the group exhibition *Not for Sale*, Trapholt, Denmark, 2015; 'Creativity and Destructiveness in Art and Psychoanalysis' in the *British Journal of Psychotherapy*, Vol.31:1, 2015; 'A Life of its Own' in *Free Associations*, Vol. 65, 2014; and 'Making Space' in *Little Madnesses: Winnicott, Transitional Phenomena and Cultural Experience* (I.B. Tauris, 2013). Her work can be viewed at: www.patriciatownsend.net.

Acknowledgements

We would first of all like to thank each of our case studies who have all so generously given of their time for interviews, shared insights into their work and practices and given permission to reproduce their photographs, which we feel is a real endorsement for the aims of this book.

A special thank you goes to our other contributors who have openly shared their professional experiences through their essays and images and who have supported our intention so actively. And to Peter Kennard for distilling decades of research into a foreword which so succinctly captured the spirit of what we set out to do.

We would also like to thank Sian Bonnell, Andrew Dewdney and Jennifer Hurstfield for their help with the interviews. We are also grateful to Andrew Moran, Leila Miller (London College of Furniture) and Itai Doron (London College of Furniture) for their support and Nigel Shafran for his patience while we went through his archive of work books to find our cover image.

Shirley Read would like to thank Sian Bonnell, Lynda Finn, Jennifer Hurstfield, Georgina McNamara, Nicole Polonsky and Jane Roberts for their comments, advice and discussion of practice.

Finally we would also like to extend our thanks to Judith Newlin, Galen Glaze, Anna Valutkevich, Kimberly Duncan-Mooney and Helen Evans at Focal Press for their trust in our idea and for their advice and support in bringing the project to fruition.

Index

References to illustrations are shown in italics. References to endnotes consist of the page number followed by the letter 'n' followed by the number of the note, e.g. 167n1 refers to note no. 1 on page 167.